WITHD D0835479 3

York St John
Library and Information Services

Please return this item on or before the due date stamped below (if
using the self issue option users may write in the date themselves).
If recalled the loan is reduced to 10 days.

RETURNED		1 MAY 2009
- 1 FEB 2008	2 9 MAY 2009	
RETURNED		
1 7 APR 2008		
0 3 OCT 2008 RETURNED		
1 8 SEP 2008 RETURNED		
1 7 MAR 2009		

Fines are payable for late return

York St John

3 8025 00517747 5

YORK ST. JOHN
LIBRARY & INFORMATION
SERVICES

Critical Studies in Art & Design Education

Education

Edited by Richard Hickman

Series editor: John Steers

intellect™
Bristol, UK
Portland, OR, USA

First Published in the UK in 2005 by

Intellect Books, PO Box 862, Bristol BS99 1DE, UK

First Published in the USA in 2005 by

Intellect Books, ISBS, 920 NE 58th Ave. Suite 300, Portland, Oregon 97213-3786, USA

Copyright ©2005 NSEAD

All rights reserved. No part of this publication may be reproduced, stored in a retrieval system, or transmitted, in any form or by any means, electronic, mechanical, photocopying, recording, or otherwise, without written permission.

A catalogue record for this book is available from the British Library

ISBN 1-84150-127-1

ISSN 1747-6208

Cover Design: Gabriel Solomons

Copy Editor: Julie Strudwick

Printed and bound by The Cromwell Press, Trowbridge, Wiltshire

Contents

Appendices

Preface

This book is the first in a planned series of anthologies dealing with a range of issues in art and design education. Other titles in preparation include assessment and evaluation, histories of the subject and postmodernism. The primary - but not exclusive - sources of chapters are papers previously published in the [*International*] *Journal of Art & Design Education* and where appropriate these have been updated. It should be noted that references to the English National Curriculum Statutory Orders, etc., are to the version of the curriculum current at the time of the original publication.

The National Society for Education in Art and Design is the leading national authority in the United Kingdom, combining professional association and trade union functions, which represents every facet of art, craft and design in education. Its authority is partly based upon a century-long concern for the subject, established contacts within government and local authority departments, and a breadth of membership drawn from every sector of education from the primary school to universities. More information is available at www.nsead.org or from NSEAD, The Gatehouse, Corsham Court, Corsham, Wiltshire SN13 0BZ. (Tel: 01249 714825)

John Steers, Series editor

Acknowledgments

I would like to thank the contributors, three of whom have died in recent years - Arthur Hughes, David Thistlewood and Leslie Perry; their collective wisdom is sadly missed.

Jo Styles is thanked for her assistance in compilation and Andy Ash for his help and advice. I would also like to record my thanks to Keith Winser, from Park High School in Kings Lynn for bearing the burden which fell to him during my work on this book.

Finally, I am grateful to my wife Anastasia for her support and forbearance.

Richard Hickman, Editor

Notes on Authors

Nicholas Addison

Dr Nicholas Addison teaches on the Postgraduate Certificate in Education (PGCE) and MA courses at the University of London Institute of Education. He has sixteen years teaching experience at secondary and sixth form level prior to his higher education work. His educational research centres on the integration of critical and contextual studies within studio-based learning. He is chair of the Association of Art Historians Schools Group.

Alison Bancroft

Alison Bancroft, at the time of writing the paper included here, was head of art at Wembley High School, and a freelance consultant/researcher for Brent. She co-edited *The Brent Visual Art Teachers Directory*. Her research interests are in critical studies, curriculum development, and postmodern theories of identity. She was secretary of Brent Arts Forum for Education, Training and Access.

Sue Cox

At the time of writing the paper included here, Sue Cox was senior lecturer in primary education at Nottingham Trent University. She has since moved to the University of East Anglia. Prior to university teaching, she taught at primary level for eleven years. Her research interests focus upon the teaching of primary art and design. She received her MA in the philosophy of education (specialising in aesthetics) from the University of London Institute of Education and an art teachers' in-service diploma from Goldsmith's College.

Lesley Cunliffe

Leslie Cunliffe is senior lecturer in art and art education in the School of Education and Lifelong Learning, University of Exeter, where he runs the Secondary PGCE course in art and design. He has published regularly in *JADE* and elsewhere, with his research interests covering a range of subjects, including aesthetics and art education, and the work of Wittgenstein, Gombrich and Peter Fuller.

Paul Duncum

Paul Duncum is associate professor of art education, School of Art and Design, University of Illinois at Urbana-Champaign, USA. He was previously a lecturer in Visual Art Curriculum at the University of Tasmania, Australia. He has published regularly in international journals and has made a significant contribution to the development of visual culture art education. He co-edited, with Ted Bracey, a series of important essays entitled *On Knowing - Art and Visual Culture*, published by Canterbury University Press.

Richard Hickman

Richard Hickman is a senior lecturer at the University of Cambridge. His teaching experience includes thirteen years as a teacher of art and design and as a university lecturer in art education since 1985. He is editor of *Art Education 11-18: Meaning, purpose and direction*, published by Continuum. He is currently director of studies for art history at Homerton College, Cambridge, and course leader for the art and design component of the University of Cambridge PGCE.

Arthur Hughes

Professor Arthur Hughes was head of art and art education at the Birmingham Institute of Art and Design at the University of Central England, which he joined in 1972 when it was the Birmingham School of Art and Design. He was co-editor of *JADE* from 1994-2000; his obituary appears in *JADE*, 19: 2, 2000.

David Thistlewood

Professor David Thistlewood worked in the Department of Architecture at Liverpool University. He was past President of NSEAD (the National Society for Education in Art and Design) and co-founder of the *Journal of Art and Design Education*, which he edited from 1986-1993. He published very widely, including in the area of critical studies. His obituary appears in *JADE*, 18: 3, 1999.

Nick Stanley

Professor Nick Stanley is director of research and postgraduate studies at Birmingham Institute of Art and Design, University of Central England. He has a background in anthropology but has worked in art and design education for most of his professional life. He served as co-editor of the *Journal of Art and Design Education* from 1994-2001. He has interests in cross-cultural visual studies and the employment of art and design graduates, and he has been involved in producing curriculum development materials. The NSEAD has published two books that he has co-authored: *Designs we live by* (1993) and *Planning the Future* (2000). He is currently editing a book on the future of indigenous museums, with particular reference to the Southwest Pacific.

Leslie Perry

Professor Leslie Perry was professor emeritus at the University of London, having formerly held the Chair in Philosophy of Education at King's College. He was a member of the National Curriculum Council Art Working Group and was an active visual art practitioner.

George Geahigan

George Geahigan is professor of art and design and co-ordinator of art education, Department of Visual and Performing Arts, Purdue University, Indiana, USA. His primary research interests are in aesthetics and art criticism and their application

to curriculum and instruction in the visual arts. He has published extensively on these and other topics in most of the major art education journals in the United States. The University of Illinois Press published his book *Art Criticism and Education*, co-authored with Theodore Wolff, in 1997.

Rod Taylor

Rod Taylor is a freelance Art Education Consultant. For eighteen years he was art adviser to the Metropolitan Borough of Wigan, during which period he established the Drumcroon Education Art Centre and the Artists in Wigan Schools scheme. From 1981-1984 he was director of the National Critical Studies in Art Education project that led to his first book *Educating for Art,* published by Longman in 1986. Subsequently, he has written and lectured extensively in the field of critical studies and approaches to art education.

Introduction

Richard Hickman

This collection of essays is largely made up of up articles published previously in the *Journal of Art and Design Education* (*JADE*), the journal of the National Society for Education in Art and Design (NSEAD). From 2000 the journal was renamed the *International Journal of Art and Design Education (iJADE)* to reflect its international authorship and readership.

In addition to co-founding *JADE* and editing it from 1986-1993, the late David Thistlewood edited an earlier but entirely different book titled *Critical Studies in Art and Design Education*.[1] His prophetic article from volume 12: 3, 1993 was important in terms of its contribution to the debate on the nature and purpose of critical and contextual studies in art education and I am pleased to include it in this publication.[2] Thistlewood bemoaned the fact that the validity of critical studies as a component of the art curriculum has often been measured only in terms of its enhancement of practice. He introduced his 'new heresies', which put forward the notion that 'critical studies should not necessarily inform practice', and that, moreover, practice in art and design may be undertaken 'principally for the benefit of informing critical studies'. Drawing upon John Berger's philosophical analysis[3] he outlines a case for integrating critical studies with photography and media studies in addition to art and design. Volume 18: 1, 1999, *Directions*, was dedicated to David's memory; there is an updated version of Nicholas Addison's article from *Directions* included in this collection.

Together, this collection reviews past practice and theory in critical studies and discusses various trends; some papers keenly advocate a re-conceptualisation of the whole subject area while others describe aspects of current and past practice which exemplify the 'symbiotic' relationship between practical studio work and critical engagement with visual form. The introductory chapter looks back at recent educational trends and traces the development of what in the UK has come to be termed 'critical and contextual studies'. I have drawn upon the work of two well-known and important figures in British art and design education - John Swift and the late Arthur Hughes - to inform my overview of the development of critical studies. Other contributors to the present collection have made reference to Hughes' insightful article from volume 12: 3, 1993, 'Don't Judge Pianists by their Hair' and I am pleased to include it, to give further insight into the genesis and growth of critical studies and his views on the 'forced marriage between practical and theoretical aspects of art'. David Thistlewood's paper traces the origins of critical studies back to the Great Exhibition of 1851 and gives an informed overview of its development in higher education and its percolation into the secondary curriculum.

Leslie Perry, whose paper also appeared in volume 12: 3, 1993, asserted that critical studies 'caters for cognitive thinking of the kind that arises in the presence of practical work'. He went on to suggest that there should be 'visiting critics' to school classrooms along similar lines to artists in residence. He placed himself firmly within the camp of those who advocate a two-way relationship between making and criticising, and asserted that critical studies is 'fundamental and equal to practical work from which it is inseparable'. I have included my own paper to give an example of school practice which demonstrates the relationship between responding to visual form and making; the visual form in this instance being architecture.

Other papers give practical examples of how critical studies - in its various guises - can be effectively taught: Cunliffe provides an interesting theoretical basis for engaging with art objects, drawing upon a range of philosophical perspectives; he goes on to demonstrate how his particular vision of critical studies works in the classroom situation. Nicholas Addison's paper reminds us of the importance of semiotics, arguing for a pluralist curriculum that facilitates 'motivated inquiry' into visual culture and its contexts. Addison's useful outline of 'ways into' visual form is included in Appendix II.

Rod Taylor, who has done so much to promote and develop critical studies in the United Kingdom, provides other examples of classroom practice and gives us his more recent thoughts on fundamental issues - 'universal themes' in art - and gives examples of how both primary and secondary schools might develop their teaching of art through attending to themes such as 'identity', 'myth' and 'environments' to help 're-animate the practical curriculum'. Sue Cox provides a further useful contribution to debate about practice in primary schools. She argues that the prevailing orthodoxy, which informs approaches to art in education, is derived from modernism - a merging together 'into the overarching view that the necessary conditions of art are its formal qualities which express or induce subjective experience or feeling'. This view is challenged in the light of postmodern theory and a case study of a primary teacher's work with children is discussed, with particular reference to what was known as Attainment Target 2.[4] She describes an approach which can enable children to relate to the work of other artists in ways that are appropriate to their own level of development, laying the foundations for later learning, in terms of procedural knowledge both for interpreting art works, and, ultimately, for understanding that theory itself. She goes on to assert that the metacognitive dimension of critical enquiry, implicit both in the theory and the concomitant processes of the learning she describes, opens up rich possibilities for developing critical thinking.

Although some of the discussion in these papers centres on or arises from the English National Curriculum, the issues are more global, and relevant to anyone

involved in developing or delivering art curricula in schools. An American perspective is afforded by the comments of George Geahigan and Paul Duncum. Geahigan outlines an approach to teaching about visual form, which begins with students' personal responses and is developed through structured instruction. Geahigan argues that current models of criticism both distort the actual discourse of critics and they force educators to rely upon a problematic instructional method: classroom recitation. He suggests that critical inquiry, rather than critical discourse, is a more fruitful concept for structuring art criticism instruction.

The focus of Duncum's paper on the other hand is not so much on pedagogy as curriculum content, arguing for the need to totally re-conceptualise the art curriculum. Duncum examines what visual culture might mean in the context of art education, and how pedagogy might be developed for visual culture. His chapter draws on attempts by art educators to redefine their field and others outside art education who are attempting to define visual culture as an emerging trans-disciplinary field in its own right. Duncum asserts elsewhere[5] that sites such as theme parks and shopping malls should be the focus of students' critical attention in schools; it is apposite then that Nick Stanley gives a lucid account of just such an enterprise and practical examples of ways to engage students with this particular form of visual pleasure.

Debate has moved on since David Thistlewood's *Critical Studies in Art and Design Education*. The present publication serves to highlight some of the more pressing issues of concern to art and design teachers. It has two strands; these can be termed the epistemological and the pedagogical. First, it seeks to contextualise the development of what has been seen as an important aspect of art education, discussing its place in the general curriculum - possibly as a discrete subject - and second, it examines different approaches to its teaching. The pedagogical aspect is enhanced further by the inclusion in the Appendices of what I believe to be useful strategies that have already been successfully employed by teachers.

Notes and References

1. Thistlewood, D. (1989), *Critical Studies in Art and Design Education*, Harlow: Longman/NSEAD.

2. Unless specified otherwise, I have adopted the convention of using the term 'art' to include 'art, craft and design'.

3. Berger, J., and Mohr, J. (1982), *Another Way of Telling*, London and New York: Readers & Writers.

4. For the benefit of readers not familiar with the English National Curriculum, the original statutory requirements for art set two 'attainment targets' the second of which ('AT 2') was 'Knowledge and Understanding' and was widely interpreted to refer to critical studies. From September 2000 a new curriculum was introduced, having one attainment target - 'Knowledge, Skills and Understanding' - with four strands:

 • Exploring and developing ideas.

 • Investigating and making art, craft and design.

- Evaluating and developing work.

- Developing knowledge and understanding.

5. Duncum, P. (2001), 'How are we to understand art at the beginning of the twenty-first century?' in Duncum, P., & Bracey, T. (eds.), *On knowing: Art and visual culture*, Christchurch: Canterbury University Press. pp. 15-32.

Chapter 1: A Short History of 'Critical Studies' in Art and Design Education

Richard Hickman

Debate within art and design education over the past 50 years has followed broadly the debates within education in general. Of particular significance has been that concerning apparently opposing educational philosophies based on subject-centred approaches and student-centred approaches. These differing, sometimes polarised views are at the heart of any discussion about the function of visual art in education and are two approaches which determine the nature of the art curriculum: education in art and education through art.

Education *in* art implies learning about the nature of the subject and its related disciplines; it is bound up with the notion of declarative knowledge, that is 'knowing that'. This inevitably leads to further debate about balance between the component disciplines. Education *through* art is based on the notion that the most important factor is education in its broadest sense, and the most important consideration is the learner; in this case, procedural knowledge, 'knowing how', takes precedence. Herbert Read referred to these educational philosophies as being concerned with 'originating activity', that is concerned with facilitating creative expression, and 'didacticism', that is concerned with instruction that is based on the transmission of knowledge and skills. Read advocated a synthesis of these two approaches in the teaching of art[1] but for him the emphasis was on procedural knowledge - making, not 'appreciating'. In a similar way, Viktor Lowenfeld referred to the need to cater for the artistic predilections of both the 'visual' child who strives towards naturalism in representation, and the 'haptic' child who interprets the world in an expressive way; the work of Lowenfeld was very influential in both the United Kingdom and America in advocating a child-centred, process-based approach to art education.[2] Lowenfeld emphasised the importance of the growth and development of the child as a primary goal for art education; this approach characterised much of art education in the post-war years and beyond.

A change in emphasis began in the late 1960s; Dick Field noted this in his influential book *Change in Art Education*:

> *Only within the last two years or so have certain art educators begun to argue that a truer balance must be sought between concern for the integrity of children and concern for the integrity of art.*[3]

Field advocated a move towards a subject-centred approach, asserting that the art teacher must draw upon a range of disciplines, including philosophy, criticism, and history. This heralded the start of a fundamental change in art education in the United Kingdom. The past 30 plus years, has seen a shift of emphasis away from child-centred art education towards a more subject-centred approach, with an attendant emphasis upon cognitive elements in art, in particular, an emphasis upon critical discourse about art.

Developments in art education in the United Kingdom have to some extent paralleled those of America, both are described here. General concern in America about standards in education could be said to have its roots in the late 1950s, during a period of critical reflection on the education system, popularly ascribed to a concern over the then Soviet Union's apparent superiority in space technology with the launching of *Sputnik 1* in 1957. Arising from this general concern, the National Assessment of Educational Progress (NAEP) was set up as a long-term, nationwide curriculum project. Barkan's 1962 article 'Transition in Art Education', which proposed that art should be taught in a more structured way than had been advocated previously, provided some direction.[4]

In the American Summer of 1965, twelve fine art experts were appointed to define the nature and scope of art education. This panel of experts developed four major goals for students to aim towards:

- Perceive and respond to aesthetic elements in art.

- Recognise and accept art as a realm of experience, and participate in activities related to art.

- Know about art.

- Form reasoned critical judgements about the significance and quality of works of art.[5]

The first two goals are concerned with perception, attitudes and production, while the second two goals focus on art history and criticism. Several committees, who recommended that more emphasis be put on art production, reviewed these goals but clearly, the goals reflected a significant move away from a view of art education based on what we might term the 'child-as-artist' model. Goals, such as the four described above, were used as a basis for developing specific objectives for the age levels of nine, thirteen and seventeen, becoming progressively more demanding, according to age. We have, then, a structure for art education in America which not only emphasises the role of the consumer of art (and by implication, diminishes the

role of the maker) but in addition, a structure which is set firmly within an overall model based upon incremental learning objectives.

The theoretical foundations for the development of subject-centred curricula for art in American schools were laid at a seminar in art education research and curriculum development at the Pennsylvania State University in 1966. In particular, a paper by Barkan[6] recommended that art curriculum development should be derived from its disciplinary sources: the artist, art historian, art critic and the aesthetician. Elliot Eisner, adopted this approach in his influential curriculum development study known as the 'Stanford Kettering Project',[7] but it was not until its endorsement by the Getty Center for Education in the Visual Arts that the subject or discipline centred approach to art education came of age. Dwaine Greer coined the phrase 'discipline-based art education' (DBAE) and outlined seven features that characterise it.[8] Greer asserted that a discipline-based art curriculum:

- Focuses on the intrinsic value of art study.

- Operates within the larger context of aesthetic education.

- Draws form and content from the four professional roles, i.e., art historian, art critic, aesthetician and artist.

- Is systematically and sequentially structured.

- Inter-relates components from the four role sources for an integrated understanding of art.

- Provides time for a regular and systematic instruction.

- Specifies learner outcomes.

These seven features encapsulate the philosophy of DBAE and give an indication of how far removed this philosophy is from the 'child art' approach of the progressive movement advocated by educators, such as John Dewey, over one hundred years ago.[9] We can see from this outline that there is, or at least appears to be, a link between a concern for educational 'standards', a structured subject-centred curriculum and sequential learning; such learning would inevitably be *about* art rather than *through* art.

As Swift noted,[10] there was no real equivalence in British art education at that time and many of the ideas circulating in Britain have their roots in America. The notion

of sequential learning in art was first discussed publicly in the United Kingdom in 1972 at a conference at Rolle College in Exeter. The principal speaker, Brian Allison, subsequently published several papers which presented an argument for a re-evaluation of the purpose and content of art curricula.[11] He stressed the need for learning in art to be cumulative and systematic, covering four inter-related areas or 'domains':

- The Expressive/Productive Domain

- The Perceptual Domain

- The Analytical/Critical Domain

- The Historical/Cultural Domain[12]

This curriculum model, which emphasises the need for what was described as a 'balanced' art and design curriculum (i.e. one which deals with cognitive as well as affective aspects of art), was accepted by the Schools' Council,[13] thus helping to establish an analytical, critical and historical dimension to art in British schools. The movement towards a greater emphasis on critical skills in art and design education, and the development in school students of aesthetic concepts was given more impetus by the formation of the Schools' Council/Crafts Council 'Critical Studies in Art Education Project' (CSAE). Its formation was in response to, amongst other things, a concern for the apparent lack of emphasis on the 'contemplative aspects of art education' and the 'consequent reduction in the amount and variety of verbal communication'.[14]

The importance of verbal language skills and the attendant emphasis upon the cerebral aspects of art and design activities accompanied a move away from the child or learner-centred affective approach to art in education. This was of course entirely in keeping with the general concern about 'standards' and the need for teachers to be 'accountable', which meant engaging in assessable activities. Some arts educators, notably Malcolm Ross, former chair of the now defunct National Association for Education in the Arts (NAEA), protested strongly against the notion of increased assessment in the arts, seeing it as undermining the very essence of what makes arts subjects worthwhile. In the following passage, Ross places the arts (including visual art in schools) firmly within the affective domain, with its emphasis upon expression and imagination:

What is learnt through the experience of the arts is sensitivity to the affective dimension of personal expression itself: in particular the arts extend our awareness through the imaginative realisation (and dwelling within) of invented worlds, fictions that are

in a sense truer (because closer to our hearts) than the illusory world of everyday reality.[15]

Despite such passionate opposition, many visual arts educators appeared to welcome the added status which formal assessment gave to the subject, especially when linked to the greater emphasis accorded to the cognitive aspects of the subject. It came as no surprise that the national examination at the end of what became known in England as 'Key Stage 4', the General Certificate of Secondary Education (GCSE), introduced a specific allocation of marks for critical studies; as Wass and Bloxham[16] later reported, the 'added introduction of assessment objectives in 1998 [gave] 33 per cent of marks for critical studies' and presented many art teachers with a significant challenge. So we can add another piece to the links between standards, subject-centred curricula and sequential learning, the missing link being assessment, tied to accountability.

The Assessment of Performance Unit (APU) was set up by the British government's Department for Education and Science (DES) in 1974, and was closely linked to the general climate of accountability in education. A sub-group was formed in 1977 which was known as 'The Exploratory Group on Aesthetic Development', its terms of reference included considering to what extent assessment of pupils' aesthetic development would be desirable and the feasibility thereof; they published a discussion document, *Aesthetic Development* in 1983.[17] In this document, 'aesthetic' was equated from the outset with 'artistic', and the Group argued that artistic development could be assessed without any restriction on individuality and creativity. The report was not, in general, well received; statements such as 'there are no available procedures suitable for assessing artistic appraisals'[18] appeared to be rather sweeping and indicated a lack of familiarity with the field. It was criticised on a number of issues in the educational press, not least for apparent 'crudeness and sloppiness of the thought and writing'.[19] The National Society for Art Education responded to the discussion document in an appraisal published in the *Journal of Art and Design Education*; this response drew attention to the 'idiosyncratic' and 'ill defined use of language' and expressed 'profound reservations' about its philosophical basis.[20] However, the NSAE welcomed the importance that the document ascribed to 'skills of discourse'. Under the general heading of 'Facilitating Skills', the document draws attention to the value of developing pupils' language skills:

The importance of the linguistic ability to communicate clearly with others about the arts is not always adequately recognised or understood. Yet the lack of it could be a severe handicap to both artistic and aesthetic development. Consequently, we regard the learning of the appropriate skills of discourse as of considerable educational importance for artistic experience and appraisal. Facility in language is critical for

the pupil's development of concepts not only about technical means but also about artistic criteria and goals.[21]

Despite the weaknesses inherent in *Aesthetic Development*, it provided some useful material which not only reflected the growing trend towards more accountability in education, but in addition, the growing recognition of the felt need for school students to understand art as well as produce it, and what was perceived as the crucial importance of written and oral language in the acquisition and development of concepts.

It is interesting to note that in the same year of *Aesthetic Development's* publication, 1983, David Hargreaves, observed that:

> *...only on unusual occasions have [art] teachers made use of established works of art, either as reproductions or as art objects on loan to the school, for teaching purposes; though of course normally the art room has a shelf full of books which pupils are encouraged to consult from time to time, mainly for 'ideas'. Lessons in 'art apprecia-tion' are, according to my observations and to art education authorities, rare events.*[22]

The 'art education authorities' to whom Hargreaves refers include Louis Arnaud Reid, writing in 1980, and Dick Field, writing in 1970.[23] There was clearly a growing consensus for there to be a more cerebral element to the teaching of art in schools, linked to a requirement for a structured and assessed art curriculum.

The first clear indication of the British government's move towards a national curriculum, with all that that entails, came in 1985 with the publication of a White Paper *Better Schools*.[24] This formed the basis for the consultation document *The National Curriculum 5-16*[25] by proposing, amongst other things, to work towards a national system of records of achievement for school students and to promote national agreement about the purposes and content of the curriculum. This culminated in the Education Reform Act of 1988, which placed a duty on the Secretary of State to establish the National Curriculum which must include appropriate attainment targets, programmes of study and assessment arrangements for each of the 'foundation' subjects, of which art is one. The statutory Order for art were laid before parliament in March 1992, with its provisions relating to the first key stage (i.e. up to age seven) coming into force in August of that year.[26] For the first time, in English education there was a statutory obligation for state schools to provide art as part of the curriculum; such provision was expected to include teaching *about* art as well as to facilitate art-making experiences. The need for a more assessable, structured and subject-centred approach to art in education was explicit in the official documentation for the first

time; this had not previously been acknowledged but had been well represented in academic literature.

While there was an obligation for schools to deliver an art curriculum that had a critical studies element - 'knowledge and understanding' - there was little in the way of prescribed content. This allowed a free-for all, which, without a strong theoretical base, opened up another avenue for perpetuating stereotypes and elitist cultural values.

John Swift, who as a former editor of *JADE*, did much to shape that journal to ensure a gender balance amongst contributors and to reflect issues of international concern, alerted us to: '...the potential that critical studies possesses for the manipulation and hierarchical ordering of cultural values'.[27]

In his timely article, Swift asked if critical studies is a 'Trojan Horse for an alternative cultural agenda', fearing that, almost by default, the creeping orthodoxies identified by Hughes[28] would pave the way for a new cultural imperialism, dominated by what many people have termed 'the usual suspects' - dead white European males. Swift notes that it is the selection of the alleged 'best' that reveals the cultural agenda, arguing that the identification of 'our' national and historical values reveals the socio-political agenda. He puts forward a 'pluralist' view of the integration of making and critical awareness: a 'culturally conscious process of making in which the critical, comparative awareness and discernment is always functioning'.[29] This view is echoed and reinforced in an important paper in *Directions*[30] entitled 'A Manifesto for Art in Schools' jointly authored by John Swift and John Steers. Their 'manifesto' identified certain problems with art in schools, such as orthodox approaches which gave insufficient learner autonomy and the 'unambitious' nature of much critical studies practice. They called for the development of a clear rationale for the inclusion of critical studies in the curriculum 'based on cultural transmission, real critical thought and reaction and articulate debates'.

Elsewhere, Swift refers to the work of Ralph Smith,[31] author of *Excellence in Art Education*, accusing him of promoting elitism and perpetuating an out-dated status quo. The overall message by the turn of the century coming from many art educationalists was the need for art in schools to be more relevant to the needs of students in a rapidly changing social, cultural and political environment.

The political dimension to critical studies is sometimes played down, while Eisner confesses to feeling uncomfortable with the notion of politicising of art education,[32] but to many commentators the whole art and art educational enterprise is fraught with political struggle.[33] The debate in America has certainly become more politicised, with the advocates of Visual Culture Art Education

(VCAE), championed by increasingly influential writers such as Paul Duncum on one side and established traditionalists, upholding 'standards', represented by the likes of Ralph Smith on the other. Duncum asserts that while, what he terms 'mainstream art education', assumes that art by its very nature is intrinsically admirable, VCAE takes the view that all visual form represents an ideological position and that: '...the starting point is not the prescribed, inclusive canon of the institutionalised art world, but students' own cultural experience.'[34]

This reflects a return to student-centred learning, but with an emphasis upon knowing about visual form rather than producing it.

By the early 1990s, the relationship between making art and appreciating art came under closer scrutiny. Arthur Hughes, writing in 1993,[35] noted that 'there seem to be no necessary or sufficient reasons to believe that there is an inevitable link between making and construing' and referred us to Thistlewood's 'new heresy'[36] that critical studies *should not necessarily inform the practice of art and design*, and its corollary would be that it might well be engaged independently of "making" disciplines' [emphasis in original].

Within a decade then, art education in the United Kingdom went from a situation where there was virtually no critical studies in the art and design classroom, at least according to David Hargreaves [see note 22], to one where there was concern that it was accorded too much attention, at the expense of studio practice.

The notion that art making is in itself a cerebral 'above the wrist' activity has continued to be argued and successfully advocated by Elliot Eisner. In his more recent publications[37] he has written eloquently of the joy of making, arguing that art making has a vital role to play in the 'transformation of consciousness' - furthermore, he asserts that 'the acquisition of a technique is not merely a technical achievement; it is a mode of thought'.[38]

While some art teachers seemed to see critical studies and learning about visual culture as a necessary evil - principally as a source of stimulus material for art making activities - others had very different views. A particular viewpoint is argued by Tallack, who makes a case for 'critical studies' to be separated from practical studio art, arguing that it should not be a 'servant' to art production.[39] It seems that advocates of a critical studies approach to art education have been so successful that the knowledge and understanding of art, rather than being a complement to art making, has become, alarmingly for many art and design teachers, close to supplanting it. Critical and contextual studies could well evolve into a form of visual culture education, which, like media studies - perhaps its closest relative - has been shown to be important enough to be a subject in its own right. It is noteworthy that in recent years, media studies is becoming amongst the most popular subject

chosen for study at pre-university and undergraduate level.[40] This is not because, as some commentators would have it, it is a 'soft option', but because it is relevant to the concerns of young people.

Now that critical studies is firmly fixed in place as part of the art and design curriculum in the United Kingdom and the notion of knowing about art has at least equal status with making art, the debate has become more heated over what exactly we want students to know about. Additionally, having identified the problem of a lack of theory and the dangers of new orthodoxies, we now appear to have a surfeit of theory to the extent that Thistlewood's 'heresy' of divorcing critical studies from practical art appears to be the only practical way of ensuring that both are accorded their due attention. Notwithstanding the growing pressures on curriculum time, there is surely a case for the teaching of critical understanding of visual culture in all of its forms to be accorded its rightful status as a subject area independent from but informing and informed by art and design practice.

Otherwise, critical studies might well be seen as the cuckoo in the nest of the art curriculum.

Notes and References

1. Read, H. (1947), *Education Through Art*, London: Faber and Faber.

2. Lowenfeld, V. (1947), *Creative and Mental Growth*, New York: Macmillan.

3. Field, D. (1970), *Change in Art Education*, London: Routledge and Kegan Paul, p. 55.

4. Barkan, M. (1962), 'Transition in art education: Changing conceptions of curriculum content and teaching', *Art Education,* 15, pp. 12-18. Manuel Barkan's paper in turn owes a debt to Jerome Bruner's influential book of 1960, *The Process of Education* (Cambridge: Harvard University Press).

5. NAEP (1981), *Art and Young Americans, 1974-1979; results from the second national assessment in art*, (Art Report No. [10] A-01). Denver, p. 5.

6. Barkan, M. (1966), 'Curriculum problems in Art Education' in E. L. Mattil (ed.), *A seminar in art education for research and curriculum development* (USDE Co-operative Research Project No. V-002) (pp. 240-255). University Park: The Pennsylvania State University. Barkan's paper was based on Bruner's conception of the structure of a discipline (Bruner, J. (1960), *The Process of Education*, Cambridge: Harvard University Press).

7. Eisner, E. (1968), 'Curriculum making for the wee folk: Stanford University's Kettering Project', *Studies in Art Education*, 9: 3, pp. 45-56 and Eisner, E. (1969), *Teaching Art to the Young: A Curriculum Development Project in Art Education,* Stanford: School of Education, Stanford University.

8. Greer, W. D. (1984), 'Discipline-Based Art Education: approaching art as a subject of study', *Studies in Art Education*, 25: 4, pp. 212-218. Greer asserted that a discipline-based art curriculum draws form and content from four professional roles associated with art: art historian, art critic, aesthetician and studio artist.

9. Dewey, J. (1902), *The Child and the Curriculum,* Chicago: University of Chicago Press.

10. Swift, J. (1993), 'Critical Studies: a Trojan horse for an Alternative Cultural Agenda?', *Journal of Art and Design Education*, 12: 3.

11. Allison, B. (1972), 'Sequential Learning in Art'. Paper delivered to the Rolle College Conference; Allison, B. (1973), 'Sequential Programming in Art Education: A Revaluation of Objectives' in

Piper D. W. (ed.), *Readings in Art and Design Education Book 1 - After Hornsey,* pp. 59-68. London: Davis-Poynter.

12. Allison, B. (1982), 'Identifying the core in art and design', *Journal of Art and Design Education*, 1: 1, pp. 59-66.

13. Schools' Council (1976), *Research Programme Report* (Crafts Commission Group), London: Schools' Council.

14. CSAE (1982), *Broadening the Context*, Critical Studies in Art Education Project: occasional paper no. 1. Wigan: Drumcroon. p. 2. A leading figure in this project was Rod Taylor, who subsequently published several books which proved to be very influential in introducing critical studies into British schools; perhaps the most popular being *Educating for Art*.

15. Ross, M. (1985), 'Beyond the blue horizon: arts education and the new curriculum', *Secondary Education Journal*, 15: 3, pp. 8-10. The quotation is from p. 10.

16. Wass and Bloxham, A. (2001), 'The Trouble with GCSE and Critical Studies', *Journal of Art and Design Education,* 20: 1.

17. APU (1983), *Aesthetic Development*, Discussion document on the assessment of aesthetic development through engagement in the creative and performing arts. London: APU.

18. *Ibid.*, p. 13.

19. Church, M. (1984, 4 May), 'A Response to be Eradicated', *Times Educational Supplement,* p. 2.

20. NSAE (1984), 'Response to "Aesthetic Development"', *Journal of Art and Design Education,* 3: 3, pp. 303-316. The quotation is from p. 313.

21. APU (1983), *op. cit.,* p. 8.

22. Hargreaves, D. H. (1983), 'The Teaching of Art and the Art of Teaching' in M. Hammersley and A. Hargreaves (eds.), *Curriculum Practice: Some Sociological Case Studies,* London: Falmer. The quotation is from p. 132.

23. Field, D. (1970), *Change in Art Education*, London: Routledge and Kegan Paul and Reid, L. A. (1986), *Ways of Understanding and Education,* London: University of London Institute of Education.

24. DES (1985), *Better Schools: A Summary*, London: HMSO.

25. DES (1987), *The National Curriculum 5-16*, London: HMSO.

26. DES (1992), *Art in the National Curriculum (England),* London: HMSO.

27. Swift, J. (1993), 'Critical Studies: a Trojan horse for an Alternative Cultural Agenda?', *Journal of Art and Design Education,* 12: 3.

28. Hughes, A. (1989), 'The Copy, the Parody and the Pastiche' in Thistlewood, D. (1989), *Critical Studies in Art and Design Education*, Harlow: Longman/NSEAD.

29. Swift, J. (1993), *op. cit.*

30. Swift, J. and Steers, J. (1999), 'A Manifesto for Art in Schools', in *Directions,* special issue of *Journal of Art and Design Education,* 18: 1.

31. Swift, J. (1992), Reviews section, *Journal of Art and Design Education*, 11: 1, review of Smith, R. (1991), *Cultural Literacy and Arts Education,* University of Illinois.

32. In discussing the principles underpinning Duncum's vision of visual culture, Eisner declares the political dimension of it to be 'a source of discomfort' - Eisner, E. (2001), 'Should we create New Aims for Art Education?', *Art Education*, September 2001, p. 8.

33. I am indebted to Nicholas Addison and Lesley Burgess for the following quotation from Barbara Kruger:

> *Look, there are politics in every conversation we have, every deal we make, every face we kiss. There is always an exchange of power, an exchange of position - it happens every minute. I make art about power, love, life and death.*
>
> in Weintraub, L. (1996), *Art on the Edge, New York: Art Insights Inc.* p. 194.

34. Duncum, P. (2002), 'Clarifying Visual Culture Art Education', *Art Education*, May 2002, p. 7. For other material on Duncum's views on visual culture see for example Duncum, P. (2001), 'Visual Culture: Developments, definitions, and directions for art education', *Studies in Art Education*, 42: 2, pp. 101-112.

35. Hughes, A. (1993), 'Don't Judge Pianists by their Hair' included in this collection, originally published in *Journal of Art and Design Education*, 12: 3, pp. 279-289.

36. Thistlewood, D. (1993), 'Curricular development in Critical Studies', included in this collection, originally published in *Journal of Art and Design Education*, 12: 3.

37. See for example Eisner's description of the sensual delights of studio practice in Eisner, E. (2001), 'Should we create New Aims for Art Education?', *Art Education*, September 2001:

Who can forget the experience of wet clay coursing between your fingers? There is a certain joy in working with a paper collage and finding relationships of color and form that you could never have imagined at the outset. The smell of paint, the feel of clay, the heady aroma of rubber cement are qualities that satisfy. [p. 8]

38. Eisner, E. (2002), *The Arts and the Creation of Mind,* New Haven: Yale, p. 146.

39. Tallack, M. (2004), 'Critical Studies: values at the heart of education?' in Hickman, R. (ed.), *Art Education 11-18 Meaning, purpose and direction* (2nd ed), London: Continuum.

40. In 2004 there was a 15.8 per cent rise in student numbers taking media studies at university in England and Wales; this was on top of the previous year's rise of 20 per cent. There were nearly 25,000 students taking media/TV/ film studies in 2003 at GCE Advanced level; numbers are slowly catching up with the perennially popular art and design GCE advanced level examination, which had 38,314 examinees in 2002 [figures sourced from Joint Council for General Qualifications].

Chapter 2: Don't Judge Pianists by their Hair

Arthur Hughes

Contemplating the future of critical studies in art education, I find myself doubting what I and many like-minded colleagues were advocating some 30 years ago. In that distant age we were vaguely aware that:

> ...to engage children in practical activity with art materials is not necessarily to engage them in worthwhile creative activity.[1]

We were engulfed in our art departments by what some of us dimly perceived to be an excess of art making with a corresponding paucity of discourse and reflection. It was Dick Field who told us that:

> ...to enjoy the arts fully as a human phenomenon one needs to be able to approach them philosophically, critically, and historically.[2]

And although most of us lacked any systematic education or training either in the discipline of art history or the practice of criticism (and had certainly never read any philosophy), we had doubts about an education that rarely mentioned, let alone formally introduced children and young people to, the art of others.

Gradually, in individual schools, a largely unplanned and uncoordinated process began to take hold. In terms of art history we were self taught. Much of our background knowledge came from commercially produced film strips (and, in particular, the notes that went with them), together with a fairly superficial reading of an art history text written for young people of the age we were teaching: Ernst Gombrich's classic, *The Story of Art*. Most of us of course read this book uncritically. We knew nothing of different schools of or approaches to art history. We certainly knew nothing of the Vienna school or the Warburg Institute. Unlike many present-day teachers, we had no concept that art history was not a unitary discipline. To us it was a simple linear, casually deterministic progression centred upon what Gombrich has called the 'making of good pictures'.[3]

These pictures were representative of what Raymond Williams called the 'great tradition'.[4] In this sense, therefore, art history was evaluative. It presented us with a particular canon of images that were seen to represent the very best of the great Western European tradition. I think for us at the time, as for Williams, this tradition was seen as neither elitist nor exclusive, and we would have heeded his caution that:

We must always be careful to distinguish the great works of the past from the social minority which at a particular place and time identifies itself with them.[5]

Unfortunately for us young art teachers, the model of art history with which we worked left very little room for the neglected byways of art or the importance of social context - what Gombrich terms 'the ecology of the image'.[6] It emphatically ignored 'bad work' and we did not yet understand Williams's point (made similarly by Quentin Bell)[7], that:

In education we must be prepared to look at the bad work as well as the good. The principle in the past has been that once you know the good you can distinguish the bad. In fact this depends on how well you know the good, how well and personally you know why it is good, and how close the bad work is, in form, to anything you have learned to discuss.[8]

In the intervening years our views about 'good' and 'bad' have perhaps become a little less sharply defined. The discipline of art history has changed and expanded and its incorporation into the school curriculum has been guaranteed by the revisers of the National Curriculum in England. On the face of it, a very great advance indeed but, to return to my opening sentence, one is now filled with some doubt.

Possibly because we knew so relatively little of 'art history' - and certainly did not have access to it in a scholarly sense, many art teachers were attracted to the writings of North American art educators who tended to emphasise understanding rather than knowledge; the general over the specific; criticism over history (with the honourable exception of Joshua Taylor, whose work questioned the unitary concept of art history). An important 'imported' text was Harold Rosenberg's paper from the famous 1966 'Mattil' seminar, *Criticism and its Premises*,[9] with its ringing and confidence-boosting first sentence, stating unequivocally that:

The first requirement of art criticism is that it shall be relevant to the art under consideration - how correct are its evaluations of specific art objects is of lesser importance.

We were confronted by issues like this which were new to us. Unfortunately, what passed for art criticism in this country was, in the main, a species of journalism but what Rosenberg, Smith, Efland and Manzella taught us was that contemporary art is important to art education and there is no substitute for knowing and understanding the actual works and learning to place them within a contemporary socio-cultural context. Slowly, what Anthony Dyson has termed a more 'capacious view'[10] of what should constitute art knowledge in the curriculum began to develop.

In the 1970s, the Schools Council through its Morrell Fund offered early financial support for proto critical studies projects in West Midlands schools,[11] and in 1981 this much lamented body supported the *Critical Studies in Art Education* project directed from the Drumcroon Education Arts Centre in Wigan by Rod Taylor. By this time, criticism (or, rather, a fairly open but analytical form of discourse) was increasingly seen as the overarching concept, supported where appropriate by 'art history' - a concept of art history that had changed little in twenty years. The early aims of the *Critical Studies* project were broad, undogmatic, but quite clear. Its purpose was:

> *...teaching and developing the more reflective and contemplative aspects of the subject [by] helping pupils to become more critically aware.*[12]

Unlike many other developments in art education which have grown out of academic study in psychology or experimental activity leading to the development of philosophy of pedagogical theory, critical studies developed with little or no theoretical underpinning, either from within the field of art education or from other disciplines. There was, for instance, no reference to the critical traditions within art history and, apart from Taylor's use of the sociologically-based work on the 'conversive trauma' by David Hargreaves (renamed by Taylor, the 'illuminating experience'), there was little or no theoretical basis in critical theory. Instead, the professionalism and creativity of many enthusiastic and adventurous art teachers in developing classroom techniques and strategies for engaging young people with works of art masked the lack of an underlying theoretical foundation.

It is my contention that we are now coming to the end of the initial, pre-theoretical phase of critical studies. Following a period of great activity and innovation by those whom Thistlewood labels the 'pioneers' of critical studies,[13] there now appears to be the danger of a vacuum. Visiting schools, one is struck by the repetitious nature of much that is currently taught as critical studies and the modalities of related practical activity. There appears to be much 'routine art and routine thinking'[14] about art. Children are increasingly exposed to a limited canon of predictable images by 'favourite' artists and work that generally presents few iconographic barriers to understanding - Turner, Van Gogh, the Impressionists, etc. Of course this is a broad and perhaps crude generalisation of what is happening but it appears that in too few schools are difficult or challenging art and design concepts being introduced. What some call 'issues-based' work is central to the education programme of the Tate Gallery Liverpool, and is relatively common in many London schools, but elsewhere there is a tendency towards consolidation rather than innovation. This is very understandable at the primary level where non-specialist teachers are now required to introduce children to ideas about art that are often new to themselves. It is more worrying for the continuing vitality of the subject at key stages 3 and 4, where a repetitious aping of the superficialities and

external details of works of art often predominates at the expense of prolonged attempts to penetrate the meaning and significance of works.

Into this situation the Department for Education, through the agency of the National Curriculum Council, saw fit in England to introduce a model of Critical Studies that was a subversion of the clear intentions of the Art Working Group, and was grounded in an establishment view of the importance of 'our artistic heritage':[15]

> ...the chemical poured on the detritus of the era before last, which makes it harmless and even sometimes useful to the partisans of the present.[16]

These modifications owe more to a narrow, élitist Euro-centred view of art history than to Williams's conception of the great tradition as:

> ...a mixed inheritance, from many societies and many times as well as from many different kinds of men [which] cannot easily be contained within one limited social form.[17]

Feelings ran high over what many saw as an impertinent modification to the structure and content of the Working Group's original report and even the mild-mannered and precise Colin Renfrew, Chair of the Working Group, called the NCC modifications 'clodhopping and mindless' saying that:

There is too much mindless making in schools where teaching is not well developed. You have got to have the mind working as well as the eyes and hands. It has to be an integrated approach.[18]

He made it clear that in his opinion:

> ...the changes are just unworkable ...if these changes go through we will be moving art out of the studio into the classroom which is not where it belongs. Everything will depend on how many names you know.[19]

We know that a late and simplistic attempt was made by the NCC to mollify such informed opinion by the decision to suggest a notional, but in reality quite meaningless and unworkable 2:1 weighting between the 'theoretical' and the 'practical', but the damage was done. The official view was explained by David Pascall, the then Chair of NCC in a handwritten postscript to a letter to the writer:

> For a subject like art we felt teachers should decide the exact balance - particularly as there are no SATs. 2:1 does not seem unreasonable as the Secretary of State has already indicated.[20]

This is hardly a carefully worked out curriculum policy.

In spite of this and other official protestations, it is hard not to take seriously the view of Duncan Graham, the first Chair and Chief Executive of the NCC when he writes that:

> *Art and music are the ultimate expression of the government's determination to stress knowledge over understanding.*[21]

Knowledge is seen as more important than skills. The result, as we know, has been the arbitrary imposition of named periods - a National Curriculum Story of Art - a story that does not really accommodate the art of minorities, art that is (currently) subversive, or art from diverse, distant or little understood cultures. This is a tendency endorsed by Neil MacGregor, director of the National Gallery, when he contends that:

> *...we've over-emphasised the role of knowledge in approaching painting and gravely under-emphasised the role of intuition.*[22]

The real scandal of course is that teachers in England have not been fully trusted with ownership of that part of the art curriculum that subsumes critical studies (the programme of study for what became known as 'attainment target 2'). They have been told not simply to develop their pupils' understanding of art but to develop their understanding of particular forms of art under the umbrella of specific named 'periods'. This is a model in which 'post-Renaissance' is classified as a period in exactly the same way as medieval or nineteenth century art. In addition, ignoring the anonymity of much early Western art and almost all of the art from many non-European cultures, pupils are asked to analyse the work of influential artists who exemplify these 'periods'. Thus the crudest possible caricature of 'standard' art history has become encapsulated in the curriculum and is already having a deleterious effect in terms of the orthodoxies it encourages: 'Everything will depend on how many names you know'.[23] Anthony Dyson has already offered us a totally reasonable and rational argument for treating with scepticism the traditional notion of teaching art history through more or less clearly identifiable styles.[24] Far from denying the significance of these and their undoubted value to scholars and to some school pupils, he nevertheless proposes objections to the use of such immutable categories with younger pupils or those who are not 'academically inclined'.[25] Dyson argues with authority for what many teachers through their experience intuitively know to be true.

The title of this paper is derived from a passage in that classic work by I. A. Richards, *Practical Criticism*,[26] in which he passionately advocates the importance

of understanding over a mere knowledge of superficialities. Using response to poetry as his paradigm, he wrote:

> ...all those features that can be judged without going into the poem, all details or aspects that can be scrutinised by the mind in its practical, every-hour, non-poetical capacity, are so many invitations to make short work of the task of critical appraisement. Instead of trying the poem on, we content ourselves with a glance at its lapels and buttons.[27]

This is put slightly differently by MacGregor:

> ...we've stuck with the idea of earlier paintings as illustrations rather than poetry. We think we're looking at the way a lamentation, say, actually occurred. What we're not used to thinking is that this is a poetic investigation of grief rather than the depiction of a moment in the Christian story.[28]

Furthermore, returning to Richards:

> Far more than we like to admit, we take a hint for our response from the [poet's] reputation. Whether we assent or dissent, the traditional view runs through our response like the wire upon which a climbing plant is trained. And without it there is no knowing at what conclusion we might not have arrived.[29]

As intimated by both Renfrew and Graham, the school curriculum is in danger of becoming slanted towards the superficial glance ('lapels and buttons') and the garnering of facts (however insignificant these may be to the formation of true understanding), when what is desperately needed is neither an artificial division between the 'practical' and the 'theoretical', nor the forced marriage of the two that so frequently results in the kind of activities that I discussed in my 1989 paper 'The Copy, the Parody and the Pastiche'.[30] What is needed is a genuinely holistic art and design curriculum which does not seek arbitrarily to divide the subject or insistently substitute the classroom for the studio. In Richards's terms, we should be seeking, through a range of appropriate pedagogical strategies, to 'place' works of art, craft and design into children's minds - a necessary precursor to the development of a genuine ability to construe meaning from works of art - surely the main aim of critical studies. Whether or not an education in the construction of meaning requires children to '...apply imaginatively the methods and approaches of other artists in the representation of their own ideas and feelings'[31] as demanded by the National Curriculum, is still open to informed debate. There certainly does not seem to be a proven case to support the necessary use of practical art-making activities to help in the attainment of this skill of construing, although there appears to be sufficient circumstantial evidence from the work of Taylor, Robert Clement and others to support the notions that this may be a significant help to

many young people, and that art teachers have made considerable advances in the relating of theory to practice, since Field reminded us that '...simply to practise art in school is an inadequate initiation into art as it exists in the adult world'.[32]

Nevertheless there seem to be no necessary or sufficient reasons to believe that there is an inevitable link between making and construing and therefore no reason to suppose that Thistlewood's New Heresy No. 1[33] is not a perfectly tenable position. There is in fact a long history of public examinations for sixteen year olds in art history and appreciation that bear witness both to a demand from some young people for a non-practical syllabus and the capacity of art teachers to deliver this form of curriculum to relatively young pupils. Perhaps one of the most interesting examples of this was a past Joint Matriculation Board Alternative O level GCE syllabus entitled 'Art and the Environment' for which candidates could select a rich and wide ranging programme from fine art, the crafts and aspects of industrial, graphic and environmental design, from 1850 to the present. This was a free-standing, theoretical paper that required its own specially taught course, quite apart from any studio course a candidate may also (but not necessarily) have been studying. The resulting scripts were often a joy to read and were an eloquent testimony to the values of an entirely non-practical approach to the teaching of genuinely critical study for the fourteen to sixteen age group. Most of the young people who followed this syllabus were academically able and eager to engage in analytical discourse about made artefacts and environments, underpinned by a sound knowledge of relevant historical, social and aesthetic understanding.

It is certainly true that if we believe that '...to enjoy the arts fully as a human phenomenon one needs to approach them philosophically, critically and historically'[34] we must use and introduce young people to whatever framework of discourse is appropriate and teach them techniques for doing this. Many theoretically-based public examinations in art have allowed, and in fact encouraged, teachers to do this. However, until the National Curriculum is quantitatively reduced, we are unlikely to see a return of many of these very valuable courses that often enabled teachers to put into practice Mary Warnock's maxim that we should '...begin to give priority to method rather than content, to a specific manner of dealing with information rather than the information itself'.[35]

If we do this there is reason to believe that the pupil may also learn valuable transferable skills of verbal discourse, analysis and speculation. Indeed, Warnock maintains that for every subject there are two possible approaches, the practical and the theoretical and that:

> The approach [she has] called theoretical as opposed to practical must have as a major part of its aim not merely the passing on of facts and formulae but the inculcation of critical and speculative habit...it must be the theoretical aspects of a subject

that are employed to encourage free, imaginative thought, speculation, and the conceptual connections between one subject and another.[36]

This position seems to be supported by many educators, including Creber, who, writing from the perspective of an English teacher, insists that 'our task is to energise perception by exercising it'.[37] To encourage this habit he cites many classroom strategies that employ speculation and hypothesis as 'ways of making looking both more strenuous and more interesting.' He eschews formula teaching of the kind that often now masquerades as critical study, encouraging art teachers like their English colleagues to make confident use of language and consider what looking at things can do to our thinking. Certainly it is encouraging to note that his many observations of art lessons has led him to the belief that '...the art room was potentially a rich environment for talk, precisely because exploratory talk could be sustained by doing, and vice versa'.[38]

However, he cautions that:

> *In an average English or art lesson, if you ask children to look hard at an object, they will anticipate a subsequent task, that is they will have to draw it or write about it. Such knowledge does little to liberate their thinking.*[39]

So, our task as teachers of critical studies is to find ways, at all levels, of liberating the thinking of our pupils. There are facts that are important or useful. Anthony Dyson for example argues eloquently for an understanding of the temporal dimension as part of a young person's intellectual equipment when looking at works of art.

A number of frameworks for analysis have come to the fore during the last few years, including Taylor's model of 'Form, Content, Process, Mood' and Dyson's 'Style, Technique, Context'. These frameworks or focusing devices are valuable if they help pupils truly to construe meaning, and to form what Barnes terms 'action knowledge',[40] but it will take much more than the limited exposure to received views and practices that is becoming the all-too-dominant critical studies orthodoxy, including the participation in possibly amusing or entertaining but essentially superficial attempts to appropriate the style, technique or subject-matter of others.

Many talented and perceptive teachers are devising new strategies for developing critical studies away from current conventions and have found that the imaginative engagement of artists or craftspeople (including art students) can be a way of avoiding conventional practices. The recent Arts Council/Crafts Council Project directed by Norman Binch has thrown light on much work that justifies optimism. Regional groups, including Devon, London, the West Midlands and Wigan have

produced much work that points the way forward. Nevertheless, it would seem to be the case that if the theoretical underpinning of critical studies is, at best, undeveloped, this is likely to remain the case until we arrive at a sharper notion of what we mean by critical studies and whether we wish to see young people engaging in genuinely critical activity. At present we are encouraged to see critical studies as an induction into 'our heritage'[41] - but this is hardly helpful.

One also hopes that it is much more than a means to enrich the pupils' own productive, studio skills (useful though this may be). Without this clarity, we cannot hope to go forward to the development of this subject beyond its present rather confused state, where it appears to mean many things to many people. Certainly a degree of pluralism is to be welcomed. For some, history will be particularly important and will provide the conceptual framework while for other teachers and their pupils it may be the development of a wide-ranging capacity to handle critical concepts linguistically. None of the various UK National Curricula at present gives any particularly clear steer, and this leads one to hope that the teacher of art will increasingly gain a genuine ownership of this part of the subject. The expectation must be that the more stereotypical modes of dealing with the works of others will give way to fresh methodologies informed increasingly by a consideration not only of pedagogic principles[42] but also of the structures and methodologies of the group of disciplines that loosely constitute critical study. If we want truly critical study, the pupils' own intuition must be encouraged alongside the learning of appropriate information. Critical studies must engage issues and imagery that connect with pupils' current 'taste manifestations', vivify the art curriculum, and replace the constant repetition of information about the predictable high peaks of the Western tradition.

Finally, Warnock reminds us that:

> *Education...has always been valued for its liberating effects. It should aim to free a child from the chains of his environment.*[44]

Through a lack of rigorous thinking about critical studies, let us not chain our young people to one, given and officially accepted artistic environment but seek to empower them to make meaning for themselves. To do this, we will need more than an armoury of good lesson ideas. We will need a philosophy about critical studies and a clear and evolving sense of its educational purpose - an important task for the next ten years.

Originally in the Journal of Art and Design Education, *Volume 12: 3, 1993*

Notes and References

1. Field, D. (1970), *Change in art education*, London: Routledge & Kegan Paul.

2. *Ibid.*

3. Gombrich, E. H. (1993), *A Lifelong Interest*, London: Thames & Hudson.

4. Williams, R. (1976), *Communications*, Harmondsworth: Penguin.

5. *Ibid.*

6. Gombrich (1993), *op. cit.*, p. 75.

7. Bell, Q. (1974), *The art critic and the art historian*, London: Cambridge University Press.

8. Williams, R. (1976), *op. cit.*

9. Rosenberg, H. (1966), *Criticism and its premises*, Pennsylvania: Pennsylvania State University.

10. Dyson, A. (1991), *Empathy and an education*, Birmingham: Article Press.

11. The schools council gave financial support to a school-based research project, *Developing discourse in art education* directed by the author in three West Midlands schools.

12. Taylor, A. R. (1982), *The illuminating experience*, Wigan LEA, Arts Council of Great Britain; Schools Council; Crafts Council.

13. Thistlewood, D. (1993), 'Curricular development in critical studies', *Journal of Art and Design Education*, 12: 3, [also this publication].

14. Williams, R. (1976), *op. cit.*

15. DES (1992), *Art in the National Curriculum (England)*, London: HMSO.

16. Smith, A. (3 December 1987), *Listener*, London, BBC.

17. Williams, R. (1976), *op. cit.*

18. Renfrew, C., quoted in *The Independent*, 4 March 1992.

19. Renfrew, C., quoted in *The Guardian*, 4 March 1992.

20. Pascall, D., postscript to a letter sent to the author from the National Curriculum Council, 30 January 1992.

21. Graham, D. (1993), *A lesson for us all*, London: Routledge & Kegan Paul.

22. Macgregor, N. (27 December 1992), 'Tops of the postcard pops', *The Observer*.

23. Renfrew, C. (1992), *op. cit.*

24. Dyson, A. (1989), 'Art history in schools' in D. Thistlewood, (1989), *Critical Studies in Art and Design Education*, Harlow: Longman/NSEAD.

25. *Ibid.*

26. Richards, I. A. (1978), *Practical criticism*, London: Routledge & Kegan Paul. The title of the present paper comes from a section dealing with technical presuppositions:

> *...when something has once been well done in a certain fashion we tend to expect similar things to be done in the future in the same fashion, and are disappointed to or do not recognise them if they are done differently... whenever we attempt to judge poetry from outside by technical details we are putting means before ends, and such is our ignorance of cause and effect in poetry - we shall be lucky if we do not make even worse blunders. We have to try to avoid judging pianists by their hair.*

27. *Ibid.*

28. Macgregor (1992), *op. cit.*

29. Richards (1978), *op. cit.*

30. Hughes, A. (1989), 'The copy, the parody and the pastiche' in D. Thistlewood (1989), *op. cit.*

31. DES (1992), *op. cit.*

32. Field, *op. cit.*

33. Thistlewood, D., *op. cit.*

34. Field, *op. cit.*

35. Warnock, M. (1988), *A common policy for education,* Oxford: Oxford University Press.

36. *Ibid.*

37. Creber, P. (1990), *Thinking through English,* Milton Keynes: Open University Press.

38. *Ibid.*

39. *Ibid.*

40. Barnes, D. (1977), *From communication to curriculum*, Harmondsworth: Penguin Books.

41. DES (1992), *op. cit.*

42. Parsons M. J. (1987), *How we understand art,* London: Cambridge University Press. A valuable cognitive developmental account of aesthetic experience that begins to provide a form of theoretical foundation for children's preferences that should be extremely useful to many teachers.

43. Warnock (1988), *op. cit.*

Chapter 3: Theoretical Comments

Leslie Perry

The predicament in teaching art and possible ways of dealing with it

It is timely to review the role of critical studies in art teaching. A mounting pressure has emerged which will greatly affect art as a subject among others. This pressure arises form the strengthening of the view which takes education to be principally a preparation for work and careers. For art as subject this pressure bears both the practical and the critical studies aspects of art teaching, and it will also affect the relationship between these two aspects.

Traditionally, arising out of the qualification and training of art teachers, the subject has been viewed first as a training in practical skill and proficiency and second in critical studies, with a heavier emphasis on the first and a role ancillary to this for critical studies. These have been there to amplify and broaden the understanding acquired in practical training. Critical studies has to achieve a sound cognitive structure, and show how it contributes to the practice and the appreciation of art works.

It caters for cognitive thinking of the kind that arises in the presence of practical work. Critical studies does not deal primarily with detached and abstracted intellectual thinking of any kind (including aesthetic and historical thinking) in which feelings related to motivation are quiescent. What it does do is extensively to support and identify that fundamental practical activity, in respect of diagnosing, understanding and developing practical problems.

All this amounts to skilled training of how to make practical judgements, both for those pupils that elucidate practical problems of making art work, and those pupils that profit principally by the training that occurs in appreciation of works of art. These are not separated but interdependent aspects of art teaching; appreciating firstly one's own work, and then that of others, involves a combination of several types of judgment which pupils are being trained to use, until such a mixture of judgements is thoroughly well understood: a long business requiring constant regular recourse to actual practical work if it is to be fully understood. The final justification of practical work in art teaching arises not from the hope that all pupils will become artists (a vain and vague hope which cannot withstand a long scrutiny). Practical work is justified not by this but by a thorough insight into the art-making process which is as essential for those who are going to appreciate art (the majority) and those that are to be personally involved in making it (a small number). Both types of pupil require practical experience as a necessity: a remark that is valid for all arts subjects, and indeed a parallel situation applies in other

practical subjects. In all this, critical studies is as central to successful learning as practical activity, because it is an essential feature of that learning.

However, to return to curriculum pressures, discussion includes three methods of attaining education in art. They are:

1. Concentrate on practical doing of art work as the real thing, and pick up some idea of appreciation from critical studies by way of useful relevant background to the practical process. In this way we can do two things. The first, which carries the banner, is to teach so as to allow the emerging of creative art work; the second is to allow the emerging of art which is firmly based on traditional schools and procedures. Critical studies has always catered for the second, but have not been the support they should have been to the circumstances of the actual emergence of creative art.

2. Concentrate upon critical studies as the really important ingredient, since the main task in education must be appreciating art, not doing it. The use then of practical work would be to provide necessary examples to justify critical studies judgements, but it would not be deliberately used to train pupils in a systematic way for practical art teaching to produce high proficiency as artists.

3. Systematic practical work accompanied step by step with development of critical acumen, not as two separate aspects but a practical activity to make sense of what art is about, how to do it and how to judge it, being taught simultaneously and not separated. It is then a situation in which creative training can emerge in both critical and practical experience. Along with that creative opening will be equally present an intimate understanding of traditional practical art both in practical work and in terms of judgement, both of their own art work and that of others. In this way the traditional and the creative will have an equal opportunity to emerge, according to the abilities of the pupils. Of all the needless civil wars that one can imagine, is the war between creative and traditional art. It amounts to a resolution to prefer one leg and never use the other: education in art should lay out the continuum between the traditional and the growth which creative art ushers in.

The judgements that we attempt to introduce to our pupils are of several kinds. So judgements occurring in critical studies are mixed affairs in actual use and separated only for the purpose of analysis. A judgment is not a purely cognitive notion such as a proposition. It is an appraisal from all the mind's powers of material to be learned, and includes growing insight into the impact of minds of other persons who are teaching it. Result: we have, mixed up here, aesthetic judgements, practical judgements, historical judgements, social judgements, craft

judgements, technical judgements and still others. These aspects need to be reconciled on the way to our decisions as to what to decide to do. And all of these exist in the presence of personal judgements, the kind that pupils use to appraise the sources and attitudes of their teachers. This matter is taken up further below.

Nature of learning

Firstly, this brief note assumes that much of the underlying nature of learning, like so much of educational theorising, lacks a carefully researched base and needs further strict investigation. Here, some difficulties are pointed out, to underline the fact that curricular change is an amateur enterprise, a gross mixture of politics, administration, economics and professional judgements. As with so many social problems, we learn why curricular changes have failed when we face the unanticipated results of our changes in policy. All types of social problem are sprawling and many-faceted, and often the diagnosis that is offered fails till too late to discover the underlying causes.

Let us take the aspect which we may call the *caught* and the *taught*. Why we choose to educate is a decision that has to do with value judgements about the educational system and its use. What is taught is a selection from what is caught. The caught surrounds the taught on all sides, and is going on, schools and colleges or not. What we have selected arises from a judgement that more effective inroads into educating can be achieved by interfering with the underlying caught process, according to which we choose what pupils learn and devise the means to learn it, without either teacher or pupil being conscious of this. But in education as a system, what is (officially) chosen is primarily cognitive and intellectual, and this material for learning is thought to be the most important characteristic of school and college learning, and is abundant in the National Curriculum, with its traditional core and foundation hierarchy. The choice of subjects and the importance assigned to them in the taught area neglect considerable areas that are largely caught or selected in a trivial and unmethodical way. Moreover the caught-taught relationship varies from subject to subject and with little insight into the learning process, in particular as to how taught learning relates to caught learning.

This traditional situation ignores the extent to which some subjects are not primarily cognitive, though they are so in part. The point applies largely in practical subjects where the nature of the knowledge and learning is taken as a branch of the general cognitive and linguistically based and symbol-loaded learning which is a matter of principal attention in the curriculum. Take art: its general value is to teach, including craft aspects (now not emphasised as a separate subject) and technology (on its way in) how to deal with practical problems and coordinated activity and the accompanying type of thinking; the contribution of art in the curriculum is exactly this. In art and other kindred subjects this is not properly understood because of the overloading of cognitive learning, with its classified

recorded knowledge gratuitously thought to be the final level of understanding, underlying all this. This situation leads to neglect of practical experience, which must be a constant concomitant in the process of learning art; and a focal point for critical studies is to establish that such studies are not, and never can be, of a purely cognitive kind.

The outcome of neglecting this is high cognitive training in *pure* (and more rarely, *applied*) knowledge and inefficient teaching in the whole practical area. What is caught and taught is consequently quite different in balance here from that of cognitive subjects, so that areas which should be taught are left to the caught side, with resulting inefficiency. In particular, we can conclude that personal knowledge, one of the most important for making judgements in this area, is simply left to be caught, which is a crass state of affairs.

Perhaps a note on the underlying situation will be of use here. Learning involves assuming that experienced teachers lead the pupils to develop a mind. This mind is not the sole responsibility of places of learning. The conscious mind responds to a pressure to learn all the time, and its power of adjustment is active for a lifetime, although intensive in earlier years both inside and outside of schools and colleges. Once having formed an understanding of people and their environment, we have a stock of relevant knowledge and thought in terms of which to adjust. In later years we depend more and more on established patterns and our adjustment becomes habitual in large part. This causes obstruction to change. And that is why, in our schools, we have to provide a basis of habitual and inherited experience, BUT pupils have to be taught how to view this *critically* in order that they, as learners, are able to review their own conclusions and beliefs, without continuing the unthinking acceptance of childhood. It is mentally more strenuous to think freshly than to use standard solutions of personal and social problems; but the price of standard reactions where change is needed is the obstruction of social and educational growth - all of which should concentrate our attention on the building of minds, with a more trained and thought-out open approach to educational and social problems, such as curriculum change.

As said above, cognition is always thought of as the leader in what we are to learn, with the consequent neglect of areas of the mind's activity which require education no less than the cognitive aspect. And these aspects should not be left to the casual and unorganised learning which is the caught variety, but they should be taught. Cognitive training therefore badly needs supplementation in order adequately and fully to respond and judge the environment and to do what we require of it. Basically, we should undertake the training of feeling-states, of mental-physical coordination, and motivational states. Feelings are omnipresent in cognitive mental states, no matter how abstract the cognition is. Why? This is the cognition of a person, and the person constantly adjusts feeling and motive in school and out, as

is seen when pupils' attention wanders from the teacher. This whole area in education is handled with a pitifully inadequate and untested set of notions which have not been adequately researched. The training of feeling-states for example is tied up strongly with cognitive educational success: whilst motives, that kaleidoscopic moving bundle of cognitive feelings and decisions deriving from them, are areas not of permanent decision but of mercurial fluctuation, correction and unending change.

True, the teacher traditionally offers and recommends motives, but adjustments of pupils occur in school and out and each pupil has to adjust his/her motives without being given any teaching as to how or why to adjust. To treat feelings and motivation as something to be caught is the height of unwisdom; it shows a misunderstanding of feeling-states without a balanced judgment, and lack of awareness of feeling-states and motives in the achievement of understanding. For this state of affairs an overloading of the cognitive aspects of the curriculum must bear much of the blame. If we are to understand critical studies in art teaching, we have to examine the conditions in which it takes place. We must, therefore, remember that all learning is of persons and from persons, and what is taking place is an interaction of cognition, feeling states and motives; art teaching cannot dispense with teaching of feeling-states and motives to make its own contribution to the curriculum, and critical studies has here a major role in pulling together and keeping together the total mental constituents of learning in art. Here, no mention is made of that much-discussed entity, the will. It makes better sense to leave this alone so far as learning is concerned, because of its vagueness. Rather, we should think that proper detailed attention to cognition, feeling-states and motives does justice to the education of a mind, which thereafter can make the decisions which become possible and the persistence in carrying them through as long as the mental state of decision is being held. And that is as near as we need to go to the notion of the will. Books have been written on it: but it is hard to find a single one which can be applied systematically to educational problems; the notion of the will and its role in learning is best left aside for explanation. Instead, we can concentrate on the state of mind out of which decision comes. Decision making is itself a trainable thing, a regularly recurring thing, but only very rarely is it a final thing. The movement of the mind to decision then indecision and then further decision is a regular phenomenon in art teaching: the mental movement and the practical coordination movement is an unending sequence proper to the conscious mind in art. A study of this can heighten awareness in art work, and here critical studies can play an important role in freeing the mind of the pupils for creative work.

The next question which concerns learning in art and in critical studies is the notion of *fashion*. This is admired, on the one hand, as a cachet of good and up-to-date taste, whilst on the other it is disliked because it seeks to dominate

judgements when the trend to be up-to-date does not appeal to people's judgements (we are here, in Oakesholt's phrase, in a 'world of opinions'). But in both cases what we are dealing with is a set of warring judgements about how to proceed, what to aim at, what will bring success, and so on. Education is saturated with the effects of this strife among opinions. All ways of teaching, and policies about them, are part of a slowly changing fashion. This is irrespective of official or professional opposition, which has only a minor role in changing beliefs. If teachers elect to continue the fashion in which they were trained and which they continue to use as a basic conception of how to teach, they come more and more into the presence of others including other teachers; teachers with a different set of beliefs about how to do it. Educational opinion constantly reacts to and modifies notions of the 'best way'. Disagreement is never absent. From time to time a new view positively overcomes the old, and we get curricular reform. This then goes into effect, with the result that its inadequacy loses no time in announcing itself. So we fight it, dismiss it, despise it, and then often throw out the good with the bad to start anew. Change in teaching arrives in education but the new stands on no better ground than its predecessor. Possibly a large quantity of much-needed research might slow the process, but its roots are not in education at all, but arise out of complex social problems, which by nature can only be resolved *pro tem*. Realistically, and despite all seeming assurance, we have in educational change 'no continuing city'. Art teaching is not exempt from this: change and big change is on the way - disturbance is certain, but improvement is not.

This disturbs and impedes art learning, which always suffers from change under the aegis of defective planning. Early in National Curriculum circles it was suggested that constant review and adjustment to changing needs should be concomitant with present change. But this has been largely lost already. We can only be conscious that we are in a fashion context, and avoid using teaching for the indoctrination of *belief*. Curriculum studies has a very powerful role here, to safeguard both the freedom essential to creative art, and in keeping the ring for the best traditional and developing ideas and work in art. In this way continuative as well as creative artists can emerge with sound judgements to guide them, though the seduction of belief is something of which no one is free. So, caution and constant review by critical studies may do something to rebut the worst excesses of fashionable temptation as 'cures' for educational problems.

In discussing fashion, we come very near to the role of belief itself. It is possible in education to believe that the system provides us with beliefs. These beliefs are necessary to itemise and regulate these rules, conventions, regulations and all things that go to regulate in society the way we behave relatively to each other. Were it not the case that we believe in the system and each type of reasoning, its language and so on, then we could not without great difficulty interact or communicate with each other without obstructive difficulties. So we have our attitudes and beliefs.

So much may be the case. But our education system requires a *critical* acceptance of what is taught. Which appears to mean that on the one hand we believe in the system and its rationale, but we do not exclude ourselves from viewing it critically and altering features of it from time to time.

That makes of education a very precarious and difficult undertaking. There are two evils; the first, unquestioning belief without examining the grounds for the belief which we are holding, and resisting any suggestion that they should be examined; the second, a scepticism about any beliefs that we are offered, without heeding how powerful the reasons for belief may be *which paralyses action*. This is an impossible situation in education; e.g. critical studies in art is (a) to give pupils beliefs by which to live and understand the why and wherefore of art, and (b) the explanations which seek to establish the truth of this, but not to hold it as truth so completely that they are to be regarded as *unassailable* by argument. We have as a task confronting critical studies to produce a clear rationale and judicious explanation, not avoiding but even encouraging challenge from the learners. The result is belief, but rationally and stimulatingly held.

But then comes the question, what and how to commit oneself to the beliefs offered? If someone says 'this appears to be true', and gives plenty of room to doubt and criticism, we hope that learners give a wary assent. But we can learn and not believe, despite the best of reasons, in the same way as we can believe utterly what is not at all convincingly supported. Possibly all our decisions rest upon an element of belief, once we have decided. But at least we can use our authority to teach through the learning and thinking over the argument put before us. We educate for a rational approach for many problems because the excess of unreasoned belief is one of the most powerful agents for obstructing benefit and undermining our society by turning it into an arena where one fanatical belief fights another, thus greatly complicating social decisions to problems including art. I conclude that education in art must produce people that believe, but temperately and rationally, the beliefs they gain from critical studies, but that these beliefs should be taught argumentatively and with great emphasis on a critical approach and an argumentative justification of what we present for learning.

In these rapidly changing times, the role of the teacher is clearly up for revision. The general notion of what a teacher is and does is as antiquated as the notions grouped under the general title of 'training'. A teacher should not be looked upon as a repository of inert traditional knowledge, giving out the layout of her or his subject matter, and explaining the present in terms of what she/he believes to be the case. The teacher is not some kind of inert knowledge-box for the pupils. The right description of the teacher in art is that of *researcher* - a word not the exclusive property of higher education and its university outcomes. A researcher is one who systematically studies and explains what she/he is doing, treating the passing over

of knowledge as one aspect of the enterprise whose object is to train the pupil in critical thinking, with full awareness of new ideas and new practical developments, whose outcome is critically presented and reviewed. This type of teaching produces critical acumen, both of traditional art solutions and of new creative developments. So we get a full meaning of 'researcher' - not just the heaped paraphernalia of pure and applied science laboratories, but the production of ongoing enquiring minds, which the technical apparatus merely sustains. To enquire breeds mastery - the teacher is not there solely to repeat what past learning and training have provided: this leads from a garden of weeds to a slough of despond for teacher and pupils alike.

Some discontent with the teacher's role on this side has led to visiting artists with resulting refreshment in some cases. Alongside, we need visiting critics, to show where refined critical studies can lead us. A teacher often lacks the highest expertise that is available in the mastery of his/her subject, and outside help may result in refreshing the teacher's learning, but even as the teacher is, she/he can think through and review critically in the very act of doing her/his work and can use visiting artists, museums, expeditions to support a constant self review. This involves the kind of perpetual in-service training for teachers and lecturers which has been a piecemeal and restricting feature over the years, whereas it ought rather to be the work/training culmination that should be continuous after a brief initial training phase. Society has not yet faced the fact that training should be constant in professional life, not an affair of preludes based on antiquated past principles. This knowledge should be topical and the critical approach should arouse fresh interest. Critical studies provide a perfect opportunity for this critical work, both in materials and media, practical skills and the mental sharpness that can be attained only in this way. The teacher has an obligation to retain her/his own level of mastery: she/he should regard a lesson as an occasion in self education development.

A further complication of the teacher's and lecturer's position arises because education in schools and colleges has always, in each subject, dealt in pure knowledge. This enables, it is thought, the nature of that knowledge to be thoroughly and deeply understood. But the present trend of reforms is steadily pushing for a wider use of applied knowledge in the syllabuses. And this is caused by the wish to turn away from the old liberal education and its belief in personal cultivation alongside the necessity to train people for work at all levels of skill.

In art, pure knowledge of fine art in practice and criticism certainly carried the aegis, whilst application in art, though not absent, had a rather lower status and a rather smaller showing. Many teachers and lecturers follow the pure or fine art view of the matter, which they received in their own education and training - in the latter, application was not absent, but the fundamental role of pure art was the

important central feature. But the trend in curricular reform will demand of art more attention to craft and more dwelling upon design, in order to produce a closer and supportive relationship with technology. Many teachers distrust applied knowledge with strong conviction and passionate sincerity. It is not proposed here that applied art training and design task application should supplant pure art, far from it; but it appears that art could contribute more effectively if it contains teaching on the nature of applied art and where it can broaden the teaching, using design and technology as an instance. And one of these places for art is in critical studies, which could render powerful help in explaining the nature, position and contribution of applied art and its relation to pure art and could discuss the pure/applied relationship, whilst at the same time protecting the leading role from a teaching point of view, of pure knowledge in art. The basic point which needs to be emphasised here is that pure knowledge and thinking develop solely in terms of thinking and acting 'for its own sake' whereas applied knowledge is perforce concerned with the possible applied outcomes of pure knowledge. This arises from the effort to understand more deeply what knowledge and type of thinking can produce greater progress and mastery. A clear grasp of this, and of the point where we turn from the one kind of knowledge to the other, will greatly benefit art teaching and critical studies. Clarity here is essential: pure knowledge and thinking is our lodestar, which in application navigates the progress of art.

Among the general pressures on art teaching and lecturing there arises a lively interest, in the National Curriculum writings, in the cross-curricular links between existing subjects, and in the case of art, particular attention needs to be paid to the relation of art to craft and to technology. The National Curriculum clearly reaffirms that the traditional foundation subjects will stay, with art (but not craft) among them. These subjects rest for their identity on the divisions of knowledge worked out by philosophers. With this division comes the strong conviction that each should be thought of as a branch (or sometimes branches) of pure knowledge (the central characteristic) admitting of a small amount of applied knowledge, as already mentioned. These subjects have all of them busied themselves in teaching so as to familiarise this knowledge as a first duty, and they commonly show resistance to making close relations with other subjects. The effect of the National Curriculum, however, is undoubtedly to look closely as to whether the subject can so revise its teaching as to support some other closely related subject which would profit by the extra support. The obvious case is what art could do for design in technology. This would involve setting up a permanent liaison between any two or more of cross-curriculum subjects. The timetabled and collaborative committee work which this would involve is an obvious problem. But the question here is not about practical difficulties. Rather, the question is, is the nature of the subject matter to be *radically reorganised* to make such cross-curricular support really have its effect. Here, critical studies would have to consider its role not only with art, but also with the needs of the linked subjects, and to what extent, say, would

putting a strong emphasis on design affect the central emphasis on pure knowledge with which the National Curriculum is principally concerned.

In any case, subjects face a constant slow change with the seeping through into teaching and lecturing of fresh knowledge arising from research in the subject area. In addition however, there are other disturbing factors, such as the arrival of new materials and technical change in the practical process. Here, critical studies has a special responsibility to study any such new developments and to play its part in ensuring a keen and appreciative reception of such developments, and emphasising *both* pro and con. Often such developments are pressed with miracles of cajoling upon us: but we find in applying them that heaven remains the same distance away. Further, the growth of new art forms, especially powerful and distinguished ones like photography, must have a proper treatment of their relation with fine art, which is often all too tightly bound to the habit of explaining everything in terms of traditional painting and sculpture and traditional drawing. It is possible indeed that a special responsibility for design teaching, together with a more searching review in teaching of technical, even technological aspects of art work (not at all impossible nowadays in modern creative work, and not unknown even in traditional art forms), may produce a benign alteration of some of the pure knowledge taught and the potential application of this knowledge. For pure knowledge needs keeping up to date, and will not be harmed either by fresh art directions nor by the careful pointing out of the application of such new thought and knowledge.

Cross-curricular relations undoubtedly would bring new emphases into teaching, which would greatly concern critical studies, which involves considering in detail other areas of application of art teaching and would have to take a lead in how the application of art knowledge would sit in the presence of say, a strong role for design which is already one of its central concerns. Really, what is being introduced, if this arrived on any large scale, would be a redistribution of the knowledge base on which the subjects have traditionally depended. It could be that such a development, if pressed a good way, would gain much more emphasis on applied knowledge but weaken the central nature of art knowledge (as could be the case with other foundation subjects). Against this there is the strong conviction that high mastery in a subject comes only with a thorough training in the pure knowledge, and then applied knowledge can be mastered whilst maintaining the integrity of the pure learning. (A similar set of comments could be made e.g. for subjects like history.) But the intimate connection of art with craft, and the close similarity of the teaching structures in both areas, inclines the writer to suppose, as has been hinted above, that this would not be cross-curricular at all, but rather the joining of two closely related aspects of a basic knowledge, which differentiates the one from the other, not by reason of applied knowledge but rather the same practical knowledge with a differing outcome resting upon motive and feeling-

states about the nature and handling of materials which will be other than those picked out by art. But the very close relationship of the two is unlikely to disturb the integrity of art teaching in any way.

It has been pointed out that critical studies judgements, by reason of their subject matter, are a mixture of several kinds. This, as in all kinds of social judgement, is rather the rule than the exception. Each type of judgement offers a perspective of the whole learning problem being judged, and then each of the perspectives thus offered must be reconciled as a prelude to action with the other ones. The prospect thus opened out is a capital responsibility for critical studies. There is often a tension between, say, the aesthetic judgement and the practical judgement, and the solving of this is required for a decision as to what is going to be done. This is of course occurring on a general scale between design in art and design in technology. Is the functional aspect of the problem or the aesthetic one to take priority? No such priority can be completely reached where the problem requires for its solution the co-presence of both judgements because they have to act jointly through the practical work to get a curriculum appropriate to both judgements. But the habit of using both requires a special presentation by both teachers and lecturers. And all this is in the presence of personal action and relationships and the personal knowledge in terms of which they are learnt.

A word on aesthetic judgements might help here. These judgements are basically trivial and are often very peripheral occasions in daily life. They play a regular role for instance in supermarket shopping, in games, in people's way of putting things, in dressing, in sexual attraction. Their appearance in art however is often sensational and signalised by powerful feeling-states, strong motivation and intense cognitive working in the practical situation. It is a rarer and more special example of aesthetic judgements than is the daily use of them. But none the less, for that, it is a very special responsibility for critical studies to undertake the teaching of the natural aesthetic judgement. Indeed, this provides the best opportunity, though not the only one, for teaching aesthetics. The educator has to show, however, the broad nature of aesthetic judgements. Pointing to the special nature of these artistic judgements (both creative and traditional because traditional artists have their moments, no less renowned than great creative art works).

Perhaps this is the place to put a note in about the relations of art and craft. Both have trivial and intense aesthetic judgment to offer. But in craft, the balance of judgements accords a higher place to technical handling of material than it has in art. A very slight alteration of emphasis and art goes over into craft, and vice versa. Both arise out of sustained and coordinated practical activity, but a slight altering of the practical-aesthetic judgement co-relation will produce the one or the other. The view that craft is subordinate merely reflects the belief of the greater

importance of art, which is a value judgement and like all value judgements, subject to change according to the fashion of belief. The facts do not appear to support the traditional art opinion. Lastly, on aesthetic judgements, my view is that the teaching of the skilful use of them is feasible. No attempt is made to define aesthetics, but we can rely upon its emergence at an early age, and communicate our experiences in a manner that makes sense.

But the main point is and has been to emphasise its frequency and equally frequent triviality, and to suggest that in art teaching the rarer and more intense form often arises and constitutes a good opportunity for teaching something of the nature of such judgements.

In conclusion, these notes, it is hoped, indicate that critical studies has a role to play in art teaching which is fundamental and equal to the practical work from which it is inseparable. Our mistake has been to think of it as a visiting intellectual commentary on practical work that is going on some other time. Often as a mere historical commentary it has nothing like the impact that it needs to develop the practical work in art. It should range intimately over all aspects of the practical work in the actual course of that work. That is the point of entitling it 'critical studies'. The critical effort is the analytical tool that can do so much to contribute the developing practical experience. In the murk of the past, we can note the mutual suspicion of those who regard art as a suspect form of knowledge and a rather vague activity; and on the other side, as a riposte, the suspicion of language and intellectuals and all their work. It is time to realise that these two horses are pulling the same cart. The needless and irrelevant suspicions and muddled views are the only brakes that can stop the cart.

Originally in the Journal of Art and Design Education, *Volume 12: 3, 1993*

Chapter 4: Curricular Development in Critical Studies

David Thistlewood

Over the past ten to fifteen years critical studies has become established in the primary and secondary phases of art and design education. This has been due to a small cohort of educationalists to whom I shall refer simply as the 'pioneers' of critical studies in schools. Their work has been effective to the degree that critical studies is enshrined in the National Curriculum; yet the nature of its presence in the National Curriculum suggests two things: (a) that it is a 'discipline within a discipline' (it has no role outside the context of art and design), and (b) it is a servant discipline. The interests it serves are those of 'making' or practice, but I suggest in this paper that this role should be questioned. It may be appropriate now to consider whether critical studies may become an independent subject, studied equally for its illuminative capacity in relation to practice, or for the benefit of its own inherent knowledge systems. If this seems heretical, I suggest that the history of the development of critical studies is replete with heretical moments that have given rise to productive revisions of its role.

Critical studies is today an accepted component of the art and design curriculum. It is a collective term for a range of interests and activities that, by present consensus, enrich those practical components of the art and design curriculum that are regarded as its core disciplines. Yet though there is a consensus belief in its validity, there is in fact little general agreement about its model content. While critical studies comprises subject-matter, forms of engagement and criteria of development that are *tacit* the art and design educational community acts as if they were *explicit*. This alone should be sufficient to warn against complacency.

The issues critical studies embrace are many and complex, but there is a virtual conspiracy to present them as few and simple. This may be explicable in terms of fears that critical studies may become a *served* rather than a *serving* discipline. It is possible that a general acceptance of its 'supporting' status has hampered its development, and may be responsible, for example, for what is a real, but at the same time vague, presence in National Curriculum documentation. Here is the paradox which any consideration of a future role for critical studies must address. It is vaguely present in the National Curriculum not because of some desire to accommodate it in a minor key, but because of a determination to ensure that it remains a powerful force. Those who have drafted the non-statutory guidance within the National Curriculum would no doubt maintain that in order to preserve its potency critical studies must remain tacit.

It is characterised by understatement because of what has become a convention - that it is most effective when discreet. Creative work is evaluated first as achievement and second as a means towards achievement. Critical studies cannot normally receive high credit unless a related, created outcome is perceived to have 'succeeded'. There is a respected constituency of belief that in the very tacitness of critical studies is its potency. But to maintain it as simultaneously a potent and a tacit educational force only makes sense in relation to its projected future as a subservient discipline. Any serious discussion of a future for critical studies must include - what has previously been considered unthinkable - the possibilities that it may be engaged independently of practice, and that in certain educational contexts it may be regarded as a core discipline in its own right.

These proposals will be regarded in many quarters as provocative: they challenge the basis of a great deal of the pioneering efforts to establish the validity of critical studies - such validity having been measured by an *evident enhancement* of practice. But it is also a tribute to the great pioneering initiatives to regard them as now sufficiently well established to resist heretical questioning. They themselves were once heresies, the periodic positing of which seems to be the fundamental principle by which critical studies has accomplished its insinuation into the curriculum.

A discussion of the future role of critical studies is not the occasion for a detailed history of art and design education - nevertheless a brief outline seems necessary for orientation and contextualisation. In Britain this history may be drastically simplified - so far as critical studies is concerned - as having consisted in two principal phases. There *was* a phase in which the history of art (a principal component of critical studies) was largely irrelevant to the proper study of art and design; and there *is* a phase in which the history of art is regarded as indispensable.

The first of these phases occupied practically all of the period between the Great Exhibition of 1851 and its commemoration a century later in the Festival of Britain. Drawing education was introduced into the Victorian curriculum largely as a reaction against the worst features of taste displayed in the manufactures exhibited in 1851. It had historical referents, but these were few and specific - typified in aspects of form, proportion and decorative treatment associated with antique modelling and architecture, and with an iconography of representation associated with sub-Raphaelesque naturalism. Drawing education was minutely prescribed, down to the minutest details of its regime of exercises. A legacy of prescription survived the 1913 Education Act because - whatever its disadvantages in terms of stifling originality - prescription at least focused on practising and executing assessable skills that were regarded as essential.

The second period of this simplified history overlaps the first in recognition of the

alternative, child-centred, philosophies that began to be proposed as early as the 1913 Act, but which were not enabled until the Education Act of 1944. Because child-centred theory, legitimised in 1944, had all along maintained affinities with certain aspects of the recent history of avant-garde creativity (notably Expressionism) its acceptance carried an inherent obligation (on the part of teachers rather more than their pupils) to be familiar with certain aspects of modern European art. It was this need on the part of teachers that challenged the dominance of a subject-centred discipline, as increasingly they used avant-garde imagery and creative strategies to encourage their pupils to be appropriately 'expressive'.

So the first heretical 'moment' in the history of critical studies was in fact an extended episode in which modernism was proposed as an alternative to classicism as the ideal referent for art and design. It was from this 'moment' charged with risk because it challenged an ingrained orthodoxy of belief in the proper foundations of culture. At a time when its most extreme opponents identified it with madness, modernism was proposed as the normal referent for the creative work of children below the age of ten. This 'irresponsibility' was compounded by extension: pupils themselves were to be conducted in the ways of Gauguin, Van Gogh, and the Fauves. As late as the 1950s this was sufficiently scandalising for some teachers - even while utterly accepting child-centred principles - to agitate for more wholesome role models for artistic emulation.

So the first heresy was the proposal that pupils, particularly the very young, should receive an induction into modernism. However, it should be recalled that 'modernism' in the 1940s and 1950s connoted very differently than it does today. At a time when a literature of modernism hardly existed, when virtually no well-produced visual information was available and when twentieth century art was poorly represented in museums and galleries, Gauguin, Van Gogh and the Fauves *typified* modernism. They represented unprecedented 'visions' that were more or less associable with children's creativity, but even so, in an age when popular, incidental histories of modernism were better known than aesthetic critiques, they also represented unsavoury lifestyles involving lechery, mental instability and wild behaviours.

Other aspects of modernism - its publication in newspapers remaining largely uncorrected in the absence of a dedicated press - conveyed comparable implications: Epstein modelled pregnant women; Picasso visited wilful disfiguration on his subjects; the Surrealists were unhealthily explicit about sexual fantasies; Abstractionists were said to have abandoned the easel and to paint upon the floor. Traditionalists believed that resistance to modernism was a moral crusade. There is more than a suspicion that critical studies' tacitness is a defence characteristic naturally rooted in such controversy.

By the early 1960s it had become apparent that critical studies needed to be recognised in *policies* for art and design education. The Coldstream and the Summerson Committees (which made recommendations on the degree-equivalence of higher education in art and design, and on the need for students to experience a specialising interlude between school and art college) each contributed to the legitimisation of critical studies. This was accomplished by a tactical alliance between two distinct interests. There were members of these Committees who insisted on the necessity for studio-based activities to be informed by courses in art history, particularly featuring contemporary issues. There were others who insisted that the previously narrow world of art and design be enlarged and enriched with knowledge of an eclectic range of appropriate disciplines - engineering, psychology, the natural sciences.

In recognition of the fact that only a very small number of people in Britain at this time were *capable* of teaching the history of twentieth century art, those who spoke for art history proposed the notion 'cultural history'. This would embrace a great variety of essentially non-artistic matters - for example, principles of architectural construction or of biological formation - which nonetheless could submit to artistic criteria and assimilate to a growing body of art historical expertise. This alliance of interests produced the notion of *complementary studies* in order to comprise a range of disciplines to be afforded 'honorary' art historical status, and thus to make catholic provision for supporting studies throughout all recognised foundation and degree-equivalent courses. But the introduction of a category of study with such generalised content as implied by the term 'complementary studies' of course was to invite other, persistent heresies. One of the more obvious of these was a 'taxonomic' approach to aesthetic analysis, justified by the biological analogy, the inherent systematisation in which, however, was essentially stifling of creativity.

But in the absence of definitions of what was appropriately 'complementary', any form of study could be legitimised. For example, it was not unreasonable to inform studio-based activities with philosophy, politics and sociology - in the late 1960s and the 1970s there were manifold opportunities for graduates of these disciplines to provide supporting courses in art colleges, especially as these colleges entered the new polytechnics and thus joined *communities* of diverse disciplines. There were many productive ramifications of this widening contextualisation of art and design, particularly associations with other disciplines that became reflex and were carried from higher education into secondary and primary education as art and design graduates entered teaching.

But there were at least two unforeseen consequences that were undesirable. One was the opportunity provided for outrageous contributions to complementary studies. Representatives of other disciplines who were either unable or unwilling to contribute to their own fields legitimately, could here find an arena in which to be

taken seriously. While the great majority of beneficial contributors to complementary studies remain unsung (when something works well it is often unspectacular) folk-memories of this period are likely to be dominated by a few shamanists and apocalyptics. The history of this tendency remains unwritten precisely because it involved ideas that could be taken seriously in the seminar room but not in print.

The second unforeseen consequence arises from the confinement of complementary studies to the spoken discussion. As recently as the late 1970s there was still little tradition of scholarly writing in degree courses in art and design. The contextualisation of art and design in bordering and overlapping disciplines - the noble cause of complementary studies - remained unrealised in students' writings while at the same time it was endlessly rehearsed in their images and objects. Without cold textualisation there was an invasion of uncritical stimulation into studio practice. The perfectly legitimate concerns of politics and sociology, environmentalism and even religiosity, became the objects of visual sloganising, debasing both medium and message. Again, folk-memories bear traces of traditional studio teachers cowed by the ferocity of visual slogans they were unable to counter with their aesthetics.

It should be stressed that exceptions to sound practices provide the most persistent memories, and that while complementary studies as a whole lacked a critique there were many pockets of excellence and relevance. But it is noteworthy that the generation of educationists who are now regarded as the 'pioneers' of critical studies were motivated by the general absence of a relevant critique in those complementary studies practices that began to percolate into secondary education in the 1970s.

This generation made it its business to identify a 'proper' range of disciplines and activities that could both enhance practical art and design and provide strong criteria for assessment and evaluation of the effectiveness of this enhancement. Here curiously was another heresy: the selectivity implied in such objectives was said to cut against the grain of liberality by now associated with a complementary studies tradition. It is often forgotten that a prime distinction existed as between 'complementary' and 'critical' studies, the latter signifying an intention to regain the high ground for rigorous support for practice - by identifying critiques and contextualisation that were intrinsically of practice rather than parasitic upon it. The prime criterion for admission to the critical studies canon, therefore, was (and substantially still is) the notion of what, from the wide realm of experience, stimulates the creativity of the representative practitioner.

Now of course this embraces much that came within the possible scope of complementary studies, but an essential difference resided in the principle that all

contextualisation was to be filtered through practice. Critical studies thus were seen to represent a reciprocation of rigour: rigorous practice (which art and design educationists could be confident of recognizing) and rigorous critiques (measured by their relevance to practice) could exist in profitable mutuality.

Instead of bringing a range of concepts to practice and insisting they be accommodated, therefore, critical studies (in the forms it has assumed over the last ten or fifteen years) addresses such concepts through the practices that have engaged them. Practice remains paramount and also paradigmatic in terms of a critique. The notion of integrity is important, often stated, but little defined - a prime example of the vagueness associated with critical studies which ensures its tacitness. The principal educational method is the case study, explored through the literature of art and design, or by real interaction with artists and designers (perhaps in residencies), or by location work (for example in galleries). The most common focus of investigation is the artistic or designerly 'problematic', revealed through perceived 'intentionality' as volunteered by the artist or designer, as argued by the critic or historian, or as evident in the objective reality of the work of art or design. It is perhaps the greatest achievement of critical studies that such issues today are commonplace in secondary and even primary education, whereas 25 years ago they were rarely encountered even in higher education.

Why then should there be concern about the future role for this much valued component of the art and design curriculum? There are several reasons, including simple avoidance of complacency, for giving it some thought. The most obvious aspects to be questioned, from time to time, are its tacitness and its subservience - the former because the tenor of the times suggests that what remains tacit is soon discounted and lost; the latter because of the potentiality in critical studies that will be unfulfilled through lack of an obvious application.

In order to stimulate debate it may be appropriate - especially in view of the heretical nature of the development of critical studies - to propose a number of new heresies. The first of these would be to suggest that critical studies at present reinforces a conception of artistic creation and design origination that can only be relevant to a very small cohort. This is the romantic notion that the artist or designer 'lives' principally in his or her creative work, and that the rest of this individual's experience is of significance only in its capacity to inform practice. It may be true that certain 'heroic' paradigms of, for example, contemporary architecture (half a dozen individuals shaping the course of world events) and avant-garde art (artists living lives that are themselves fashioned as artistic 'projects') confirm a principle of total dedication to creative practice, but this is surely inappropriate for the overwhelming majority of recipients of education.

New heresy No. 1 is therefore that critical studies *should not necessarily inform the*

practice of art and design, and its corollary would be that it might well be engaged independently of 'making' disciplines. It will be protested that even though only a small cohort of pupils will be destined to be artists and designers, all pupils will be future *consumers* of art and design. In order to consume with discrimination, these citizens would require intimate knowledge of those processes that have sustained production, including that corollary of the romantic paradigm, the intense struggle that dignifies and authenticates the truly creative. However, there are at least equally compelling reasons for shielding consumers of works of art and design from graphic knowledge of their gestation in the minds and habits of their creators. This is a version of old concerns about whether appreciation of the works of artists such as Gauguin automatically convey indelicate knowledge otherwise accessible only in his *Intimate Journals*.

However, there is no inherent requirement for detailed 'process' knowledge to inform the activity of consuming art and design. It is not axiomatic that relevant 'critiques' emerge only from 'process' knowledge. Conversely, deep interest in 'process' does not require this justification. Clearly there are distinct critiques of 'process' and of 'product', each of which may equally serve critical studies if critical studies is accepted as a discipline in its own right. This is more heretical than it may seem, for critical studies (in primary and secondary education) has conventionally addressed 'process' in order to generate a critique of 'practice' that would facilitate an evaluation of 'products'. What is suggested by 'new heresy no. 1', then, is that critical studies may address a culture of images and objects directly as things in completeness, as things in interactive relationship with other goods, habits and values, and not simply as outcomes of process histories.

'New heresy no. 2' follows from this: art and design practice may then be undertaken principally for the benefit of informing critical studies. There is a potentially illuminating correspondence here with subjects that also have tacit presence within the art and design community of interest and which are likewise unrecognised as prime disciplines - photography and media studies. Here it is acknowledged that while each significantly enhances the other, each may also stand-alone.

They are both *serving* and *served* in their mutual relationship. It is this that makes them difficult to assimilate entirely into the art and design community as presently conceived. The rest of this paper compounds the second heresy by speculating that critical studies may more satisfactorily fulfil its potential as an educational force if photography and media studies are permitted coequal status within a community of disciplines comprising art and design, photography, critical studies and media studies.

There are tangible similarities between the *actual* relationship of photography and

media studies and the *potential* relationship of art and design and critical studies, which may be apparent in the following discussion. There are obvious distinctions to be made between seeking knowledge *through* taking photographs (through making art) and seeking knowledge *in* the study of photographs (in the study of artworks). However, there is a clearer conceptual separation of these two activities in the realm of photography than there is in the realm of art. If this relationship of separate but mutually-enhancing disciplines works well in respect of photography and media studies, it is worth considering whether it may be paradigmatic for art and design and critical studies.

The activity of taking photographs challenges pupils to pursue complex activities associated with art and design (a) to scrutinise their environment for perceptions they can isolate from the welter of possible perceptions, (b) to interpret their observations within the potentialities of the medium, (c) to *evaluate* their subject-matter and establish positions in relation to it, and (d) to pass on their perceptions in communicable forms. At the heart of this is the principle of arresting visual data from the mass of information that camouflages them, in order to find and express meaning.

However, subject-matter does not reveal itself. It has to be sought, which means that it is affected by the searcher's goals, needs, attitudes and expectations. It is recognised for its capacity to match pupils' current interests, and this is a powerful justification for a form of teaching that stimulates the search without prescribing the resulting discovery. In this sense media studies is the counterpart of critical studies - however, in critical studies there is a powerful tendency *towards* prescription in the sense that pupils' discoveries in works of art are encouraged to approximate to what is known of the artists' intentions.

This may be undesirable, but it is easy to appreciate how it has arisen. Studying a photograph presents the observer with two fundamental 'messages'. One relates to permanence (the preservation of a moment in time); the other to discontinuity (the obvious fact that the moment has been dislocated from the stream of events of which it was once a part). These 'messages' combine to oblige the observer to construe an imagined 'past' for the photographed event, and a probable 'future' - that is, to see it in a context. This context is likely to be an extrapolation of the 'event' depicted in the photograph - an 'episodic' construct based on 'facts' observable in subject matter. The counterpart of this contextualisation of a work of art is more likely to feature the artist's *intentionality*, simply because of the obvious fact that the artist modifies his or her perception in the act of responding to subject matter. Any suggestion that the two sets of paired disciplines under discussion - 'art and design/critical studies'; 'photography/media studies' - are alternative modes of study is thus refuted. All four are required within a comprehensive model of creative education.

The contextual knowledge constructed around photography is likely to be much more tangible than that invoked by, say, painting because of the indisputable fact that the event isolated in the photograph actually occurred. This gives rise to something unique in education - the possibility of attaching to a photograph an imagined, explanatory context which, because it is reinforced with photographic evidence, is convincing, realistic and perceptibly 'true'. This is the phenomenon exploited in advertising, and countered by media studies.

One of the principal objectives of media studies is therefore to enable individuals to perceive legitimate meaning in photographs, discounting the illegitimate. This establishes it in the mainstream of education, where meaning is sought in texts, diagrams, maps, equations, experiments, field observations, and so forth, by acts of inclusion and exclusion. By association with media studies, critical studies is also established in the mainstream (something its conventional association with art and design has failed to accomplish).

As in other realms of education, meaning is derived by making conceptual connections between discrete observations and/or experiences. For example, the realisation of meaning in a photograph of a building may be reinforced with supplementary photographs of the same artefact taken at different times, under different conditions of weather and time of day. The host of alternative appearances will not contradict, but enrich, the conceptual information available in each isolated image.

Drawing or painting the same building will enhance conceptual understanding in a slightly different way, because these activities extend over time and consequently accommodate changing appearances within single images. They also result in spatially three-dimensional and discursive perceptions, which are not the usual characteristics of photography. The isolated percept (the photograph) reinforces the cumulative percepts (in the drawing or painting), and they reciprocally enlarge and enrich the subject's contextual meaning. Meaning that is found, constructed and developed in this way is of a very high order of authenticity. Art and design thus brings photography into the mainstream of education.

Their interaction integrates two different, but complementary, forms of knowledge. A photograph is in effect 'raw evidence' of an occurrence which comes to the observer's attention relatively 'uninterpreted'. A drawing or a painting, on the other hand, consists of evidence that has constantly been subjected to interpretation in the process of its production. There is a much clearer distinction between the photograph as 'art' and as 'visual evidence' than there is between the drawing or painting as 'art' and as 'visual evidence'. There is great potential for 'raw' and 'processed information to be exploited for their capacities to reinforce each other. As the role of media studies is transparent in the identification of

'processed' information, its presence in the curriculum, and its manifest facilitation of appreciation and criticism, may therefore provide a link between art and design and critical studies that permits the latter much more than its conventional serving capacity.

There is an evident symbiosis, then, of art and design, photography, critical studies and media studies capable of supporting productive speculation. I will offer one or two further examples in order to suggest that the field of speculation is potentially vast.

Awareness of photography tests the limitations of syntax in the work of art. Syntax consists in the structures and networks of marks, the products of pencil, brush or knife, that 'range' over and around the depicted subject, giving it tangible presence while offering evidence that it has been engaged by human perception. Photography is virtually free of syntax in this special sense: its structures and networks of marks are minute. Familiarity with the compelling 'reality' of photography's syntax-free graphic imagery, therefore, establishes an important parameter for focused discussion on this aspect of aesthetics in the realm of art, and gives purpose to a study that would otherwise be confined to comparing alternative syntactic systems.

There is also potential for pupils to become aware of differentiated effort and significance. A drawing or a painting does not deal even-handedly with all the information present in a perception. A drawing of a person or a scene, for example, may dwell on certain features and deal sketchily with others. It will therefore embody decision-making and choice which are acceptable as evidence of a legitimate act of visual translation.

A photograph does not 'translate' appearances in this way. It 'quotes' appearances. The isolation of the photographic quotation sets it apart from the stream of events to which it belonged. This both facilitates detailed and prolonged examination and familiarisation, and creates a sense of dislocation of the image that must be 'repaired' by the observer's construction for it, as previously noted, of a 'past' and a 'future'. Thus the 'length' of the quotation in the photograph is not confined to the instant of its exposure, but is as long or as brief as the reconstructed context that the observer is able to supply. The 'length' of the quotation embodied in a representational drawing or painting matches exactly the space of time expended before the object. In this sense the quotation embodied in representational art tends towards the factual and that embodied in the photograph tends towards the fictional.

Because of the often highly fictional elaborations of some received photographic images (for example, in advertising) they must first be de-contextualised of

imposed histories of meaning before pupils can substitute their own. This activity is genuinely educational - concerned as it is with the reinforcement of existing knowledge, the searching for complementary knowledge, and the subjective sensing of meaning in the act of interpreting the ambiguous. The observer associates in direct sensation (empathises) with and through the appearances recorded in the photograph and this is a powerful source of stimulation for other constructive creative acts.

Photographic images share with other manifestations of the arts the capacity to elucidate concepts that otherwise defy description - profound grief, ecstasy, decay, religiosity, patriotism, brutality - but the photograph's obvious connection with a real event lends an immediate tangibility that is not easily evoked by other means. A stronger association of art and photography would reinforce a conventionally weak aspect of art knowledge - the fact that it does not readily approximate to other forms of communication and becomes diluted when the attempt is made.

But this reinforcement may be reciprocal. Photographs may be worked on, composed, cropped, enhanced and modified after the act of perception, whereas works of art are much more likely to be modified, in comparable ways, *during* the act of perception. The latter connotes greater perceptual 'integrity', which is both paradoxical in view of other aspects of the comparable relationship of the two disciplines, and also evidence of their necessary familiarity.

Conclusion

I hope I have outlined enough of a potential relationship between art and design, critical studies, photography and media studies to suggest that here is a profitable field for extensive speculation. The prime purpose of this paper is to stimulate other equally compelling and equally extensive fields. Of course it will be pointed out that such speculation is substantially pointless, since the National Curriculum is unlikely to accommodate further disciplinary development at least until a period of beneficial reinforcement of existing initiatives has been accomplished. My response, however, would be that this does not prohibit creative thinking about developmental possibilities. Critical studies, in its present form, was for a long time 'merely' a topic that consumed much conference time and paper argument. New argument and debate should proceed in readiness for the next great revision of education, so that when opportunities for change occur the arguments will be well rehearsed. I believe this forthcoming, fruitful phase of development will centre upon critical studies. A curriculum now heavily predicated upon 'making' will transform to accommodate more and more 'critiques'. In the special case I have outlined, enlargement of the art and design community of disciplines from two to four, and the establishment of their co-equality, will not diminish but enhance the significance of the two (unequal) disciplines that are its present incumbents. Any further, fruitful, curricular development of art and design demands an immediate

willingness to accept critical studies in more than the serving capacity that has become conventional.

Acknowledgment

In my comparison of the essential characteristics and disciplines of drawing/painting and photography I have leaned heavily on John Berger's philosophical analysis. For an extended discussion of this field see: Berger, J. & Mohr, J. (1982), *Another Way of Telling*, London & New York: Readers & Writers.

Chapter 5: What Do Dragons Think About in their Dark Lonely Caves?
Or Critical Studies: The Importance of Knowledge[1]

Alison Bancroft

Overview

Increasing numbers of critical studies publications are currently reaching the market, with teachers receiving numerous advertising materials and catalogues to persuade them to buy. This paper considers the content and approach of some of these materials, with particular reference to teaching packs, and examines some of the issues that the decisions embodied in these publications raise for art teachers and for critical studies teaching. The orthodoxies that would seem to be developing are worrying, and rigorous debate is needed to expose and explore the grounds on which categories of inclusion and exclusion are constructed. It is argued that such debate needs to be underpinned by knowledge of the paradigms in operation, and that access to such knowledge is essential, for both teachers and students, if critical studies is not to degenerate into imaginative speculation or indoctrination.

Introduction

With the legal requirements of the English National Curriculum,[2] the creation of a body of knowledge under the broad heading of critical studies is moving with increasing speed. Lacking solid theoretical foundations, this term is used to cover a wide range of disparate practices, and equally, different terminologies are used to cover the same practices.[3] This makes any debate on critical studies extremely problematic, particularly with the tensions created by the juxtaposition of approaches with a substantially different philosophical base. It would, for example, be relatively simple to agree that critical studies includes art history as one of its strands. It would be less simple to identify what different writers, and teachers, mean or understand by art history. Traditional approaches have been challenged, yet these survive in the National Curriculum virtually untouched, but alongside the contextualised approach of newer methodologies.

These issues can, and need to be addressed theoretically. Hughes argues the importance of this in 'Don't Judge Pianists by their Hair'.[4] However, my intention is to consider the body of knowledge and approaches that are being defined through the publishing of educational materials, the practical physical expression and construction of the boundaries of critical studies through what is included and excluded, and to use these materials to map out some of the areas that, I believe, need much more rigorous debate.[5]

In particular, I intend to concentrate on the teaching packs that have recently arrived on the market.[6] These packs may not provide a wide analysis, but if, as Hughes and Swift have argued,[7] developing practice in this area is already settling into accepted orthodoxies, they may provide a small picture of what is currently deemed appropriate for study and the approaches advocated.[8] Decisions about content and approach are never value free, and it is through considering these that a number of underlying assumptions (intentional or not) may be revealed and exposed to question and debate. Philosophical and cultural starting points need to be examined with rigour if possibility is not to stagnate into disturbing orthodoxy.

Teaching packs: inclusion and exclusion

The materials for analysis were identified using the advertising materials and catalogues sent to the secondary school art department in which I teach.[9] From this range, I selected seven teaching packs for more detailed considerations of content.[10] To categorise the images offered in these packs is in itself problematic for a number of reasons [See Appendix 1 for a full list and Table I for an analysis of period, gender and culture]. It is true that the opinions of educationalists differ on whether the proper focus of critical studies is 'works of art'[11] or 'all visual artefacts of an aesthetic order',[12] but whilst the former position is often assumed, the latter is usually argued, giving a message about where the status quo lies.

The National Curriculum states that 'art' should be interpreted to mean 'art, craft, and design'.[13] As categories these are value laden, culturally, historically, socially and politically defined constructs. I use them reluctantly, but broadly speaking the overwhelming majority of the images in the seven packs can be placed in the traditional Western category of fine art: most of these are paintings. There is also the occasional photograph, and piece of textile 'art' (as opposed to textile design). The packs contain no examples of 'craft' or 'design'. For example, there is one ceramic sculpture, but when does ceramics move into 'craft' (studio ware) or 'design' (industrial production)? These are shifting boundaries.

The work shown in the packs is not all European in origin. There is some evidence that the work presented from other cultures is intended to he seen as 'art', as falling into the same broad category definition (with all its attendant meanings) as the selection of European images. In fact some of these pieces offer a sharp, though unacknowledged, challenge to accepted Western notions and categories of 'art'. For example, how is the nineteenth century 'Beaded Cloth' from the Yoruba tribe intended to be viewed? The written information on the back of the card tells us that:

> ...the astonishingly sophisticated works of art produced by the Yoruba have only been discovered in the 20th century.[14]

This statement tells us far more about the world view of its writer than it does about the work itself, but to unravel just one small strand, would it be unreasonable for students to wonder why other items of clothing are not offered as 'art'? Does a beaded cloth hat change categories depending on where it is produced? Why? What messages are given, and what issues hidden, by such categorisations and juxtapositions?

It is perhaps particularly surprising to find this image in a pack whose theme is 'Faces' (although there is a face in the bead design). Nine of the other eleven images in this pack show examples of European painting. The remaining two are 'Tutankhamun's Funerary Mask', and 'The Wedding: Lovers' Quilt' by Faith Ringgold. The images in the pack do not sit together comfortably, and the implications of placing work from a variety of cultures into European categories need to be faced, not ignored.

Out of the seven packs, a total of 120 reproductions, only ten works (to my knowledge) were not produced by white artists. It is of course possible that amongst the other 110 are works produced by artists that neither my knowledge, nor the cards, identify as black.[15] This raises a number of issues. How much do we use the content and style of the image to make assumptions about the artist, and what meaning do we place on what we assume? Should the racial, cultural, religious, identity of the artist be stated on all cards? Why? What of nationality? Who decides these categories, and who do they benefit? If it is important that images of black people are presented in the packs, then what issues are raised by the images of black people produced by white artists? With the patterns of representation and categorisation emerging in the packs it would seem that these issues need serious and urgent consideration.

Out of the 120 images only thirteen are identified as being produced by women. Only one of these, that by Faith Ringgold, is identified as being produced by a black woman. The writing accompanying her piece also provides the only hint that feminism has existed.[16] Whilst the seven out of the ten images previously discussed were dated before the twentieth century, only one of the pieces by women (an undated piece by Ann Kearns - nineteenth century[17]) could possibly be pre-modern. This pattern is perhaps not surprising. Work from other cultures tends to be placed in a 'timeless past'[18] whilst it is often assumed that there were no women artists before the modern period.

From this analysis it would seem that the dead, white, male, European canon is alive and well. Challenges to its categories of inclusion and exclusion, and to the fundamental principles on which it is founded have been firmly ignored by the makers of these packs at all but the most tokenistic of levels.[19] The narrowness of the selection confirms Hughes' statement that '...children are increasingly exposed

to a limited canon of predictable images by "favourite" artists'.[20] The 'favourite' artists in these packs are Hockney, Van Gogh, and Picasso, each are represented five times. Klee, Spencer, and Rousseau, come a close second with four representations each. Few others are represented more than twice. In the pre-modern category (before 1850) Uccello, Arcimbaldo, Durer, and the Cholmondeley Sisters (British School) are the favourites with two appearances each. This analysis could be taken much further. Who, and what, is not represented at all is extremely interesting, and worthy of much more detailed exploration.

Ethical issues and choice

Hughes has suggested that one criterion for the selection of work is lack of iconographic barriers to understanding.[21] I would wish to add to that and suggest that there are other unspoken criteria in operation that relate to what is considered 'suitable' for children. Brandon Taylor's challenge to the appropriateness of modern art for younger students helps to open up some of these issues (Folens produces a pack on Modern Art for KS1 students).[22] His argument operates on a number of levels and is contradictory in places, but is still valuable for the directions it provides for consideration. He questions what childhood 'need'[23] might be satisfied by an understanding of 'the violence unleashed upon natural appearances by a "cubified" representation or an Expressionist caricature'. He argues that such representations can 'appear deeply threatening and disturbing to a mind unequipped to cope with adult sophistications'.[24] He identifies cultural, psychological and even biological reasons why children might be disturbed by distorted imagery. Price offers one answer to this in her assertion that Modernism does not present any special problems, that much of pre Renaissance European art and the art from other cultures employs formal distortion, and that students responses to distortion are 'schooled' rather than instinctive.[25] Without wishing to enter into the nature/nurture debate, this does not fully refute Taylor's point as the students he refers to are likely to operate within the meaning systems of this time and culture, systems that they would bring to bear on both of Price's examples also. To what extent we would wish, as teachers, to challenge or change this is another issue. We are, however, left with an ethical question, to what extent do we need to consider the ways in which the images we use may be disturbing to students?

Stanley's considerations of the Assyrian relief sculptures in the British Museum, an example given in the National Curriculum for KS2 students, take this issue into a different arena. He cites the positions taken by Reade and Bersani regarding these sculptures. Reade draws attention to the aesthetic and historical qualities of the works, and their social purpose in glorifying the Assyrian monarchs. This provides a not overly problematic focus, and would typify the approach used by the teaching packs, but Bersani's characterisation of the sculptures' content as providing examples of 'non-sexual sadism' leads into more difficult arenas:

We may only remember the sculpture as images of warfare where suffering slaves and animals are dealt with by a pitiless and casual brutality.[26]

Does chronological distance cleanse such images of their more disturbing associations rendering them 'suitable' for young children?

Rod Taylor, in arguing for the importance of considering issues of content brings us sharply and uncomfortably into the very recent past. The image he chooses to illustrate his point 'the charred head of an Iraqi soldier leaning through the windscreen of his vehicle, burnt-out during the retreat from Kuwait'[27] allows no escape. It could be argued that this is not 'art' but documentation, but Taylor's choice and reproduction of it in the context of his book on the Visual Arts recreates its meaning once again and places it firmly into the debate, if indeed it was ever separate:

Nobody could believe that the photographer who took it was only thinking about, or concerned with, technical and formal matters: its content is its message.[28]

It might indeed be considered 'immoral' by even the most dedicated formalist to look at such an image in terms of its formal qualities. What are the aesthetics of death? Would it be more acceptable if it was a painted image? Where are such boundaries set, on what grounds do they rest? Would such an image be appropriate to consider in the classroom (documentary style photographs are included in the project books)? Some students may have seen it already, some may not. There is little doubt that this would shock and disturb. It could be argued that it is not a proper subject for artistic response, but what of the many works of artists in response to war and death? It could he argued that the students are too young, but there is no age limit on such experiences, just as there is no age limit on the power of images to disturb. Students who have personally undergone such experiences, and those who are trying to deal with the images presented on the daily news, may choose to represent their response visually. What age limit would we place on such choices? Desirable or not, children are exposed to many disturbing images. The question is whether or not the issues raised should be dealt with in the art room, and also importantly, for whose benefit would they be raised? Imposition or response? Is it the teacher or student who sets the agenda? Contemporary representations of killing, war, death and disaster are absent from the packs considered. Is this because of their subject matter, or because they are likely to lead us into a more political arena? Are our concerns to protect our students from disturbing images, or for what might present disturbing issues for us, as their teachers, to deal with?

This returns us to another part of Brandon Taylor's argument. He asserts that

'modernism is a complex but also a controversial topic'[29] and as such is 'scarcely suitable for the younger child':[30]

> *Denoting nothing so simple as a stylistic 'development', modernity in painting and sculpture announced itself sometime in the course of the nineteenth century, partly as a vogue for contemporaneity, partly as a response to the changing inner life of the individual under conditions of developing capitalism.*[31]

Even if children can be brought to an understanding of such work, is it desirable, or appropriate, raising as it does what may be considered 'difficult' contextual issues? Taylor's view of childhood would seem to be of a time of innocence, a time requiring protection from adult realities. Are questions of class, capitalism and the individual, poverty and exile (to name some of the contextual issues that Taylor cites) unsuitable for children, separate from their lives? Or are they identified as such because, as I have suggested, we find them difficult? This adds other layers to what I have identified as an ethical question. Firstly, the extent to which we are we prepared to bring disturbing images into the art room (and how we recognise what might be disturbing), and secondly the extent to which we are prepared to tackle disturbing issues in the art room. As I have suggested what is identified as disturbing may often have a political aspect. If there is an unspoken criterion of 'suitability' in the selection of work for use with students it needs to he exposed and opened up for debate. Who decides, and whose criteria are used? Whose needs are being served? On what grounds do we censor what we bring into the art room?

There is also a third question which I believe needs to be raised: To what extent are we prepared to do violence to the image, to strip it of its more disturbing aspects and so render it 'safe' and 'suitable'? Taylor asks 'whether the reduction of modern art to the level of the visually given is desirable'[32] and argues that 'a seriously wrong understanding is worse than no understanding at all'.[33] Is it 'ethical' to reduce any work of art to a response to its formal qualities just because it is possible? What 'disturbing' information has been missed out of the packs concerning the images chosen because it is not considered 'suitable'?

Teaching packs: whose 'ways of seeing'?

The information and approaches in the cards direct our looking in a number of ways, many of which relate to these issues. The packs considered provide both image and text. Berger has pointed out the ways in which text can affect image, and the ways in which an image is affected by the context in which its reproduction appears. This has already been touched on to some extent in the discussion relating to the Yoruba 'Beaded Cloth Hat':

> *The meaning of an image is changed according to what one sees immediately beside it*

or what comes immediately after it. Such authority as it retains, is distributed over the whole context in which it appears.[34]

Most of the cards in the packs have the title of the work, the artist's name, and possibly the date next to the image itself. The portrait cards from Oliver and Boyd[35] have considerably more, with the image itself fighting against a background of detail. The information, discussion points, and activity suggestions in the packs confine rather than inform our responses, trapping them within an unacknowledged, but pre-mapped out approach. The common format of text within a pack has a tendency to unify, sterilise and reduce the often highly disparate images. The ways in which the images are trapped within the text help to render them safe, and available for unproblematic consumption. What is lacking is an acknowledgement that we are being invited to engage in a highly specific way of looking. The text clings to the image, in ways that are difficult to disengage.

The information most commonly provided is biographical detail and general information about the image that starts to interpret and 'place' its meaning. Anecdotes are often interspersed to highlight points. Questions to direct looking frequently carry the implication of a 'right' answer within their phrasing, they certainly promote a particular way of looking. Their focus certainly makes it clear what it is important to consider. Meaning is predominantly derived from subject and formal qualities. Our access to the images is controlled not empowered.

The information given is very patchy both across and within packs. Dates are often missed out even when it could be presumed that such information would be relatively easily available (with artists such as Picasso for example). In the 'Texture' pack from Goodwill dates are given for the birth and death (where appropriate) of the majority of male artists. The women artists are placed within a century.[36] The artist may be further placed by nationality or school of work, but inconsistencies abound. Why are different artists in the same pack identified as English, Scottish and British? Sizes of the original work are often missing as are details of the media used.

The information provided is problematic at many levels. One strand, already raised by the quote about the Yoruba, is the way in which the language used reinforces a particular world view. Folens' pack 'Art of Different Cultures' provides an example of this. European 'explorers' discover, claim and annex land,[37] the Japanese seize it,[38] Moslem Arabs overrun it.[39] In the 'Animals' pack, 'A Composite Elephant'[40] is described as a 'company painting' and the information on the card states that these 'were painted for European clients who were connected with the East India Company'. Colonial history is calmly factualised out of existence.

The construction of the category of 'primitivism' needs serious consideration, and

direct challenge, as does modernism's 'aesthetic appropriation of non-western others'[41] particularly as such constructions and appropriations are mirrored throughout the packs. The following quote provides just one example:

> *The term 'primitive art' refers to the art of primitive peoples and should be distinguished from work by 'primitive painters'. Primitive art from Africa and Oceania influenced western painting and sculpture in the early 20th century.*[42]

The relationship between image, information and activity is also extremely problematic. A common practice is to relate activities, including practical art work to the subject matter of the image. This provides suggestions for students' engagement that descend to the random and the banal. What understanding can be gained when Uccello's *Saint George and the Dragon* is reduced to the level of such questions as 'What do dragons think about in their lonely, dark caves?'.[43] Unfortunately this is not a particularly unusual example. Imaginative speculation related to subject matter abounds. Free association relating to the subject matter of an image provides neither knowledge nor understanding. Subject is not the same as content:

> *Analysing the content of an art work requires the consideration of subject, form, material, technique, sources, socio-historical context, and the artist's intention.*[44]

An imaginative response may have its own validity but when related to the subject matter of an image it bears little connection to critical study. Any object could be selected from the art room and used as a basis for speculation and imaginative reconstruction. Practical activities suggested tend to follow the same pattern. One of the activities suggested on the Uccello *Saint George and the Dragon* card is to make a Chinese Dragon for Chinese New Year. Why?

If contextual information is necessary to move from subject to content the cards give little access to such information. Despite the rhetoric of contextualisation used throughout the packs, there is little evidence of an attempt to place the images in context (I would argue that approaches to the images should also be placed in context, which they are not). Indeed, it is difficult to believe that a commonly agreed definition of the term exists. Work is categorised rather than contextualised. This is perhaps the area where teachers are most in need of information, the failure of the packs to provide it has serious consequences for the level of understanding of the works that can be reached.

Palmer's book *Art and Design in Context* is particularly disappointing in that it promises the most, suggesting the possibility of different approaches (although these shift uncomfortably between methodologies and themes), but fails to deliver.

To take an example, under the heading of 'Contextual Studies' under the 'Chronological approach', Palmer suggests that:

> *A chronological study is undertaken so that changes may be appreciated and placed in an historical, cultural, social, religious, political and economic context.*[45]

Here, one of the approaches for consideration is 'the role of women in the family'.[46] This would seem to offer rich possibilities, although it is not clear whether Palmer intends this role to be reconstructed through pictorial evidence, or for serious consideration to be given to the ways in which representation has both reflected and constructed the roles of women, with attention given to who the representations were constructed by and for. The images presented span time, and distance. They include paintings, photographs, a poster and sculptures. Dates are not always given, and no contextual information. What we are left with is a seemingly random collection of images that use the family as their subject matter, and an impossible task, that of historical contextualisation. Unless the teacher using this book is exceptionally well informed, all that is possible (as with the cards) is speculation under the headings that Palmer provides.

I would argue that this situation is exacerbated by the construction of packs, and books, around topics that are thematic at the level of subject matter. Any move toward in-depth considerations of content and meaning would rapidly loosen the thematic ties between the images. With this method of organisation contextualisation becomes an after thought. Serious consideration needs to be given to the forms of presentation we use, and the ways in which the connections we create in linking images reinterpret and shape meaning, and thus have implications for the ways in which students are taught to understand and interpret the world. What is selected shapes understanding, and shapes what becomes reality. What is selected as a significant organising factor affects what we look at and what we see.

Towards a richer understanding

Other methods of organisation are possible. Images that were linked together by an aspect of their meaning might have very different subject matter but would at least be addressing the same issue. Contextual information would then become integral to the construction of the pack rather than an optional addition. Collins, whilst focusing on further education, provides an interesting possibility with his argument for the 'history of art as the history of recurring artistic problem'.[47] He identifies each chain of solutions as a 'form class' and argues that:

> *...the chain of solutions which composes the form-class held by a frame of problematic reasoning cuts cleanly across orthodox classifications of style (formalism) or theme (iconography).*[48]

Dyson, also challenging the traditional focus on formalism and iconography, proposes a different alternative:

> *One such strategy may be based on a calculated and progressive series of compar-*
> *isons of artefacts, images and visual experiences of all kinds: calculated and progres-*
> *sive, since particular comparisons are likely to raise particular questions.*[49]

Price, however expresses a concern that:

> *Dyson's approach could stimulate a level of discussion based on careful observation*
> *of the visually given, but encourage the practice of reading 'from' rather than 'into'*
> *images.*[50]

For Dyson's method to move beyond the 'visually given' the bases for comparison would need to be carefully considered, and contextual issues addressed.

The organisation, and approach of the cards encourage the reading 'from' rather than 'into' images that concerns Price. This is likely to contribute to the situation identified by Hughes where:

> *...a repetitious aping of the superficialities and external details of works of art often*
> *predominates at the expense of prolonged attempts to penetrate the meaning and sig-*
> *nificance of works.*[51]

Approaches that place emphasis on counting activities, or searching the image for particular pieces of evidence are likely to encourage description not deconstruction, knowledge of a particular kind, not understanding. Concern is often expressed about holding students' attention, and activities such as counting or copying are provided as ways to direct the students' attention to the image for longer than a cursory glance. Unfortunately, prolonged attention in itself does not necessarily guarantee the quality of that attention. Neither does it necessarily lead the student on to more qualitative exploration. To attempt to penetrate the meaning and significance of an image to read 'into' rather than 'from', other activities are necessary. Knowledge may be a necessary precursor to understanding, it is not synonymous.

Hughes writes of the emphasis on knowledge in the National Curriculum:

> *Knowledge is seen as more important than skills. The result, as we know, has been*
> *the arbitrary imposition of named periods - a National Curriculum Story of Art.*[52]

This emphasis is reproduced in the cards, as is the National Curriculum's stipulation that students should 'know' about influential artists. I do not, however,

believe that the National Curriculum provides sufficient justification for reducing critical studies to such an impoverished level. To deconstruct the ways in which 'influential artists' are created, or to critically examine:

The thrusts of modernism in art that have emphasised genius, originality and self-referentiality - qualities associated with male development,[53]

may not be precisely the approach envisaged by the writers of the National Curriculum, but it is certainly not proscribed. It would provide students with the 'knowledge' required, and more.

Equally the fundamental conception of a 'National Curriculum *Story of Art*' may be flawed, but in its very representativeness of traditional approaches could form a useful basis for critical activity. It could be placed in context as one approach among many. Garber describes how Carrier,

...proposed teaching a plurality of interpretations of art works to students as expressions of various cultural-historical eras. Sixty-eight interpretations of a Northern Baroque painting by Caravaggio exemplify the ideologies about art that were popular in the era each was written.[54]

Postmodernist argument has provided conceptual freedom from the notion of a single over-arching truth to be discovered, and refined in the march of progress, but multiplicity in itself is not enough. The doctrine of different but equal has its own dangers. Garber extends Carrier's model and argues that:

The critical endpoints at which students arrive need to be dissected in terms of their socio-political ramifications. Students learn to identify and construct critical interpretations cognizant of their ideological implications.[55]

Three levels of knowledge and understanding

These approaches, however, require more knowledge not less. The debates in this area are complex, and their tendency to splinter into what often appears as an argument between the comparative values of knowledge and understanding is not always helpful. I want to propose a three level 'knowledge and understanding' model in an attempt to clarify and place some of the positions held. For the purposes of this model I have defined knowledge as information, and understanding as the ability to internalise and apply that knowledge to give access to, and to create meaning.

Level one

The first level of knowledge is knowledge that may be gained by the student 'about' the piece by their own observations, by following the clues to provide 'evidence' of

their interpretations. Many of the activities suggested in the packs will lead to an increase in this level of knowledge. This knowledge will be mediated by the knowledge and understanding that the students brings with them, and by the ways in which the questions direct looking.

The first level of understanding is that which may be gained by the student from their own interaction with the work. Through intuitive and imaginative response the student reconstructs, for themselves, the meaning of the work by placing meaning on the knowledge gained. There are no right answers, only individual interpretations, and understanding that relates to that individual's knowledge. The activities proposed by the critical studies materials often focus on this level of understanding, and in many cases, where they are unrelated to any knowledge of the work, could not be placed within the model at all.

There is obviously some value to be found in explorations at this level. Students can become aware of their own criteria for judgement, and the ways, and contexts, in which they construct meaning. There are, however, two issues which need to be raised. The first relates to the argument that all opinions are equal. This can be unpacked at many levels, its theoretical underpinning is complex. I want to take just one strand, one that may be typified by Bowden. He states:

> *The teacher needs to emphasise - in order to encourage debate - that the uninitiated can express valid views without 'expert' knowledge.*[56]

Through research, Bowden developed a strategy to 'control and develop the quality of initial debate',[57] a way of moving students beyond closed statements of like or dislike. There are two possible problems with this approach. Bowden points to one when he writes that his strategy,

> *...avoids the transmission of a complex critical model through a formal, chronological art history inappropriate to the typical pupil.*[58]

This moves us directly to questions of access and empowerment. Who is such a model appropriate for? If the model itself is inappropriate but prevalent, then surely all students should have access to its deconstruction. He may provide a useful starting point, as do other similar frameworks, but an unacceptable end, and one to be wary of.

The second issue relates to the fact that, in many cases, the work considered will be the product of a different cultural framework to that inhabited by the viewer. The work may be culturally distant in time or space, or if we accept Taylor's argument that, 'Modern culture, in particular, far from representing 'the art of our time' constitutes a specialist minority culture,[59] then it may also be distant in

terms of social grouping. Intuition and imaginative interpretation may go a long way to understanding work whose symbols and codes are accessible to us but the more distant from our understanding those codes become, the less meaningful our interpretation is likely to be. In the context of post-colonialism, there is also a serious danger that such interpretations will re-enact the imposition and appropriation of meaning to an unacceptable degree. There is no such thing as an innocent eye.

Level two

The second level of knowledge contains information which we could not construct for ourselves. It is the knowledge about the work that is typified by the kinds of information on the cards, name of the artist, date, biographical details, the school of work to which the piece is identified as belonging, etc. It also includes formalist and iconographic approaches (although typically on the cards these are unnamed, and are identifiable as watered down versions of these approaches only with additional knowledge) and traditional chronological art history. The meaning of art developing within and from art. Contextualisation is limited to within the art world. This is the information deemed important by the dominant ideology, information that directs and contains by its particular focus. The National Curriculum's emphasis on periods, and influential artists provides an example of this.

The second level of understanding allows for a basic understanding of content, as opposed to a response to subject. At this level it becomes possible for students to interpret meaning with reference to established artistic conventions (although these may still be inappropriately applied with conventions of one time and place interpreted, unacknowledged, through the eyes of another).

The critical studies materials published reproduce the government's emphasis on second level knowledge at its most basic level, dates, movements, artists. When the emphasis on knowledge is questioned, it is, I believe, the value of this type of knowledge that is being challenged. This is knowledge which is necessary to speak easily about art, to make reference to works, but it is perhaps here that the gap between knowledge and understanding is at its widest.

Rod Taylor's model of content, form, process, mood, would seem to provide an example of what might be achieved at this level, and also of the dangers. Despite his insistence on the importance of contextual knowledge, the examples he provides of students' writing conform to a particular model. They provide imaginative and intuitive responses informed by second level knowledge, but show little evidence of critical distance or awareness of the paradigm that they are working within. It is too easy for this paradigm to turn into the 'right' approach, and limit rather than empower looking, by failing to provide an awareness of alternatives.

Taylor's examples of the students' levels of enthusiasm and engagement are impressive, but what if students do not respond positively to the art work available, if they do not appreciate its qualities? What if they wish to challenge the whole category of 'great' art, and the elitist ideology it could be seen to represent? This level of knowledge gives no access to the issues involved. Swift's identification of positions on cultural identity are of use in clarifying what is at stake. The first two are the:

> *'Naïve' view - the uncritical employment of a mainstream tradition that is essentially Western European in terms of history, definitions and exemplars,*[60]

and the:

> *'Covert-naïve' view - an educational strategy of showing interest in what learners know and appreciate in order to alter it, and enable the unlearned to subscribe to the 'naïve' (or 'hardline') view.*[61]

The 'hardline' view (the third out of six) represents a conscious choice, and the positive pursuit of the cultural values held uncritically in the 'naïve' view. The danger with second level knowledge and understanding, typified by the National Curriculum's focus, the critical studies materials, and teaching that takes place within unchallenged paradigms is that it moves (depending on consciousness and intention) between these three positions, and provides no means for escape. Students are taught to appreciate what is predefined as 'great'. Many of the discussion questions on the packs are to guide students towards this 'correct' appreciation. It is perhaps not surprising that many teachers want to avoid placing too much emphasis on 'knowledge' about works of art, or that an underlying concern might be:

> *...the potential that critical studies possesses for the manipulation and hierarchical ordering of cultural values.*[62]

The second issue here relates to one already raised. If the student's cultural identity often differs from that of the work, becoming an imposition, so does that of the second level approach. The theoretical underpinnings of the framework need to be exposed and contextualised. Unfortunately this approach commonly gives the appearance of giving true access to the meaning of the work.

Level three
The third level of knowledge I want to propose is that which gives knowledge of methods of analysis. It contextualises both the methods and the work in their broadest possible cultural, social, and philosophical terms, and explores the ways in which meanings are constructed. Semiotics and iconology belong at this level.

Second level approaches can, and should, also be reinterpreted at this level. Here are all those aspects which could not be 'known' from the most prolonged individual study of the work, or from confining study to within art itself as a self-referential system.

The third level of understanding enables students to deepen their understanding of content in context, and to start to approach the implications of the ways in which meaning is created. It seeks 'to empower them to make meaning for themselves'.[63] It may be that the original context of the work can never be fully accessible to understanding, but its multiple meanings can be explored, and the students can place their own interpretations alongside these, and be equipped to challenge others and argue for the validity of their own position.

I would argue that it is only the third level of understanding that corresponds to Bateson's definition of education as opposed to training,[64] and that access to this level is not possible without access to the third level of knowledge. Indeed, given the issues of cultural agenda raised by Swift the second level comes dangerously close to indoctrination, and even the first, without the third will be affected by the ways in which students' personal responses are drawn out. Another advantage of the third level is that it might also help to break through students' reluctance to make incorrect interpretations. Here the absence of one 'right' answer is fully exposed, and students could gain confidence through arguing different positions and exploring their socio-political ramifications. Whilst students still believe that 'experts' hold the answers, a belief which does not have to come from the art teacher, then their own interpretations are devalued, and become 'school knowledge' to be paraded to please the teacher, or the examination system, but lacking outside validity.

In this model, I would argue for the second level to be subsumed within the third. It is not necessary to believe one particular approach is 'correct' before learning about the nature of its construction. But without third level knowledge and understanding critical studies is seriously impoverished. Collins argues that:

> *If we allow historical perspectives upon current practices to vanish from the curriculum, then we are indeed guilty of perpetuating an act of deprivation, sensory and intellectual.*[65]

I would argue that to deny students access to 'third level knowledge' constitutes just such an act. This does not mean that third level knowledge always needs to provide the starting point for all activity. Collins, among many others, advocates starting from the students' own work and interests. The first and third levels can interact in a multitude of ways with one another and with the students' own practice. To explore these goes beyond the scope of this paper, but starting from

the students' own knowledge and understanding needs to be seen as a teaching method, not a method for determining the boundaries of the curriculum. It is how we make links and negotiate the journey that is important. If we truly seek to empower our students, it is also vital that we do not predetermine the destination. That is manipulation, not education.

Conclusion

The materials being published matter. Not only do they contribute to the development and perpetuation of worrying orthodoxies, but also they limit us, as teachers, confining us within the limits of our existing knowledge. If critical studies is to develop into a worthwhile practice on a widespread scale 'third level knowledge' needs to be available in the published materials provided for critical studies. Questions of access and empowerment do not only relate to the students we teach.

Originally in the Journal of Art and Design Education, *Volume 14: 1, 1993*

Notes and References

1. This question was taken from Brigg, C., & Penn, A. (1993), *Art Pack: Animals*, Philip Green Educational Ltd., Card no. 12.

2. When the term National Curriculum is used in this paper, it refers to the statutory Orders for Art in England.

3. The National Curriculum uses 'Knowledge and Understanding'. Longman's Art and Design Catalogue 1993 uses contextual studies, art history/appreciation, and critical studies when referring to very similar materials, teachers themselves use a wide variety of terminologies and definitions, and educationalists have provided a variety of frameworks, each with a slightly different focus.

4. Hughes, A. (1993), 'Don't Judge Pianists By Their Hair', *Journal of Art and Design Education*, 12: 3, pp. 279-287, and in this volume.

5. Alternative issues or threads of enquiry could have been explored, and whilst I have tried to select those that have a broad base across many of the materials, a completely different impression could no doubt be given by the selection of different points of focus. My selection highlights what, for me, are currently important areas.

6. I acknowledge the importance of debates relating to students' engagement with original works, but questions of access mean that reproductions will inevitably need to be used. Whilst, with inadequate resources in schools, many teachers use their own collections of books, catalogues, postcards and slides, the packs represent the cheapest way of adding to school resources and providing a range of images for students to study individually.

7. Hughes, A. (1993), *op. cit.*, p. 283, and Swift, J. (1993), 'Critical Studies: a Trojan Horse?', *Journal of Art and Design Education*, 12: 3, p. 229.

8. It is not possible to know without extensive research how much the decisions embodied in these packs reflect the current approach of teachers. However, at least two art advisors and one art advisory teacher were involved with the design of the packs considered (Arthur Penn, County Inspector for Art and Design Education, Gloucestershire, Robert Clement, Art Advisor for Devon and Shirley Page, Art Advisory Teacher, Devon).

9. These included ones which had been sent to the department regularly over the years with materials that had obviously been designed to meet the needs of traditional art history and art appreciation courses. As my intention was to concentrate on those materials that had been produced specifically in response to 'critical studies' I did not include these materials for consideration. I also did not consider video productions as my focus was on printed materials.

The advertising materials and catalogues remaining matched with those materials I was able to obtain access to. The selection considered came from Nottingham Educational Supplies (NES), Longman, Philip Green, and Goodwill, which appear to be the main publishers in this area. In general the materials available from these sources divide into three main areas (teaching packs, print portfolios and postcards, and books). The teaching packs are predominantly A4, although the Clement's and Page pack 'Primary Art' from Longman is A3 and Goodwill's packs use postcards. The Print portfolios and postcards collections (usually giving only the title of the piece, artist, and possibly date) divide into two types. Those that take a particular artist or group of artists as their focus, and those that provide a selection of various works, usually under the heading of a theme. The books divide into those containing images and projects largely designed for GCSE (usually organised under thematic headings), and those that discuss practical and theoretical approaches for the teachers' own use.

10. For this purpose, packs were selected that included a range of artists, contained teaching information, and could reasonably be expected to give examples of work across the spread of areas for consideration. With these criteria, the final selection was based largely on the availability of packs that had been purchased by teachers for use.

11. Thistlewood, D. (1989), 'Critical Studies, the Museum of Contemporary Art and Social Relevance' in Thistlewood, D. (ed.), *Critical Studies in Art and Design Education*, Longman/NSEAD, p. 2.

12. Collins, T. (1989), 'Before the Vanishing Point' in Thistlewood, D. (ed.), *ibid.,* p. 139.

13. DES (1992), *Art in the National Curriculum*, p. 3.

14. Brigg, C., & Penn, A. (1993), *Art Pack: Face's*, Philip Green Educational Ltd, Card no. 1.

15. This term was chosen in preference to the negative 'non-white'.

16. Brigg, C., & Penn, A., *op. cit.*, Card no. 5.

17. Listed on postcard artists and titles leaflet *Texture*, The Goodwill Art Service 1992.

18. Araeen, R. (1987), *From Primitivism to Ethnic Arts*, 3rd text no. 1., pp. 6-25 deals with this issue and it implications.

19. See Appendix 1 for a more detailed breakdown.

20. Hughes, A. (1993), *op. cit.*, p. 281.

21. *Ibid.*, p. 281.

22. Baker, E. (1993), *Primary Art: Modern Artists KS1*, Folens.

23. Taylor, B. (1989), 'Art History in the Classroom' in D. Thistlewood, (ed.), *op. cit.*, p. 105.

24. *Ibid.*, p. 105.

25. Price, M. (1989), 'Art History and Critical Studies in Schools' in D. Thistlewood, (ed.), *op. cit.*, p. 119.

26. Stanley, N. (1993), 'Objects of Criticism', *Journal of Art and Design Education*, 12: 3, p. 331.

27. Taylor, R. (1992), *Visual Arts in Education*, The Falmer Press, p. 34.

28. *Ibid.*, p. 34.

29. Taylor, B., *op. cit.,* p. 103.

30. *Ibid.,* p. 103.

31. *Ibid.,* p. 103.

32. *Ibid.,* p. 104.

33. *Ibid.,* p. 108.

34. Berger, J. (1972), *Ways of Seeing,* BBC & Penguin Books, p. 29.

35. Somerville, J., & Ulph, C. (1990), *Art and Design Resource Packs: Portraits*, Oliver and Boyd.

36. See postcard artists and titles leaflet *Texture*, The Goodwill Art Service 1992.

37. Baker, E. (1992), *Primary Art: Art of Different Cultures KS2*, Folens, pp. 10, 12 & 20. There are other examples throughout the time lines pp. 4-27.

38. *Ibid.,* p. 16.

39. *Ibid.,* p. 8.

40. Brigg, C., & Penn, A. (1993), *Art Pack: Animals*, Philip Green Educational Ltd. Card no. 11.

41. Clifford, J. (1998), *'The Predicament of Culture',* Harvard University Press, p. 197.

42. Clement, R., & Page, S. (1992), *Primary Art*, Oliver and Boyd. Resources Pack Teacher's Book p. 99.

43. Brigg, C., & Penn, A., *Art Pack: Animals*, *op. cit.,* Card no. 12.

44. Atkins, R. (1990), *Artspeak*. New York: Abbeville Press, p. 68.

45. Palmer, F. (1990), *Art and Design in Context*, Longman, p. 13.

46. *Ibid.*, p. 14.

47. Collins, T., *op. cit.*, p. 137.

48. *Ibid.*, p. 139.

49. Dyson, A., 'Art History in Schools' in D. Thistlewood, *op. cit.*, p. 127.

50. Price, M., *op. cit.*, p. 116.

51. Hughes A., *op. cit.*, p. 281.

52. *Ibid.*, p. 283.

53. Garber, E. (1990), 'Implications of Feminist Art Criticism for Art Education', *Studies in Art Education*, 32: 1, p. 17.

54. *Ibid.*, p. 24.

55. *Ibid.*, p. 24.

56. Bowden, J. 'Talking about Art works' in D. Thistlewood, *op. cit.*, p. 93.

57. *Ibid.*, p. 87.

58. *Ibid.*, p. 87.

59. Taylor, B., *op. cit.*, p. 101.

60. Swift, J., *op. cit.*, p. 298.

61. *Ibid.*, p. 298.

62. *Ibid.*, p. 291.

63. Hughes, A., *op. cit.*, p. 287.

64. Bateson's model is discussed in Swift, J. (1993), *On Not Learning from the Past: Constraint or Empowerment in Current Art Education*, in proceedings of the National Research Conference in Art and Design Education, Fribble Electronic Publishers.

65. Collins, T., *op. cit.*, p. 135.

Chapter 6: Universal Themes: Content and Meaning in Art and Design Education

Rod Taylor

Art and life

In the end I do not distinguish science and art, except as methods, and I believe that the opposition created between them in the past has been due to a limited view of both activities. Art is the representation, science the explanation - of the same reality.[1]

The 'same reality' that links art and science is life itself and the world we inhabit. Unfortunately, during the last decade of the twentieth century an imposed National Curriculum elevated the status of science while diminishing the place of the arts to the point where there is the risk of them becoming so marginalised it is going to be difficult for them to recover fully. One still occasionally comes across car stickers informing us 'scientists do it for 20 per cent of the time', while less and less timetabled time is now allocated for the practice of the arts in the vast majority of institutions at all phases and levels of compulsory education. Not surprisingly, morale has never been lower among art and design teachers. However, on secondary art and design in-service training days, a colleague and myself ask teachers to provide justifications for their subject, and though many valid reasons for its inclusion emerge, only rarely does anybody latch onto its importance as a means of expressing and communicating ideas and concepts to do with fundamental birth, life and death issues. This is equally reflected in much of the classroom practice currently taking place. Many adults who 'dropped' art at the age of fourteen can be forgiven for thinking the subject is solely about the elements of art, given the unalleviated diet of colour, line, tone and texture exercises they received. A long overdue change is needed, and the 'Art and Design' document for 2000 placed a welcome emphasis on 'ideas and meanings' and pupils using the elements of art, and materials and processes, 'to communicate what they see, feel and think'.[2]

'Universal themes' and their significance

If art is concerned with life and life issues, this should be clearly reflected in the content and form of the whole curriculum. To my mind, the most obvious and relevant way of achieving this is to construct it around 'Universal Themes'. My book, *Understanding and Investigating Art*,[3] was initially commissioned by the National Gallery, and my brief was to relate National Curriculum requirements to the National Gallery collection. It uses 'Universal Themes' as a basis, with chapters devoted to each of the following major themes in turn:

- The Human Figure: identity and relationships

- Environments: natural and made

- Flora and Fauna

- Events: personal, communal and historical

- The Fantastic and Strange: myth, metamorphosis and dream

- The Abstract: form and meaning

The human figure naturally comes first because we are human; Henry Moore argues that our humanity shapes all our feelings, thoughts and sensations, determines our sense of scale and proportion, and the way we sit, walk and move: If you don't learn from your own body, you'll learn from nothing'.[4] Environments are also vitally important to us. We try to shape our surroundings according to how we want to live, work and play. When we get it wrong, the impact in environmental and ecological terms can be immense. Likewise, we also depend on flora and fauna in all kinds of ways, being part of the same delicate infrastructure and food chain. Events - the first day at school, birthdays, holidays, starting work, the loss of a loved friend or relative - all help shape who and what we are. Their impact on vast numbers of lives ensures major events like wars, plagues, floods, tempests and famine inevitably feature prominently in history books. Periodically, many people feel the need to escape into their inner imaginative worlds. The Fantastic and Strange enables us to communicate with others about this extraordinary world, which ranges from the hilarious to nightmare horrors; the only restrictions are those of our own imaginations. Finally, according to Herbert Read, 'All art is primarily abstract'. An innate human desire to establish order and harmony in our lives equally affects our art. Plato found greater beauty of shape in straight lines, curves and the surfaces of solid forms made by mathematical instruments than in living creatures. Though it is easy to think of abstract art as a purely twentieth century phenomenon, the abstract in art has always existed. Each theme's importance and potential within an art education that has content and meaning becomes immediately apparent even in an outline as brief as this. Each theme is vast and varied and extends from the micro to the macro, and all the works in any gallery or museum collection can be grouped according to them - with inevitable overlaps, of course! The topics and projects that form the school art curriculum can likewise be grouped together round these themes. By using contextualised displays of artists' works, teachers can therefore encourage pupils to see and make connections between art and artists, and what they themselves are doing in their own practice. In the process, a natural ebb and flow evolves between studying art

in galleries, museums, the locality, and reproductions in schools, and the range of practical activities pupils can undertake in relation to them. In the process, all pupils can benefit from an art education which encompasses knowledge, skills and understanding in in-depth thematic projects. National Gallery paintings naturally provide the main focus of my text, and these exemplify important aspects of the Western tradition. Examples are chosen from the different European nationalities and periods represented in that collection, ranging from the medieval to the twentieth century. In order to meet as many National Curriculum requirements as possible, works from the British Museum are also used to 'exemplify a range of traditions from different times and places', and to provide a glimpse of how the themes manifest themselves in the art of the other four continents. Architecture, sculpture, monuments, and signs and emblems in public places are also used to represent the art of the locality. These range from examples to do with civic pride and commemorating major events, to pub signs. As such, they include popular forms of culture alongside 'high art'. The book proposes a model that can be adapted to make use of local galleries, museums and art in public places in any locality or part of the country.

One artist's love of flora

Each theme is worthy of in-depth study, for they all have the potential to shape and influence artists' work in significant ways. The American textile artist Kaffe Fassett provides a fascinating insight into why flora is important to his practice. 'This most joyously universal of themes seems to bring a musical lightness to whatever it graces'.[5] For him, flowers are:

a constantly renewing theme. In knitting I usually treat them in a stylised, flat manner, whereas I use a more realistic and detailed approach in my needlepoint.

He finds their magic in decorations 'eternal', as can be seen in the arts and crafts of all cultures.

The frail, ephemeral quality of a flower amazes me again and again, especially after studying the decorative portraits of them painted on furniture and porcelain, woven and embroidered on fabrics and carved on stone.

The fruits and vegetables 'born of flowers' is another related and recurring theme in decorations, and he is enthralled by Dutch, Italian, Turkish and Oriental paintings of fruits and vegetables. 'I have found good sources of these subjects on dishes, box labels, wrapping paper and reproductions of old still lifes.'

Always on the look out for fresh examples, Fassett surrounds himself with these in his studio. Glancing up from his work to the studio pinboard, the various cards and cuttings that catch his eye include:

A rose on a scrap of linoleum found in a skip, fat Victorian roses decorating a sewing accessories packet, embroidered flowers from Yugoslavia, stylised painted flowers on a Chinese burial paper, and rows of tulips from a Turkish embroidery, knitted as a swatch for a new jacket. There is a lattice of eighteenth-century flowers from a chair back and a delicate painting of Japanese flowers. All these different flower moods, styles and colourings are just a taste of the possibilities to be found, collected and then revitalised...

Resources and critical studies contextualisation

Fassett vividly highlights a number of basic critical studies principles. He is knowledgeable about and enjoys flora in art for its own sake, and this has developed into a lifelong passion that constantly supports and sustains him. In his own work, he draws freely on these art history interests to the point where his knowledge and enjoyment of flora in art, past and present, has become virtually inseparable from his working methods and, indeed, his whole textile work. His use of relevant examples of flora provides a clear, simple contextualisation model. Surrounding himself with examples from different times, places and cultures gives him access to a wealth of reference material with the potential to affect and inform his own work. These examples also range freely across the art, craft and design continuum, include two and three-dimensional examples, and move easily between 'high art' images we might expect to see in gilt frames to bits and everyday examples that are often thrown away without anybody even bothering to give them a second glance.

Since art became a foundation subject in the English curriculum in 1992, a number of art educators have maintained the generalist teacher cannot deal with the knowledge and understanding aspects because of a lack of training in the history of art. These critics, of course, usually have in mind a chronological approach to teaching the history of art, inappropriate though this is for pupils aged five to fourteen. However, while obviously accepting that all teachers should further their own knowledge, contextualisation is already a feature of many aspects of primary school practice. One does not need to be an art history expert to get together a variety of relevant resources for a portraiture project, for example. Profile heads on stamps, and coins, photographs of newsworthy people in papers and magazines, political cartoons etc. are all part of life today, and portraits and self-portraits by artists, past and present, are readily available in book plates, reproductions, slides and on CD-Rom, etc.

The 1992 introduction of art as a foundation subject in English schools, with its critical studies requirements, highlighted not only the absence of existing appropriate resources in most schools, primary and secondary, but the lack of any clear criteria for their acquisition. Each universal theme is an obvious focus around which to build a relevant resource bank. It makes sense, for example, to have one on the human figure. This can include every available image of people to provide

as rich and in-depth a picture of the human figure in art as possible, but it can also sub-divide into sections appropriate to every human figure project in the curriculum. Reference has already been made to portraiture but there could be a specific self-portrait section within featuring a range and variety of self-portraits to support a 'Me, Myself' project requiring the pupils to reflect on who and what they are. Other sections could address group relationships, bodily forms and rhythms to do with action and movement in dance and sport, etc. In other words, the resources for each theme can sub-divide into groups in support of each practical project to do with that theme. Over a reasonable time-span, examples from different periods, cultures and continents can be acquired, offering pupils at least a snapshot of the theme in art across different times, places and cultures. Any school using these approaches can start to reconcile immediate needs with longer-term requirements.

Gallery and museum visits

Fassett goes on to recall 'one amazing day' from his youth. He was taken to the Victoria and Albert Museum by a friend. He discovered under one roof, 'carpets, embroideries, jewelled boxes, Indian miniatures, costumes and fans of many ages, highly decorated musical instruments and, most exciting of all to my eye, room after room of beautifully patterned china'. He returned again and again, spending hours alone sketching anything with a pattern, 'and the V&A was one large storehouse of them'. He has continued to use this stimulus right up to the present day. He highlights the initial excitement that 'captured' him and the long-term significance that can arise from one key formative gallery or museum visit.

Fassett was introduced by a friend. For the majority to benefit likewise, though, it is essential that schools take on this commitment. Though the National Curriculum makes desirable noises about gallery visiting, unfortunately no positive entitlement statement was ever made. One visit each key stage only amounts to three in nine years between the ages five to fourteen. Considering how important gallery visits are, this would have provided an eminently achievable entitlement minimum had the necessary commitment been made.

The motivating impact of seeing art works in the original can have on even the youngest child is sufficient justification. The late Ted Roocroft's 1991 exhibition at the Drumcroon Education Art Centre in Wigan included numerous pig sculptures. A family visited early one evening, the father carrying a seven-year-old daughter, the mother holding the hand of her ten-year-old sister. The elder child had been mithering to visit, but only because the younger one had already been. The father explained that at the meal table for a week she had talked about nothing but wallowing and farrowing sows and saddleback pigs. 'We've never heard her use words like that before!' The elder sister was fascinated; her young sister was already on the first rung of a ladder Fassett has spent his life climbing - perhaps one day fauna will motivate her artistic practice as profoundly as flora does his!

Breadth and balance using universal themes

Many students by post-sixteen level have identified the field of study they feel is most significant to them, devoting most of their time to work within this area. Ideally, though, this choice should grow out of a full awareness of the range of options and possibilities open to them, as opposed to what they feel secure with born of ignorance. For example, during a recent university-based in-service training day, three final-year B.Ed. art students admitted they had never studied the human figure. Asked why, they explained that whenever figure drawing took place at school they chose the option - drawing a pot plant. As a consequence, they now saw the human figure as a daunting challenge. They were specialising in flora for negative reasons. Equally important, if the majority of pupils who do not study art beyond key stage 3 are going to find it meaningful in adult life, they must experience a broad and balanced education up to age fourteen.

To Leonardo, the painter who is not universal 'is not worthy of praise', and to qualify as 'universal' must possess wide-ranging skills. It is a poor artist who:

> *... makes only a single figure well. For do you not see how many and varied are the actions performed by men alone? Do you not see how many different animals there are, and also trees and plants and flowers? What variety of mountainous regions and plains, of springs, rivers and cities with public buildings, instruments fitted for man's use; of diverse costumes, ornaments and arts? All these things should be rendered with equal facility and perfection by whomever you wish to call a good painter.*[6]

To stimulate the imagination, he recommends looking at walls splashed with stains, stones of mixed colours, ashes in the fire, clouds and mud. He advises on how to treat fantastic events like tempests and deluges, and, though he belongs to an era prior to 'abstraction', emphasises that we get 'intense pleasure' from paintings that have beautiful proportions 'like a musical chord with different notes sounded all at one time'. The artist's vision and skills should, in other words, encompass all the universal themes. In an age of ever-increasing narrow specialisation, we no longer embrace this concept of 'universal artist', but what Leonardo advises is still relevant to everybody involved in planning primary and secondary school art curricula.

All six themes should therefore not only be built into school courses but should reappear on as regular an ongoing basis as possible. Some are presently more neglected than others. During a series of seminars in different local authorities, current schemes of work covering the five to fourteen age range showed, for example, that in some pupils' educations the human figure went missing for five years, from when they were eight to thirteen. When asked why, every teacher, without exception, said they did not realise it had. Nobody said this was because

the human figure was an inappropriate subject for pupils of that age range! The human figure had simply disappeared by default.

An approach to curriculum auditing

A constructive way forward, therefore, would be for every school to identify what opportunities they are currently providing for the study of each universal theme. What activities involve the human figure, for example? Are these for all pupils, or are some optional? When, where, how and why do activities relating to each theme occur? How regularly is each theme revisited? Does any undue repetition occur? Do projects adequately take account of, and build upon preceding ones? Are the activities relating to each theme sufficiently varied, and in total do they add up to as challenging and rigorous a course as the school can offer? Is there scope to improve any of the projects or activities currently on offer within any one or, indeed, each of the themes?

Such a curriculum audit, focusing on each theme in turn, provides a clear overview of the place each currently occupies in the curriculum, highlighting where some predominate and where any are treated inadequately, neglected or dealt with too spasmodically. In order to deal with each in sufficient depth, and in ways that fully encompass knowledge, skills and understanding, there is an obvious need for projects to be of several weeks' duration. If approximately half a term is allowed for projects, each theme can be revisited annually. Longer time-spans obviously facilitate two or more themes being addressed within one project. A curriculum structured in this way makes it more possible to build in gallery and museum visits, location work involving use of sketchbooks, ongoing use of contextualised displays as well as the basic teaching of essential practical skills and activities.

A Year 8 project case study

One high school, for example, chose 'Victor and Vanquished' as the title for a Year 8 project designed to make use of that year's Sainsbury's reproductions into schools. The art curriculum already included the use of universal themes. One reproduction was Poussin's 'Triumph of David', which shows David with Goliath's head on a pole as part of the victory celebrations. Another was Stubb's 'Cheetah and Stag with Two Indians'. The pupils were encouraged to study both these reproductions from the standpoints of content, form, process, and mood, working together in small groups, and making notes. They visited Manchester City Art Gallery to actually see Stubbs' painting. While there, they sought out and studied other works appropriate to their Victor and Vanquished' topic. Captioned displays of predatory animals with their prey and of human beings in conflict situations, including other art works of David and Goliath, ranged from twentieth century examples to prehistoric cave and Egyptian wall paintings as well as including examples from non-Western traditions and cultures

Objective work included drawing the teacher's cat, sketching domestic pets and studies of other pupils in poses that emulated the body language of predatory or hunted animals. All this information informed their subsequent work in clay and two dimensions. They worked with an animalateur sculptress, studied Stubbs' anatomical drawings of horses, stuffed animals, skeletons, etc. They thought about how the topic affected their lives and was reported in that day's newspapers - bullying, a stalker and his victim, the conflicts in Bosnia and Northern Ireland, winners and losers in sport, etc. Some pupils, influenced by Stubbs' anatomical drawings of horses, constructed predatory animals in half-relief, starting with ribs, ribcage, skull, etc., then adding layer on layer until finally arriving at the outward appearance of the animal. Others build surrealistic models in which the topic was treated in a role-reversal manner. Others, working in groups, produced large format paintings and collages of winners and losers at football. The project dealt with a wide range of issues that profoundly affected the pupils because they found them relevant to their own lives, and the rigorous ways in which their practical skills were developed could clearly be assessed.

Reanimating the practical curriculum

Critical studies approaches like these can help reanimate the practical curriculum in exciting ways. To mark the Millennium, an exhibition about 'Time' was held in Greenwich. It included Titian's *Allegory of Prudence,* a triple portrait showing the head of a youth, a middle-aged man and an identifiable portrait of the artist in old age. A great deal of school portraiture involves pupils drawing or painting the person sitting opposite seen frontally.

The Titian comprises one frontal portrait and two profile views. In total, they can be seen as a potent kind of time-based autobiography that can stimulate a child to ask: What am I like now in terms of outward appearance, temperament and personality? What was I like five, six or seven years ago? How, if at all, have I changed? What will I be like in ten or fifteen years' time? Such a project involves the pupil in observing, remembering and imagining and, at its best, art work of this kind can parallel with the most potent kinds of written autobiography the English curriculum can generate.

In an art context, pupils can be encouraged to grapple with interesting - but often neglected - artistic concepts like expressiveness, idealisation, distortion. Meanings can be amplified by introducing a thesaurus into the art room for use by both teacher and pupils. In the process, practical and verbal concepts can develop hand in hand, emphasising how 'communication' as a National Curriculum key skill takes on a dual significance in art contexts. Once content and meaning are introduced through approaches of this kind, it is inevitable that 'pupils' spiritual, moral, social and cultural development'[7] are promoted in art and design, in keeping with the new requirements about learning across the curriculum.

Conclusion

'Universal Themes' help bring content, meaning and significance back into art and design education. When I chose the title 'Understanding and Investigating Art' for my book about these themes, I was consciously choosing words from each of the art attainment targets in operation then. I was emphasising the role of these themes in bringing together the practical, theoretical and historical aspects of the subject. The introduction of a single profile art curriculum underlines even more the need for the kinds of integrated approaches that can flow from their systematic usage. These approaches can ensure all pupils benefit from an art education that has practical rigour, develops communication skills and is meaningful in the way it addresses moral, spiritual, social and cultural values by means that are relevant to the pupils' lives and are informative about life in general. Such an approach is long overdue, but its immediate introduction could help activate a positive rebuilding process - essential if art and design education is going to reassume its rightful place in the curriculum. Sufficient amounts of time must then be found to enable pupils to immerse themselves in a subject that is so multi-faceted and meaningful it can be of lifelong significance to everybody.

Originally published in Education *3-13, 2000*

Notes and References

1. Read, H. (1943), *Education through Art,* London: Faber and Faber, p. 11.

2. QCA (1999), *Art and Design: The National Curriculum for England, Key stages 1-3*, London.

3. Taylor, R. (1999), *Understanding and Investigating Art: Bringing the National Gallery into the Art Room,* London: Hodder & Stoughton.

4. Reede, J. (1985), *Arena*, BBC2.

5. Fasset, K. (1988), '*Kaffe Fasset at the V&A: Knitting and needlepoint,* London: Century Hutchinson Ltd.

6. Richter, I. A. (1977), *Selections from the Notebooks of Leonardo da Vinci,* Oxford University Press.

7. Richter, I. A. (1977), *ibid.*

Chapter 7: Critical Discourse and Art Criticism Instruction

Originally published in the *International Journal of Art and Design Education*, Volume 19: 1, 2000

George Geahigan

Introduction

Art criticism can be understood as a form of studied discourse, as a mode of inquiry, and as a discipline or field of inquiry.[1] Although all of these concepts are relevant to the design of curriculum and instruction, criticism for most educators in the United States has come to be equated with critical discourse: 'talk, spoken or written about art.' The model of criticism proposed by Feldman is typical of many in the literature.[2] In his model, criticism is broken down into a number of discrete steps or stages - description, analysis, interpretation, and evaluation - which students proceed through in a linear fashion.

The pervasiveness of such models and their widespread acceptance as representations of what art criticism is and should be raises questions about the nature of critical discourse and the practicality of these models as guides for classroom instruction. In this article I argue that such models present a distorted picture of the actual talk or writing of critics and, if followed, lead to an unworkable method of instruction: namely, classroom recitation. After discussing the problems inherent in recitation as an instructional strategy, I conclude by suggesting that critical inquiry rather than critical discourse is a more fruitful concept for structuring classroom instruction.

The emergence of art criticism in the educational literature

Interest in art criticism arose with the general curriculum reform movement of the 1950s and 60s where it was seen as a promising approach for bringing about an understanding and appreciation of art, learnings that had been widely neglected during the preceding Progressivist era.[3] During the decades that followed, educators sought to arrive at an understanding of the nature of criticism, principally by appealing to analyses of critical discourse in the writings of aestheticians.

Although it is sometimes difficult to identify precisely the sources that individual educators used in formulating their models of criticism, it is likely that most relied upon such works as Beardsley, Osborne, Stolnitz, and Weitz - all influential studies in the philosophy of criticism during the immediate post-war period.[4] In basing

their theories of criticism upon such studies, educators conceptualised criticism as a linguistic activity having a number of stages or phases, usually identified with a specific kind of critical statement.

Speech act theory and critical discourse

Although educators focused their attention upon different types of critical statements in formulating their models of criticism, little attention was given to the concept of a statement itself. What, then, are critical statements? Contemporary philosophers now look upon them as specific types of acts that people perform in uttering or writing words and sentences. The idea is most closely associated with the work of the philosophers J. L. Austin,[5] and J. R. Searle.[6] Their views about language, however, are now widely accepted by others. In the technical terminology employed by contemporary 'speech act' theorists, statements have come to be identified with the class of illocutionary acts.[7] These acts are customarily distinguished from acts of speaking or writing (utterance or locutionary acts) on the one hand, and acts performed when one affects someone through speaking or writing (perlocutionary acts) on the other.

Some further observations about illocutionary acts can help shed light on the nature of critical discourse. Illocutionary acts, first of all, can be performed in uttering or writing a single sentence or a larger stretch of discourse. A description, interpretation, or evaluation of a work of art, for example, might be given in a brief sentence or it might extend over several pages of text. Within a complex illocutionary act there may be many different kinds of statements which, if looked at individually, might be characterised in terms of some other kind of illocutionary act. An extended description, for example, might contain a value judgment as one of its components. Illocutionary acts such as describing, analysing, interpreting, and evaluating are also rule-governed.

In order to perform these acts successfully, speakers have to follow certain conventions or rules. These are internalised by native speakers in learning a language, and allow native speakers to both recognise an utterance as a specific kind of illocutionary act and to sense when these acts are successfully performed. Thus, they not only regulate the performance of the act but they define the act as well. It is only by specifying the rules intrinsic to a given illocutionary act that one can individuate that act from others.

Eliciting these rules, however, is not easy. It requires philosophical analysis and an examination of different contexts in which an act is performed. Part of the difficulty of identifying relevant rules comes about because different principles of distinction are needed for different types of acts. Illocutionary acts can differ in their point or purpose, in the relationship of the speaker *vis-à-vis* a hearer, in the expression of different psychological states, in the intended perlocutionary effect, and in other

ways as well.[8] All illocutionary acts have a point or purpose, however. Acts of criticising are what Searle calls 'assertives'.[9] Their point or purpose is to convey knowledge (describing and analysing), understanding (interpreting and explaining), and the value or worth of something (evaluating and judging).

Educational models of criticism as representations of critical discourse

Contemporary speech act theory presents an immensely more complicated view of language than that held by aestheticians at mid-century. In presenting their theories of critical discourse, these philosophers operated with only a rudimentary conception of the nature of language. They, first of all, only recognised a mere handful of different statements. Contemporary philosophers, by way of contrast, estimate that there may be upwards of a thousand different types of illocutionary acts in the English language.[10] Because most of these are a common part of everyday speech, they will be found in the ordinary discourse of practising critics.

Aestheticians at mid-century also misrepresented the nature of critical statements. They lacked a clear understanding of how critical statements were to be individuated from one another. Instead of defining such illocutionary acts as description, analysis, interpretation, and evaluation through an explication of their underlying rules, they frequently stipulated technical meanings for these terms or appealed to other illocutionary acts to convey their meaning. For example, analysis was sometimes defined as a form of description, interpretation as a form of explanation, and evaluation as a form of judgment. Sometimes several different illocutionary acts were used as synonyms for a specific kind of statement. Weitz, for example, uses 'report,' 'tell,' 'remind,' 'enumerate,' 'analyse,' and 'compare,' as synonyms for the term 'description'.[11] Even though these concepts may be related, it is now generally recognised that all of these are distinct types of illocutionary acts: one is not a synonym for another nor is it likely that one can be treated as a general category that would subsume another.[12] The net effect of all of this was to leave educators with a radically oversimplified and distorted view of critical discourse. What are the implications of this for instructional practice?

Translating art criticism into classroom instruction

In formulating their models of criticism, educators for the most part seem to have assumed that the typologies of critical statements embodied in their models would be followed by students when confronting works of art in the classroom. But what kind of instruction would this imply? Despite widespread references to dialogue and discussion in the literature, current models of criticism are clearly inadequate as representations of this sort of classroom discourse. One reason, as we have seen, is that ordinary English is made up of an enormous array of illocutionary acts. The typologies of critical statements in current models of criticism encompass only a few of the huge number of statements that one could reasonably expect to be made

when students and teachers speak to one another about works of art. Another reason is that dialogue or discussion does not proceed in a step-by-step fashion. These forms of classroom discourse are dynamic, fluid, and unpredictable.

There is in fact only one plausible way of interpreting current models of critical discourse: not as recommendations for class discussion, but as recommendations for another traditional method of instruction, student recitation. Recitation, unlike discussion, is a structured form of talk or writing in which the student proceeds in a linear fashion through a series of discrete steps or stages.[13] Whether educators actually intended their models of criticism to be construed in this way is something of an open question. (In my view, educators simply have not recognised a distinction between discussion and recitation as separate types of discourse.) Nevertheless, if students are to follow the models as presented, this is the kind of instruction that would result.

Recitation as an instructional method

How adequate is a recitation approach to art criticism? There are three types of problems with recitation, problems that make it ultimately unworkable as an instructional strategy, these are as follows:

1. *Problems in sorting classroom discourse*

One of the working assumptions underlying a recitation approach is that when teachers request a given type of critical statement, students are, first of all, able to understand and to comply with this request and, second, that teachers are able to classify the statements made by students. Presumably students and teachers are able to do these things after learning the definitions of critical concepts embodied in current models of criticism. But, as we have seen, educators in borrowing stipulations and erroneous definitions given by aestheticians actually misrepresent the nature of critical statements. There is, thus, a potential source of confusion between the intuitive understanding which students and teachers have of these statements and the explications of these statements embodied in current models of criticism.

Consider the problems that might arise over the technical meaning of 'description' which educators have borrowed from philosophers. This sense of 'description' is equated with utterances that convey objective facts about a work of art. It specifically rules out language that is emotive or value laden. But the fact of the matter is that descriptions in ordinary language often have little to do with objective facts and often do involve emotive language. A teacher who requests a description and relies upon the technical meaning of 'description' given in many models of criticism might conceivably penalise a student who relies upon his or her

intuitive (and correct) understanding of what description is in speaking about a work of art.[14]

Erroneous definitions in many models of criticism give rise to further problems. Consider the possible confusion that might arise when a request for a description can be satisfied either by a description or an analysis, when a request for an interpretation can be satisfied either by an interpretation or an explanation, or when a request for an evaluation can be satisfied either by an evaluation or a comparison. Teachers and students are likely to talk past one another, not really communicating at all.

If teachers and students are able to communicate intelligibly about critical discourse, it is probably due more to their own intuitive understanding of such concepts as describing, analysing, interpreting, or evaluating than to any definition embodied in some model of criticism. But this gives rise to further problems because there are no clear and definite boundaries to these concepts. A given utterance, for example, might hover on the border between two or more of these concepts making it difficult to classify it as a single type of illocutionary act. Many utterances that are interpretive in nature, for example, might have an evaluative overtone and thus straddle the semantic space between interpretations and evaluations. It is also difficult to classify illocutionary acts because complex illocutionary acts often contain different types of simple illocutionary acts as their components. Thus, a student might well make an evaluative or interpretive statement as part of an extended description of a work of art, or an interpretive statement might be contained within an extended evaluation.

We know very little about how teachers actually handle such communication problems. Because of their lack of philosophical sophistication and the low priority given to teaching art appreciation, most probably muddle through communication problems by simply sliding over any that arise. However, all of this does not negate the fact that it is much more difficult to actually structure classroom discourse along the lines recommended in current models of criticism than educators have realised.

2. The inability to make critical statements

A second assumption underlying a recitation approach to criticism is that students are able to make critical statements simply through exposure to a work of art. Speech act theory also calls this assumption into question. Performing illocutionary acts, as we have seen, always presumes a context of need on the part of some audience and the ability to fulfil this need on the part of the speaker or writer. In the case of critical statements, the need is for certain types of knowledge, understanding, or determinations of value. In order for speakers or writers to fulfil

this need they must have the appropriate expertise. This presents no problem for certain kinds of statements but it does for others. For example, when students are asked to describe a work of art they will generally be able to acquire the appropriate knowledge simply through viewing the work of art (knowledge by acquaintance). Making interpretations, or evaluations, however, is quite another matter. Making the former type of statement presumes that students understand a work of art; making the latter, that they possess relevant criteria. Neither of these things is automatically acquired through observation.

Consider the problems that inevitably arise in making interpretive statements. By their very nature, recitation models of criticism imply a formalistic aesthetic. Formalism is a view that treats the work of art as a self-sufficient entity and assumes that a viewer can gain an adequate understanding of a work of art through careful scrutiny of the work, i.e., without recourse to information about the artist or the context in which a work of art was produced. That there is such an assumption underlying many models of art criticism seems readily apparent, for classroom recitation, in and of itself, makes no provision for students to move beyond the work of art in order to acquire information about the artist or to study the cultural context surrounding a work of art.

In recent years, aestheticians have come to dispute this view. They argue that much of the meaning of a work of art resides in the artist's intentions (goals) in making it. Seeking to determine what an artist intended, they contend, is a fundamental way of coming to understand a work of art and, thus, a central concern of critics. In pointing this out, current theorists have reaffirmed the relevance of biographical and contextual information to critical practice. Students who lack such a background and are denied access to an artist's intentions may not be able to offer an interpretation of that work.

3. *Unwanted side effects*

Recitation along with lecturing is among the oldest and most widely used methods of instruction. It is not surprising that teachers have welcomed procedures for talking or writing about works of art. They provide a clear and easy way of structuring lessons on art criticism. Yet recitation also has some widely recognised failings as an instructional method.[15] In using recitation, first of all, teachers impose a procedure for criticising a work of art. In doing so, they limit and shape student response. Experiences with works of art are complex and not easily sorted into separate components. Procedures for responding to a work of art invariably ignore some aspect of this experience, whether it be the emotions of the student, a concern with the intentions of the artist, an interest in the context in which a work of art was created, or some other aspect of a student's experience. If students

are to be led to a genuine appreciation of art, teachers need to respect the totality of their experience.

In imposing a procedure teachers also ignore what is immediately relevant to students in their encounters with works of art. Teachers who have held discussions about works of art with students, for example, frequently find that their immediate preoccupations are, not with what is in the work of art itself, but with how other students have reacted to the work. Most current models of criticism, on the other hand, require that students initially focus on some aspect of the art object itself. In following some mechanical procedure, teachers are likely to find that the vital interests and concerns of students have been ignored.

In relying upon procedures for criticising art, teachers may also inadvertently foster attitudes and habits that are inimical to genuine involvement with works of art. When only one student is reciting, the attention of other students is likely to wander. Teachers need to consider methods of involving the whole class in thinking about the work of art. Teachers may also become so preoccupied with teaching students the mechanics of some procedure for criticising that attention is diverted from experience with the work of art itself. It is the experience with a work of art that is of foremost importance, not the manner in which one speaks or writes about it. Finally, in asking students to follow some procedure teachers may also be training students to focus their attention only upon certain aspects of a work of art, inadvertently fostering dogmatism and rigidity. Instead, teachers should cultivate an openness to experience, a heightened attention, and a willingness to reflect upon one's initial impressions of a work of art. These are the attitudes and habits that will most likely promote future involvement with works of art.

Beyond recitation: conceptualising art criticism as disciplined inquiry

In the preceding sections I have described how an appeal to mid-century aesthetics led educators in the United States to focus on critical discourse in constructing models of criticism for the schools. Such a focus inevitably leads to a reliance upon recitation as an instructional strategy. In examining the limitations of such models, I show how a recitation approach to art criticism is ultimately unworkable. How, then, is art criticism to be conceptualised for educational purposes? In thinking about art criticism for the classroom, I would argue that it is best construed, not as a form of discourse, but as a form of disciplined inquiry.

Although talk about inquiry has been part of the rhetoric of art education for many years, educators have yet to fully grasp the implications of this concept for the practice of criticism. Many treat the models of critical discourse given in the literature as models of critical inquiry but the two concepts are quite distinct. Inquiry means to investigate, to search for knowledge, information, and the like,

while talk or writing refers to a linguistic activity, to the use of language. Disciplined inquiry, unlike everyday problem solving, grows out of an historically developing area of investigation and involves the pursuit of certain traditional intellectual or practical goals. In the case of the discipline of criticism, this involves investigation into the meaning and value in works of art.[16]

In other writings I have argued that this investigation should be carried on by means of three types of instructional activities: personal response to works of art, student research, and concept and skill development.[17] Because inquiry begins with what the philosopher, John Dewey, calls a problematic situation,[18] the first type of instruction would present students with problems of meaning and value by confronting them with contrary opinions and judgments about a work of art, by having them compare and contrast related works of art, and by exposing them to provocative and controversial works of art. In the second type of instruction students would be asked to acquire biographical and contextual knowledge through their own independent research projects. And in the third type of instruction, students would be taught relevant concepts, principles, and skills.

Such an approach to art criticism differs in fundamental ways from the simple procedures for talking or writing embodied in current models of art criticism. In contrast to such approaches, it does not assume that students can adequately understand or judge a work of art through observation alone. Instead, it assumes that works of art present problems of meaning and value for the student. Second, it does not rely simply upon exposure to the work of art for student comprehension. Instead, it recognises that students may need to be taught concepts and skills, and that they may need to go beyond the confines of a work of art in order to seek background information. And third, it does not rely upon a single method of instruction. Instead, it countenances the legitimacy of many kinds of instructional activities including class discussion, lectures, and other modes of teaching and learning.

Notes and References

1. Wolff, T., & Geahigan, G. (1997), *Art Criticism and Education,* Champaign, IL: University of Illinois Press, p. 141.

2. Feldman, E. B. (1967), *Art as Image and Idea,* Englewood-Cliffs, NJ: Prentice-Hall; Feldman, E. B. (1970), *Becoming Human through Art,* Englewood-Cliffs, NJ: Prentice-Hall.

3. See Munro, T. (1956), 'Adolescence and art education' in *Art Education: Its Philosophy and Psychology,* Indianapolis, in Bobbs-Merrill; Broudy, H. (1951), 'Some duties of a theory of educational aesthetics', *Educational Theory,* 1, pp. 190-198; and Barkan, M. (1962), 'Transition in art education: Changing conceptions of curriculum content and teaching', *Art Education,* 15, pp. 12-27.

4. Beardsley, M. (1958), *Aesthetics: Problems in the Philosophy of Criticism,* New York: Harcourt Brace and World; Osborne, H. (1955), *Aesthetics and Criticism,* London: Routledge and Kegan Paul; Stolnitz, J. (1960), *Aesthetics and the Philosophy of Art Criticism: A Critical Introduction,* Cambridge, MA: The Riverside Press; Weitz, M. (1964), *Hamlet and the Philosophy of Literary Criticism,* Chicago: University of Chicago Press.

5. Austin, J. L. (1962), *How to Do Things with Words*, New York: Oxford University Press.

6. Searle, J. R. (1968), *Speech Acts: An Essay in the Philosophy of Language,* Cambridge: Cambridge University Press; Searle, J. R. (1979), *Expression and Meaning,* Cambridge: Cambridge University Press.

7. Actually, philosophers now consider stating, itself, to be a specific kind of illocutionary act, rather than a generic term that covers all illocutionary acts.

8. See Searle, J. R. (1968), *Speech Acts: An Essay in the Philosophy of Language,* Cambridge: Cambridge University Press, p. 70.

9. Searle (1979), *op. cit.*

10. See Austin, J. L. (1962), *op. cit.*

11. Weitz, M. (1964), *op. cit.*, pp. 229-237.

12. This second claim is more controversial because philosophers, themselves, are not certain whether there are general and subordinate classes of illocutionary acts.

13. For a discussion of the distinction, see Hyman, Ronald T. (1974), *Ways of Teaching,* Philadelphia: PA. J. B. Lippincott.

14. For a discussion of this problem, see Geahigan, G. (1999), 'Description in art criticism and art education', *Studies in Art Education,* 40: 3, pp. 213-225.

15. For a discussion of these failings, see Thayer, V. T. (1928), *The Passing of the Recitation,* Boston: D. C. Heath and Co.

16. For a detailed discussion of the differences between criticism as discourse and as inquiry, see Geahigan, G. (1998), 'From procedures, to principles, and beyond: Implementing critical inquiry in the classroom', *Studies in Art Education,* 39, pp. 293-308.

17. For a fuller discussion of these instructional activities, see Wolff, T., & Geahigan, G., *op. cit.*

18. Dewey, J. (1933), *How We Think,* Boston: D. C. Heath and Co; Dewey, J. (1938), *Logic: The Theory of Inquiry*, New York: Henry Holt and Co.

Chapter 8: Critical Enquiry in Art in the Primary School

Sue Cox

Introduction

Knowledge and understanding of the work of artists is a relatively new aspect of the curriculum for many primary school teachers. Before its formal inclusion in the National Curriculum Art Orders, it may not have been given much attention and may still be an aspect of the art curriculum in which some teachers in England lack confidence. The question arises as to how to go about teaching this area.

In developing the art curriculum, there is clearly a need to respond to developments in thinking in the field of knowledge and the art agenda.[1] In this article I consider the teaching of 'knowledge and understanding' in the light of developments in art theory, illustrating how theoretical principles can be related to practice. I develop my argument by looking at the work of one teacher, Caron Ementon, who is very committed to teaching primary age children about the work of other artists. My intention is to suggest some procedural principles for teaching children about the work of other artists which are consistent with developments in art theory. These principles can provide an approach to critical enquiry in the classroom that is educationally enriching, since they make it possible for children to relate to the work of other artists in ways that are appropriate to their own level of development, and also lay the foundations for later learning. They provide the foundations of procedural knowledge not only for interpreting art works, but, ultimately, for understanding contemporary art theory itself. The metacognitive dimension of critical enquiry, implicit both in the theory and the concomitant processes of learning described, opens up rich possibilities for developing critical thinking.[2]

The context

This article arises out of my interest in exploring the place of art in the development of children's thinking and learning, which has led me to carry out investigation in classrooms, including that of Caron, a graduate in the history of art. During the investigation in her classroom, Caron and I had different roles. Her concern was to develop her own teaching strategies in this area. My focus was on developing a theoretical framework in which to locate and justify the practice. Although these might appear to be quite different spheres of research activity, in fact, there was a difference in emphasis only - the teacher's work implicitly reflected and demanded consideration of theoretical issues and my own theorising was contextualised by the practice in this particular classroom. This relationship

has much potential for developing classroom practice in that it contributes to an iterative process of developing understanding within our personal spheres of activity as classroom teacher and university researcher.

Critical enquiry in the classroom: procedural principles within a theoretical framework

Taylor[3] suggests that we must approach the whole area of critical studies with children with caution. He argues that modernist painting, for example, makes sense in terms of ideology and history rather than what is visually given, implying that an understanding of modernist work based only on what is perceived by the observer is inadequate. Since anything more may be beyond children, it may be inappropriate to introduce them to such work. This kind of thinking implicitly invokes the theoretical position of contemporary art criticism, which challenges conventional, modernist conceptions of art and therefore challenges the assumptions we might make about teaching about art.

Modernism[4] has been the dominant Western aesthetics for much of the twentieth century. Within Modernism, conceptions of art, derived from expressionism[5] and formalism[6] were merged together into the overarching view that the necessary conditions of art are its formal qualities which express or induce subjective experience or feeling. These orthodox ideas have constituted a prevailing common-sense understanding of art and, arguably, it is this kind of common-sense view that has informed approaches to art education.

These ideas, however, have been challenged in recent decades by some artists, critics, theorists and historians who argue that whatever is meant by 'art' it must be seen in the context of representational practice. The term 'representational', here, has a much broader meaning than the life-like, illusionistic rendering of 'reality' that might be its common sense meaning. Rather, what and how works of art 'represent' is understood in relation to the historical, cultural, social and ideological contexts in which they occur. Modernism's critics contend that the work of an artist makes sense in relation to a particular context or paradigm - even when it is challenging it - or makes sense differently in relation to another context in which it is being appraised.

When art is seen as a representational practice, bounded by particular parameters, there is no place for the idea that art contains 'eternal truths free of class and time and the conviction that art is somehow 'above' society or out of its reach'.[7] The Modernist idea of a transcendent aesthetic, common to all 'art' of all times and places loses its hold. To paraphrase Victor Burgin, all artists and critics have an inescapable relationship to a given history. Thus, critics contest the Modernist view that significance is intrinsic to form. They deny the existence of absolute quality or incontrovertible significance, which the attuned receiver of the work will

necessarily experience. On the contrary, they argue that the significance of form is conferred ideologically and culturally. Burgin, for one, rejects the idea of:

> *...an instantaneous and complete communication based on rapport rather than cognition. Such an idea leads to an emphasis on the intrinsic form of the art object itself, and the relation of the viewer to the form, rather than on the relations between object, viewer and the world in which both are situated.*[8]

The implications of these challenges to conventional theories is that we cannot assume unproblematic recognition of what is represented, nor can we assume there is 'quality' art which, if experienced, will evoke an appropriate response. How works of art are defined, produced and interpreted will depend on complex sociocultural factors.

Thus it seems that the skills of critical literacy need to be clearly understood and explicitly taught to children. This has already been pointed out by Buchanan for example, who argues that such skills are rarely taught in art and design.

> *All too often, art and design objects - paintings and drawings, items of craft and designed artefacts and products - are used superficially to examine technique or style, rather than meaning or content. Children learn to paint like Van Gogh yet know nothing about the meanings he tried to communicate or the context within which he worked: they make pastiches of Egyptian Art without insights into its symbolic, ritualistic and representational meanings.*[9]

He suggests that critical literacy - 'the ability to read images and decode meanings and intentions' entails the ability to question, decode, critically appraise and evaluate artefacts to reveal meaning, values and beliefs. This approach acknowledges the need for contextual understanding which is recognised by those such as Taylor.[10] Moreover, I would argue that we need to take on board the metalinguistic level of contemporary art theory. The second order discourse it entails[11] - the development of languages for exploring the paradigms of art and the way they are generated and sustained - would seem, ultimately, to be a central aspect of art education.

As teachers, we are faced with several difficulties. If we act within the framework of current theory, teaching critical literacy is no longer a matter of extending children's ability to decode so-called 'representational art' to an ability to respond to 'non-representational' art. This requires uncritical induction to the Modernist aesthetic which itself has been called into question. Indeed the distinction itself turns out to be false. The critics of Modernist ideas have argued that, even though it might seem to be a matter of common sense to separate works which appear to 'resemble' the world of fact from 'abstract' work which appear to have no such

referents, it is mistaken to assume that abstract art is 'non-representational' and that figurative work is not, in some sense, abstract. Both abstract art and so-called 'representational' art use the symbolic systems of a culture or subculture to 're-present' meanings. Frascina[12] discusses what he considers to be a key text by Schapiro to explain the misconceived distinction:

> As Schapiro implies, painting is a practice of representation. Artists work within changing systems and codes, as do practitioners of other disciplines. These systems and codes are the means by which people represent some kind of cognition of their world. Individual works of art, therefore, do not provide transparent 'illusions' of 'reality' or of the 'world' but constitute determined and produced allusions to it.[13]

It is implicit in the critiques of modernism that there is no unmediated perception of a 'real' world - the way we see is shaped by the way we think, and this is influenced by ideas, beliefs and values. As Burgin says: 'As perception is held in cognition, so cognition is held in ideology'.[14]

If children do not possess the prerequisite cognitive abilities for understanding contextual issues, in anything more than a superficial way, it might seem that experiencing the work of other artists may have little educational value. There is the added practical consideration that non-specialist teachers may have insufficient contextual knowledge themselves.

In the light of these perceptions, there is clearly a need to avoid teaching approaches which might trivialise the works, or provide inappropriate initial encounters that will distort children's future experience of them. It seems to me that the challenge that exists is to develop forms of critical enquiry that, in the light of current critical insights do not *close off* opportunities for children to be able to realise, *eventually*, first, that what seem to be 'givens' in the way in which art is made and the way in which we understand and value it are derivative from a particular conception and, secondly, that the origins and significance of such conceptions are explicable in cultural and social terms. The implicit metacognitive dimension to the understanding of art requires that children ultimately learn to think about how we think about art. We need to enable children to challenge their preconceptions in responding to and interpreting art.

An exploration of Caron's practice with her class of Year 5 and 6 children (who come from mixed socio-economic backgrounds in an ex-mining community) might begin to suggest how this might be achieved. I observed her teaching in this area over a series of sessions and the following represents the characteristic features of her practice. An underlying factor to acknowledge is that Caron had a firm, personal conviction that children should experience and enjoy the work of other artists and was not just fulfilling National Curriculum requirements. In her

own words, she believes 'that this will enrich and broaden their lives and ensure that art is not an elitist area closed to them in later years.' I intend to show, through my analysis, how these espoused principles are realised and how the principles implicit in her practice can be related to the principles inherent in current art theory.

Initially Caron's practice focused on whole class interaction which entailed:

- Sustained, extensive periods of concentration on selected works - Caron focused the children's attention on the range of visual features in the work in the sense of 'looking for clues'. She maintained their attention by peeling away the layers of a work, challenging the children to see beyond what was immediately apparent.

- Questioning the children intensively - the children were asked to say what was happening in, say, a picture, in a fairly literal sense, but were also asked to look closely at the forms within it and to offer possible views on what they signified.

- Engaging the children in dialogue - the exchange between teacher and pupil typically involved response to what had previously been offered; ideas were developed and challenged. Conversation was developed out of the questioning.

- Providing a certain amount of contextual information - Caron's personal knowledge about the context of the work; information about the biography of the artist; the social milieu in which he or she worked and the kinds of concerns to which the artist may have been responding were included to illuminate the children's readings of the work rather than an as an end in themselves. The children were also encouraged to research and use such information themselves.

- Encouraging children to consider multiple readings of the work - all the above strategies were used to support the children in offering a range of interpretations. They were encouraged to suggest the possible meanings in a work; to consider alternatives and to extend their initial ideas.

- Valuing a range of meanings - children's ideas were taken seriously. Idiosyncratic responses were welcomed.

- Asking the children to explain and justify their readings - children were asked why they had offered a particular reading to support their views with evidence and reasoning.

Analysis of these descriptive characteristics suggests a range of implicit theoretical principle:

- That critical response depends on a close, in-depth, sustained reading of the work. Neither looking nor interpreting is an instantaneous process; both require opportunities for reflection. The work of other artists is to be given serious consideration.

- That 'reading' a work is a complex process. The diversity of possible meanings, justifications and the effect of the contextual information on the range of readings that could be constructed, indicate that the process is problematic. It is not simply a matter of looking and recognising, but of seeing. The knowledge, information and experience brought to the work makes multiple meanings possible. Making different connections between parts and the whole; between contextual information and visual features, between what is perceived in the work and what is known about codes used in other works reveals how form yields meaning in complex ways. It is to be noted that the cognitive emphasis is not construed in opposition to feeling. Emotional meanings are as much dependent on the knowledge and experience the individual brings to the work as any others.

- That the meaning of a work is not transparent. There is no single, definitive meaning. Interpreting is a matter of *constructing* meaning, rather than *extracting* meaning.

- That the reading given to an image can differ according to who is appraising it and in what context; children's own meanings might differ from each other's and from the teacher's. There is a relationship between meaning and context.

- That meanings given to a work do not inevitably match the intentions of the artist. Inferences about the artist's intentions are influenced by the knowledge and experience the viewer brings to the work, including understanding of the context within which the artist worked.

Further developments that Caron made in her practice extended the ways in which these theoretical principles were played out in practice. Caron had become concerned that through the whole class teaching situation, in which she inevitably assumed authority in the eyes of the children, she might unintentionally be privileging certain readings over others, and that these might be considered the 'correct' ones by the children.

She decided that setting up independent work in small groups might generate a

wider range of readings and might enable the children to challenge each other more directly. It became clear from observing the group work that they had learned about the process of interrogating the art works from Caron. The interactive sessions which were led by the teacher had provided the procedural model for their own discussions, which demonstrated many of the features of those sessions. Certainly it would seem that extended involvement in the practice of critical enquiry, modelled by the teacher, had enabled the children to acquire some of the requisite skills and, possibly, some understanding of its procedural principles.

Conversations between myself and three of the children provided further evidence of the way in which they engaged in the kind of critical enquiry I have described. In what follows I focus on some specific aspects of this evidence. My intention is to interpret, in their particularity, some of the children's responses to illustrate and develop my argument.

At this point the children were comparing a painting by Vermeer, 'The Love Letter' with Van Gogh's 'Starry Night'.

T: [looking at the Van Gogh] This is nice 'cos you can see all the lights and the houses and the church in it.

M: Cos it's more wild an'...

T: Free

M: Rather than...

T: Yeh. Not sort of... jammed in a can (comparing here with Warhol's print of a soup can which they had looked at previously). It looks all free like it's flowing everywhere.

R: I'd say - with that (the Van Gogh) - that one's free. It can go anywhere - it looks like it can go anywhere. It can be painted as big as it wants to be - whereas that one there (the Vermeer) it's just like - caught - in just one thing. It's not wild or anything. Like a glimpse of something just to look at - it's like looking through that door there and seeing a diary. Someone's just looked through it and painted it. The thing is that's not going to be everlasting, that position, (the Vermeer) whereas that could be, that one (the Van Gogh). That looks - the sky is going to stay similar all the time, but that's - them people are going to move, so that's why it's just like - caught - in one position, all the time - but that looks like it'll move...

It was apparent that these children were more interested in the Van Gogh than the Vermeer. Although there are, in some sense, contradictions in what R. is saying, he seemed to me to imply that the Vermeer, in contrast to the Van Gogh, captured a particular moment in time. All the children unhesitatingly suggested that this was a result of style ('how it's done') rather than content.

When I went on to suggest that some people might find the Vermeer more interesting because of the level of detail and information and the possibility of reading a story into it, R. in particular rejected the idea, claiming that 'you could find more' in the Van Gogh.

For him, especially, it was as if the Vermeer was too literal to provide the kind of meaning he wanted. The children had a strong reaction to the Van Gogh. They responded to the lack of detail and the freedom of the brushwork - they did not need such detail to be able to read content into the painting. They found that the Van Gogh yielded more for them in spite of an ostensible lack of direct information of the kind available in the Vermeer.

This search for interpretive possibilities beyond what is immediately obvious to them was illustrated widely throughout the conversation from which I have quoted. They consistently made references to their interest in what is 'in' a work and in looking 'into it' in order to find it.

The reasons given for preferring the Van Gogh have some congruence with Barthes' distinction between 'readerly' and 'writerly' texts. Whereas the 'readerly' text presents a fixed view of the world that the reader is intended to passively receive, the 'writerly' text invites the reader's active participation in the construction of its meaning. Barthes subverts the idea that language - the text or artefact - necessarily *corresponds* with external reality. The assumption that illusionistic art mirrors an external and independent reality rests on the Platonic conception of the existence of an external world that is distinct from our apprehension of it. The alternative view, which is found, for instance, in the writings of Derrida[15] is that reality itself is actively constructed through social and cultural practices; through discourse. Language - and thus art - do not reflect reality so much as structure it. For Barthes[16] also, the idea that there is a single, definitive meaning for any text or work of art, conferred by the author (or artist) gives way to playful interpretation and multiple meanings produced by the 'reader'. As Eagleton explains:

The realist or representational sign, then, is for Barthes, essentially unhealthy... The sign as 'reflection', 'expression' or 'representation' denies the productive character of language: it suppresses the fact that we only have a 'world' at all because we have a

language to signify it with and that what we count as 'real' is bound up with what alterable structures of signification we live within.[17]

It does seem that these particular children's concern was to identify the visual - or iconic - features of the painting. Other children in the class had explored the symbolic or narrative content of the Vermeer. This painting, one of several on the 'letter' theme which the artist painted, is rich in imagery that is open to interpretation. It is potent with symbolic features and the postures and expressions of the two figures add further dimensions to the relationship between them and the story of the letter. In this sense it is a 'writerly' work. But these children chose to focus on what is iconically represented 'in' the work. In this respect, the Van Gogh is more 'writerly' and the children preferred it. There was an indication here that they were not content with a familiar way of looking - in which they are uncritical subjects, objectively viewing what the painting presents. R.'s apparent dissatisfaction with the 'framing' device of the doorway which determines the 'point of view' of the viewer, ('a glimpse of something just to look at'), seemed to confirm this. Instead, they were looking for more involvement - seeing what they see as what they put into it; going beyond the frame, in both a literal and metaphorical sense.

It has to be said that both these children, who responded to the painting in terms of visual content, and others who responded to its narrative content, were, nevertheless, seeing the painting as a picture they were interpreting what it depicts. This drive to construct meaning in terms of what is depicted was illustrated again in the same conversation. When faced with the work of Kandinsky the children found it frustrating that they couldn't find what was in the work:

M, R & T: [together] It's irritating cos you think there's got to be something in it. But there isn't is there? It's quite - distressing when you can't find anything.

They did try out a wide variety of imaginative possibilities suggested by the shapes and colours:

T: looks like cats to me - that's a cat's head - look - there's its eyes - it's looking to the side and there's its whiskers.

R: That looks like a massive eye and there's a smaller one and there's a mouth and a chin and a head.

There was some response to colours and shapes and other formal properties of the painting. M and T for example, compared it to other artists' work - M, for example,

liked Jackson Pollock because it was colourful. However, the possible significance of the formal properties of Kandinsky's work, in relation to the cultural codes that produced the modernist aesthetic, escaped them, of course. They did not have, and could not be expected to have, the contextual understanding that would have helped them to make sense of the work as a Modernist painting. Their interest was in giving meaning to the formal structures in terms of their existing knowledge of the world.

In referring to the theoretical critiques of Modernism, I suggested that the distinction between figurative and abstract works can be deconstructed - there is no necessary division between figurative and abstract works in terms of their being more and less 'representational'. These divisions are only apparent in relation to the codes which govern intention and style. Claims to the incontrovertible existence of this distinction rest on a particular culturally situated conception. I cannot argue that the children's responses here show that they have acquired any understanding of these ideas. Rather they seem naturally to endorse the distinction. However, this does not undermine my argument. On the contrary, the children's responses are consistent with current theoretical insights. Their ideas can be explained in terms of their own situatedness within a particular paradigm. Their inability to make sense of abstract work reflects their existing familiarity with particular codes and practices.

As one might expect, the children did not engage with the ideological issues. What, it seems, they have been given the means to do, however, is to go beyond what might be immediately apparent to them in terms of their existing preconceptions. They responded to the 'writerly' qualities of the Van Gogh. In the discussion about the Kandinsky they agreed on a preference for work where there was 'something to find out' - though, to use their own way of describing it, not too 'obvious'. T., for instance, referred to Picasso: 'when people muck around - it looks stupid... like there's nothing in it - but Picasso - it looked like he'd mucked around, but there was something in it that you had to find. This one [Kandinsky] he's mucked around so much that there's nothing you can find in it.'

This was again evident when they discussed Andy Warhol's screen print of a Campbell's soup can. Once again, there was insistence on the need to find something 'in' the piece of art. They read the work as a copy of a soup can, but 'realistic' similitude was not enough. 'Hidden' meaning which they could construct for themselves was the apparent preference. Moreover, the children's conversation indicated their awareness of different ways of being an artist and communicating meaning. They considered the validity of Warhol's print within their own frame of reference, but were questioning the boundaries of this at the same time. For instance, they reflected on the artists' intentions, suggesting that Warhol might be 'wanting to get people annoyed', and that Picasso's paintings 'look strange because

he thinks like a painter.' They questioned the status of Warhol's copy - but also of Van Gogh's 'copy' of the sunflowers, perhaps challenging some of their own assumptions:

R: Yeh... cos that's like saying when we make the wrapper that's a piece of art cos it's the same as what he's painted - he hasn't had none of his own ideas, he's just picked up the can and gone - oh, this looks nice. I'll paint that.

M: Well, if you're saying that, well what about the people, like Van Gogh, who painted the sunflowers - that's not art then, he's just copied the sunflowers.

They were looking consciously and critically at their own conceptions, clarifying and challenging the criteria which define them, again indicating that their thinking was beginning to acquire a metacognitive dimension.

Conclusion

I have suggested that those procedural principles I identified as implicit in Caron's practice can be taken as defining features of a process of critical enquiry that are logically compatible with the constructs of 'new' art criticism. I have provided the illustrations above to show how the children's learning resulting from the process relates to these constructs. My reading of the children's responses suggests that they are engaging with the idea that the codes and meanings of an art work are not fixed. They are willing to interact with the work to construct meaning for themselves. Furthermore, they are beginning to think about their thinking, to engage, at this stage at a naive level, in the kind of second order discourse in which contemporary art theory is framed. Whilst the children were clearly responding within the parameters of their own experience and knowledge, what is important is that the nature of the enquiry process, in which they are engaged, facilitates this emergence of understanding of the plurality of codes and systems and, potentially, as the children's existing knowledge expands, of their causal conditions. They might readily be brought to question why the received canon of works is largely that of male, Western artists.

The process is, over-ridingly, one of open-ended enquiry. This means that the child's emerging understanding is not closed off by common sense theories derived either from the Realism that Modernism claimed to be replacing or from the delimiting conceptions of Modernism. These theories may well be informing a child's interpretations, through the way in which the child absorbs the established and possibly dominant ways of practising, identifying, valuing and responding to art within the experienced culture and these interpretations are legitimate in that context. However, crucially, the kind of critical enquiry that I have identified ultimately defies closure. It embodies a set of principles which enable the child to progressively deepen the enquiry as greater powers of understanding and more

knowledge is acquired. This will not so much be a matter of 'progressing' towards a 'truer' understanding of art through acquiring a Modernist sensibility to form (as Modernist theory would have it). Rather, their experience of critical interpretation is 'scaffolded' by the enquiry process to provide for a transition to understanding that those codes, meanings and definitions are framed within different cognitive paradigms. The process allows children to see the plurality of possible meanings; how the meaning of a work is constructed by those appraising it, who are themselves subject to a wide range of influences.

Arguably, these procedural principles can be put in place whatever the children's existing intellectual levels and however limited their contextual knowledge. Likewise, they can be applied by generalist teachers with varying levels of knowledge. (The value of such knowledge, however, is not denied and would need to be developed if the child is to progress at a later stage to a deeper level of understanding.) The process suggests the possible development of a new kind of common sense consistent with current art theory - a metalinguistic framework through which all responses can, ultimately, be seen to be grounded in historical or ideological paradigms, which can themselves become an object of enquiry.

My concern has been to identify the procedural principles embodied in the critical classroom enquiry I observed and to demonstrate, from my own interpretive standpoint, their significance in terms of the theoretical principles inherent in contemporary art theory. Potentially, the process can enable children, in years to come, to participate in the second order discourse of that theory itself, as well as enabling them, in the years of their primary education, to experience art in the pluralistic ways that this kind of thinking opens up.

Originally published in the International Journal of Art and Design Education, *Volume 19: 1, 2000*

Notes and References

1. Swift, J., & Stanley, N. (1999), in *Directions*, special issue of *Journal of Art and Design Education*, 18: 1.

2. Although I do not directly discuss the way in which the experience of other artists' work informs children's own work, I must point out that there is no intention that understanding art works should be developed solely for its own sake.

3. Taylor, B. (1989), 'Art History in the Classroom: a Plea for Caution' in Thistlewood, D. (ed.), *Critical Studies in Art and Design Education*, Longman/NSEAD.

4. Greenberg, C. (1961), 'Modernist Painting' - reprinted in Harrison, C. and Wood, P. (1992), *Art in Theory 1900-1990*, Oxford: Blackwell.

5. Croce, B. (1921), *The Essence of Aesthetic,* (trans. Ainslie, D.), Heinemann.

6. Bell, C. (1914), *Art*, Chatto and Windus, 1935; Fry, R. (1920), *Vision and Design*, Chatto and Windus, re-issued 1981, Oxford University Press.

7. Rees, A. L., & Borzello, F. (1986) (eds.), *The New Art History,* Camden Press.

8. Burgin, V. (1986), *The End of Art Theory. London:* Macmillan.

9. Buchanan, M. (1995), in R. Prentice (ed.), *Teaching Art and Design: Addressing Issues and Identifying Directions*, London: Cassell.

10. Taylor (1989), *op. cit.*

11. Baldwin, M., Harrison C., & Ramsden, M. (1981), 'Art History, Art Criticism and Explanation', *Art History*, 4: 4, December 1981 reprinted in Frascina, F. (1985), *Pollock and After - The Critical Debate,* Harper and Row.

12. Frascina, F. (1985) (ed.), *Pollock and After - The Critical Debate,* Harper and Row.

13. Schapiro, M. (1937), 'The Nature of Abstract Art', *Marxist Quarterly*, 1: 1, January 1937 reprinted in Schapiro, M. (1978), *Modern Art: 19th and 20th Centuries*, Chatto and Windus.

14. Burgin, V. (1986), *op. cit.*

15. Derrida, J. (1990), *Writing and Difference,* (trans. Bass, A.), London: Routledge.

16. Barthes, R. (1977), 'From Work to Text' in *Image, Music, Text,* essays selected and translated by Heath, J., Fontana.

17. Eagleton, T. (1983), *Literary Theory: an introduction*, Oxford: Blackwell.

Chapter 9: Art and Worldview: Escaping the Formalist and Collectivist Labyrinth

Lesley Cunliffe

Through art we can know another's view of the universe - (Proust, Maxims)

Introduction

The first section of the chapter deals with the theoretical issues involved in understanding how worldview, culture, meaning and artistic styles relate to each other. The second section of the chapter describes and illustrates some strategies that can be used in the classroom to explore artistic style in relationship to context and meaning. The two parts are inseparable because all practice is theory-laden, and all theory is informed by practice. Those who claim to work outside theory deceive themselves, making it all the more necessary that theory is explicitly formulated and rigorously tested. Otherwise practices become inert and blinkered, and suffer from being informed by inadequate theories, which in turn impoverish the art curriculum. In Panofsky's words:

> *It has been rightly said that theory, if not received at the door of an empirical discipline, comes in through the chimney like a ghost and upsets the furniture.*[1]

This chapter attempts to bring some order to the house of art education so that the place of critical and contextual studies can be better established.

The older modernist paradigm of formalist aesthetics, basic design education and the associated approach that understood tradition as an impediment likely to inhibit the development of students' art should have disappeared in secondary education. However, this cluster of attitudes and associated practices is still quite pronounced in secondary school art curriculum and pedagogy, despite the statutory requirement in the National Curriculum, and the further requirement of GCSE and 16+ assessment objectives to deal with meaning of works of art in relationship to their historical and cultural context. Given this is the case, why do critical and contextual studies continue to be the poor relation of art education? One reason is the lack of time given to this aspect of the curriculum at all levels of education, denying art teachers the opportunities to develop a good range of subject knowledge in this area, and the appropriate teaching strategies to make this knowledge effective in the classroom. The problem is also exacerbated by conceptual confusion for dealing with critical and contextual studies at both the theoretical and practical level, so that theory-in-action and action-in-theory are rarely combined to develop a curriculum and pedagogy consistent with new

paradigms for art education, all of which emphasise the importance of critical and contextual studies, and the role that declarative knowledge plays in such curricula.[2]

The idea of the autonomous artwork promoted by formalism, and the related notion of art as an autonomous practice that has its origins in romantic ideas about creativity and which was reinforced throughout modernism, still courses through the veins of most art educators in the United Kingdom. This chapter is written to challenge this outlook as it gives an inaccurate and misleading picture of how artistic style emerges within a specific historical and cultural setting, and the related way individual artists appropriate artistic schemata, which in turn becomes the building blocks for their own style. If this were not the case, then we would flounder at understanding why styles in art change in response to a modification in social and cultural conditions and the related worldview. It will be argued that art practices are relational rather than autonomous; an irreducible feature of wider cultural processes in which art influences and is influenced by the cognitive style of given communities and traditions.

Accepting that this is the case can potentially lead to a view opposite to that of the autonomy of art, what Gombrich[3] describes as the collectivist methodology that he traces back to Hegel's influential idea of the spirit of the age that has influenced much art and cultural history. This chapter offers an alternative approach to, on the one hand, the autonomy of formalism and individualism derived from modernism and romanticism, and on the other, the collectivist approach derived from Hegel. The chapter attempts to chart a position somewhere between these two extremes, in which cognitive styles result from wider conversations and practices that are open but constrained, that provide individual minds with the necessary knowledge, skills and insights to become members of communities of practice which, in turn, provide the necessary means to change such practices. For any analysis of worldview, meaning and style in art has to tread a careful path between collective and individualistic explanations of cultural change in favour of a reciprocal and complementary relationship between the two.

Art and meaning: some theoretical considerations

Contrary to what formalism asserts, art is inextricably woven into the fabric of life, with the mosaic of meaning that make up the worldviews of different communities. Artists cannot help but be participants in such communities, although the nature of their participation varies from one historical and social context to another. Formalist aesthetics denied this in favour of a pure, uncontaminated aesthetic experience. Clement Greenberg, the father figure of formalism dogmatically stated that:

> *Visual art should confine itself exclusively to what is given in visual experience and make no reference to anything given in other orders of experience.*[4]

This prescription for making and responding to works of art fails to account for the fact that visual responses to art cannot be isolated from other sense modalities:

> *To attend to an event means to seek and accept every sort of information about it, regardless of modality, and to integrate all the information about it as it becomes available.*[5]

Mind is cross-modally integrated, making synaesthetic relationships fundamental to artistic understanding in that they form a major aspect of metaphorical thinking that underpins meaning and values in art.[6] Formalism is a denial and betrayal of this idea, a voluntary withdrawal of visual responses from other sensory modes, isolating the way art creates metaphorical meaning that is a part of sustaining the cultural life of communities. When formalist methodology is used in education this results in divorcing art from its background cultural meaning, and the potential of such art to metaphorically suggest a way of life, a worldview, a way of taking action in the world. In contrast, Wolterstorff argues that:

> *Works of art equip us for action. And the range of actions for which they equip us is very nearly as broad as the range of human action itself. The purposes of art are the purposes of life. To envisage human existence without art is not to envisage human existence. Art so often thought of as way of getting us out of the world, is man's [sic] way of acting in the world. Artistically man acts.*[7]

Worldview and art

Art then, along with other aspects of culture, is a way of working out our lives in the world, of projecting meaning about reality that equates with a worldview. This is true for both art that operates as ritual and art that belongs to the avant-garde tradition aimed at challenging and contesting worldviews. The ability to conserve and contest is made possible because the person has acquired certain plastic controls from tradition that locate and make sense of artistic practices.[8] There is no alternative to this state of affairs. Banborough comments thus:

> *In every sphere of enquiry the learner may come to question what he has been taught, but when he does so, he is appealing to what he has been taught as well as against what he has been taught.*[9]

To challenge existing representations of reality is to attempt to project alternative insights into meaning and acting in the world.

The relationship between visual and cognitive styles and cultural processes

Any attempt to make art is dependent on the available methods, technologies, materials, symbolic codes, and cultural pressures and processes. Style in art is the

interface between materials, methods, and wider cultural influences, the combination of which create certain artistic styles for relating form to content, making artistic styles are metaphorical ways of representing and transforming cognitive styles. In Wolfflin's words, 'not everything is possible in every period'. Abstract expressionism could not have flourished in Renaissance Italy because the commission took priority over the autonomy of the artist's decisions and feelings about their work. The central purpose of Renaissance practice was to evoke the right values in the audience by creating the appropriate visual effect rather than authenticity of expression. The cultural climate that created the cognitive style of Australian Aboriginal art did not produce the necessary conditions to allow, for example, the emergence of a realistic code that typifies the old-Western tradition, which needed generations of artists to overcome the complexities of representing three-dimensional space on a flat surface. The emergence of this more critical tradition that valued innovation was not as securely established in other cultures because the art was so enmeshed in rituals that any change in style would be seen as a threat to the entire religious worldview. Unlike the Western tradition, where religious values exerted a strong influence in the development of a realistic form of representation, in Aboriginal Australian culture there was no equivalent pressure to develop such a code.

Technology can play an important role in the emergence of new styles, as it opens up new possibilities for matching materials and techniques with values. The invention of oil paint allowed northern European artists to create fine-grained visual codes, which, in turn, made their representations of sacred events more convincing for their communities. Artists and patrons of the time understood such biblical stories as historical, and realism as a visual code was consonant with this idea. Artists came under increasing pressure to match the fidelity of description of biblical narratives in new forms of preaching of the time with fidelity in visual representation, as though the viewer was an actual 'eyewitness'[10] to the sacred event. The emphasis in Christianity on historical events unfolding in time provided cultural pressure that influenced the cognitive style for the choice of realistic codes that emerged in the fifteenth century.

> *Most fifteenth century pictures are religious pictures. This is self-evident, in one sense, but 'religious pictures' refers to more than just a range of subject matter: it means that the pictures existed to meet institutional ends, to help with specific intellectual and spiritual activities. It also means that the pictures came within the jurisdiction of a mature ecclesiastical theory about images.*[11]

In the nineteenth century, impressionism was made possible by the invention of tube paints, so that working out of doors became more convenient. The emergence of photography was equally important as it provided artists with a new visual schema for representation, that of grainy, blurred, and randomly cropped imagery

of the new urban environment. However, it was the cognitive style of positivism that created the philosophical climate that motivated artists to reject the salon tradition of art in preference for painting their sense-impressions. The use of broken and bright colour with broad brushstrokes was a way of metaphorically portraying the transience, movement and excitement of material reality. All these elements did not come about by accident but emerged as a cluster of decisions related to crisis of subject matter, style and representation that arose in nineteenth century France. In England, a similar crisis in values, subject matter, and style, came under an alternative set of plastic controls, which in turn lead to different solutions based on forms of historicism.

Cultural forces, change, and the logic of situations

Countless other examples could be given to support the way artistic styles relate to cultural forces. Popper[12] has tried to offer a method for understanding cultural and social changes by what he calls 'the logic of the situation', by which he means being able to reconstruct a feasible course of action that a person or group might have taken in solving a problem or realising an aim within a cultural context. Gombrich uses Popper's method to show that Freud's interpretation of Leonardo's painting of *The Virgin and Child with St. Anne* is highly improbable because it ignores the logic of the situation in which the work was made. Freud's psychoanalytic speculations about the Oedipal motivation behind the work is connected to Leonardo's illegitimate birth that, in effect, resulted in him having two mothers, which Freud thought was echoed in the composition where Mary is represented sitting on St. Anne's lap. Gombrich's alternative explanation is argued from the perspective of knowledge of the genre in which this work was made and the associated logic of the situation, where representing St. Anne involved placing Mary in her lap. Leonardo's composition reflects this tradition. This explanation is given further support by the fact that the city of Florence commissioned the work, and St. Anne is their patron saint.

As well as criticising Freud's inadequate factual knowledge about this painting,[13] Gombrich raises a general objection to the psychoanalytic concept of over-determination, a term used to describe the many factors that might influence or determine an action. According to this theory, works of art are determined by many causes, which can create different entry points for meaning. These many causes are complex, but interpreting of works of art should be centred on knowledge about the genre, the working practice of the artist, and other aspects related artwork's purpose within the logic of the situation. Gombrich draws on the idea of the logic of the situation as a way of demarcating plausible and logical explanations from speculative and irrational theories for historical events, artistic style, and meaning of works of art. Any interpretation that seems implausible in relationship to the logic of the situation could then be rejected.

The history of taste and fashion is the history of preferences, of various acts of choice between given alternatives. The rejection of the Pre-Raphaelites of the academic conventions of their day is an example, and so is the Japonism of art nouveau. Such changes in style and the prestige of style might be described [but hardly exhaustively] in terms of 'will-to-form': no one doubts that they are symptomatic of a whole cluster of attitudes. But what matters here from the point of view of method is that an act of choice is only symptomatic of something only if we can reconstruct the situation. The captain on the bridge who could have left the sinking ship must have been a hero; the man who was trapped in his sleep and drowned may also have been heroic, but we shall never know. If we really want to treat styles as symptomatic of something else [which may, on occasion, be very interesting], we cannot do without some theory of alternatives. If every change is inevitable and total, there is nothing left to compare, no situation to reconstruct, no symptom or expression to be investigated.[14]

Popper developed the method of the logic of situation as a way of combating the Hegelian dialectical method for explaining social and cultural change as the outworking of spirit. The spirit of the age is an impersonal force that influences artists to express themselves in terms of the spirit of their time rather than acting as individuals or groups by making choices about how they will create art. For this reason Gombrich makes a distinction between periods and movements. The former use of a category he attributes to Hegel's influence, as a period implies cultural unity consonant with a spirit of an age, whereas movements can exist in parallel and be contradictory, which would be inconsistent with the idea of the spirit of the age.

The Hegelian notion of spirit working towards ever-increasing stages of progress and development, what Popper describes as historicism, has created a mindset in art education that is detected in the way the word 'relevant' is used to suggest that some ways of working are more suitable for our own time than others - a view that is supported by appealing to the idea of change culminating in a particular kind of contemporary practice. This begs all sorts of questions, most notably the question about how anyone knows what is relevant for this age? To know what is relevant suggests a god-like, privileged view of history and style. Hegel's idea that history is goal directed, with progress understood as the equivalent to a law of nature, is detected in this form of thinking, which has the added, built-in advantage of self-validation that history is progressing towards the correct goal as understood by the latest form of art practice.

Alternative explanations for creativity and change in art
The alternative to Hegel's collectivist explanation for the emergence of style and change in art, as already touched on, which has dominated modernist practice, is the romantic legacy of the autonomous, creative individual whose psychological

processes and creative energy somehow manage to exist outside social and cultural reality.

> *Those who have taken the mentalist and individualist turn in their epistemology are strongly tempted to picture the self very much as the autonomous bearer of mental or spiritual properties. The social and historical surroundings in which the individual has any thoughts or feelings in the first place are unconsciously played down.*[15]

Margaret Thatcher's famous remark that there is no such thing as society is very close to the way art educators have taught their subject. Abbs'[16] rediscovery of an old insight, that plagiarism is a better explanation for creativity seems to be much nearer the mark than the popular misconception, replicated at all levels of art education, of the self-expressive isolated ego. In reality, and this is why creativity as a form of plagiarism is a better starting point in that it implies the social element of imitation, we can only be ourselves by belonging to communities.

> *Modernism postulated a pure, essential reality in which each self absolutely was itself, without any admixture of otherness. Yet self cannot be known without an other to establish its boundaries [without not-A there is no A]; so otherness becomes a necessary correlate of self, something that self is never encountered without. Seeking the other, then, one seeks what constitutes one-self by negative implication.*[17]

The way that social forces influence individuals continues to be debated. Harré[18] attributes personal being to what he describes as the conversation. Foucault[19] puts forward discourse theory, which is an attempt to understand cultural reality by analysing relationships as inscribed in a series of 'texts'. As a method it provides a way of exploring works of art and conceptual content by investigating their multi-dimensional range of background influences. Wittgenstein's later philosophy also maps the relationship between the social and individual:

> *How can one describe the human way of behaving? Surely only by sketching the actions of a variety of human beings as they interweave. What determines our judgement, our concepts and reactions, is not what one man is doing now, an individual action, but the whole hurly-burly of human actions, the background of which we see any action.*[20]

An explanation for style and content of works of art would need to take account of this hurly-burly of background, human actions and the related factors like materials used in the work, the evidence of taste and fashion, the importance and perceived relevance of the ideas being communicated, the function of the work, the viewing context, collective prestige as a result of the work being made, the geographical impact of weather and use of local materials, economic factors, the role and practice of the artist, new technology, as well as moral and metaphorical

values that different styles generate, represent, or evoke. These moral reactions can either be approving or repugnant. What is clear is that works of art operate within a multi-dimensional matrix of meaning that needs to be addressed in any attempt to do justice to the meaningfulness of critical and contextual studies.

The methodology of modernist art education of formalist aesthetics, self-expression and basic design education were all attempts to achieve a pure, universal and aboriginal form of visual experience and language, and despite the availability of alternative art curricula, their legacy continues to have a detrimental effect on the importance of critical and contextual studies, which continue to be played down. The point worth remembering is that everyone has to work in a tradition, and if it isn't Picasso, it will be Year 11. There is no alternative to this state of affairs. But critical and contextual studies extend beyond influences for practical work, as they also embrace explanation and knowledge of varieties of art in context, which can only be achieved through the acquisition of declarative knowledge, or knowing that.

Art and meaning: some practical considerations

The second section describes strategies for dealing with the multi-dimensional meaning that artworks articulate. Table I [see Appendix III] is an attempt to represent the inter-relationship between external and internal factors that make up works of art, or their non-present and present elements.

The contrast is conveyed in Searle's[21] distinction between a world-to-mind and a mind-to-world direction of fit, and such an approach offers a chance to achieve clarity about causation when planning teaching critical and contextual studies. Searle explains his idea of the 'direction of fit' using the following example:

> If Cinderella goes into a shoe store to buy a new pair of shoes, she takes her foot size as given and seeks shoes to fit [shoe-to-foot direction of fit]. But when the prince seeks ownership of the shoe he takes the shoe as given and seeks a foot to fit a shoe [foot-to-shoe direction of fit].[22]

It would be wrong of course to think that the distinction between mind and world in Searle's method is dualistic. Mind and the world are inseparable but can be given selective emphasis according to the direction of fit the teacher wants to establish in any procedure related to learning. The mutual but distinct role of mind-to-world and world-to-mind approaches to art works is a way of resolving the old and unhelpful distinction between a child-centred curriculum [mind-to-world] and subject or society-centred [world-to-mind] form of education. The nature of works of art and the range of responses needed to explain and interpret them, makes it necessary to use both approaches.

A world-to-mind approach starts with the context and uses Popper's logic of the situation to demarcate knowledge seeking from self-seeking strategies. A world-to-mind approach gathers and collates evidence, deals in probabilities, and uses the third person writing style. In contrast, a mind-to-world direction of fit involves interpretive conjectures and personal responses, deals in ambiguity, and uses first person forms of reporting. A method of teaching that is too mind-to-world would be limited because students would be expressing opinions and formulating interpretations without the necessary background knowledge on which to frame hypotheses. This, for example, is the limitation of Taylor's[23] method of form, content, process, mood, which lacks the necessary epistemic constraint that is implicit in the world-to-mind direction of fit. Alternatively, an approach that is too world-to-mind could create passive and unengaged responses from students.

Classroom strategies for the mind-to-world approach to critical and contextual studies

The three strategies for developing interpretive reasoning and responses for mind-to-world approaches to works of art are the semantic differential, bridging exercises, and thinking about works of art as though they are faces. The semantic differential was used by Osgood[24] to investigate how people relate sensory analogies so that the aural mode of sound is aligned with the visual mode, so that something loud is equivalent to something bright, and something quiet equivalent to something subdued. Osgood's use of the semantic differential allowed subjects to rate a particular response on a seven-point scale between various antonyms. There was convergence in the way subjects placed the concept of good on the good/bad scale in relationship to where they placed beautiful on the beautiful/ugly scale, sweet on the sweet/sour scale, and pleasant on the pleasant/unpleasant scale. Later studies by Osgood showed that this clustering of cross-modal relationships with moral and other values operated just as consistently at the cross-cultural level.[25]

The semantic differential can be adapted for mind-to-world responses to works of art [see Tables 2, 3 and 4, Appendix IIIa]. The antonyms are carefully selected to scaffold a variety of responses and activities to include the analysis of technique or process, composition and other formal organisation like colour harmony, or other features that give the work mood and create visual metaphors of value. Subjects are instructed to ring a number on a seven-point scale between two antonyms that corresponds to their interpretation of the work in question, so that on a sad/happy scale if they think the work is sad they register this by ringing a 1, and if they think it is happy they circle 7. If they think the work is a mixture of sad and happy emotions, they make a judgement like 3, 4, or 5 that is somewhere in between. After students have completed each antonym, they write down a brief comment to justify their response. After the sheet has been completed, individuals can share their work in groups, or with the whole class, attempting to justify their responses. The

discussion might lead to some students changing their scores in the light of insights developed from the class. The nature of the discussion should be challenging but convivial, genuinely conversational in mode.

My research elsewhere[26] highlights the potency of this method for generating a framework for discovering meaning of works of art in galleries and museums. Subjects genuinely learned from this method, and gave impressive interpretative reasoning to justify their thinking.[27] When pronounced differences in interpretation occur, it is usually linked to the ambiguity of an open-ended approach, which leads some to use the antonyms for analysing content, and others for analysing formal qualities. To avoid this form of ambiguity, each semantic differential can be given a specific function for recording responses for particular requirements. Further space could be left for students to add their own list of descriptive words.

The bridging exercise operates as its name implies: to bridge from students' mind-to-world response towards a more world-to-mind form of understanding. The stimulus frame for a bridging exercise uses material already familiar to students, or stimuli that is easily grasped, but which can act as a bridge to more complex and culturally distant art. Figure 1 shows a bridging exercise using imagery from comics to bridge for distortion in modern works of art, in this case to *Guernica*. Because distortion in comics is very familiar to students, it is not viewed in the same suspicious and threatening way as it might be in 'modern art', and by being primed with the familiar features of comics students are more likely to be receptive to the work of art that for them might be threatening or culturally remote.

An example of a bridging exercise designed to teach about attribution can be seen in Figure 2, in which Desperate Dan's attributes are compared with those that have been used for representing Hercules. Once students have established the idea of representing a person through their attributes, they are more able to apply this approach to other characters in art history and wider visual culture. Here we can think of St. Peter's attribute of keys, or Indiana Jones' hat and whip.

A bridging exercise for raising issues about representation that is taken from Deregowski's research into cross-cultural perception of representations of space[28] can be seen in Figure 3. Its minimal model of representation allows students to quickly frame arguments in support of alternative forms of representation, in this case that of an elephant. Students are asked to decide which image is the best representation of an elephant, and to back this up with the relevant interpretative reasoning. They are asked to consider which of the two forms of representation the African people who were shown the stimulus in the original research preferred. The bridging exercise has the potential to generate wisdom, tolerance and empathy

about alternative forms of representation, and opens up further possibilities to explore the logic of representation not based on the single viewpoint.

Every human being is an expert at reading facial expression, but this skill is rarely or never exploited to improve students' abilities to read works of art. The idea of scanning works of art for meaning as though they were faces is particularly apt for a mind-to-world direction of fit as it draws on expertise that students have already acquired through their social experience. Gestalt psychologists identified the importance of physiognomic perception in the way people generate meaning,[29] and argued that we read the world around us in the way we scan faces for meaning. Students can be reminded of their expertise in this area, and encouraged to transfer it by reading the 'metaphorical face' of works of art [see Figure 4]. This approach is particularly desirable when used with abstract and decorative art.

Classroom practices for a world-to-mind approach

A world-to-mind approach prioritises understanding over interpretation by using thinking skills that search for and evaluate evidence from contextual sources. It is an approach in which:

> Students move out to engage with the forms of the culture, while the forms of the culture, in turn, come to occupy their imagination...[30]

The multi-dimensional features of the background context could be broken down into their constituent parts and made available to students as a series of points of reference [see Table I, Appendix III].

One background feature would be identifying the cause and effect relationships in preparatory studies, or the role that pre-existing schemas have for making art that prevail in any particular context, as this would enable students to grasp the different ways artists have used preparatory work to achieve clarity about how to make the final product. During the Renaissance artists did precise preparatory drawings so patrons could anticipate how the commission would look when finished. In the medieval period, gothic churches and cathedrals were produced from types recorded in pattern books that circulated around Europe. In ancient Egypt the artist worked within existing, inherited schemas, which changed little over time. Riegl, in his book *Stilfragen,* traced the decorative motifs found on Oriental rugs back to their origin a thousand years earlier in Greek designs, and convincingly showed that ornament on buildings and artefacts were the result of influences of established schemas derived from tradition rather than improvised on the spot after technical and engineering problems had been solved.

Different artists in different times have used different materials and different drawing systems to explore and prepare their work. Henry Moore's contour and

wax-resist drawing system enabled him to cognitively model form on a flat surface. This method contrasts with Michelangelo's way of cognitively modelling form that simulates the cross-hatching of the marks a chisel makes when carving stone. Seurat's use of conte crayon on textured paper generates grainy imagery that logically serves his pointillist style of painting.

Students need to understand the parameters that operate when artists have to choose specific materials with which to work. You cannot use a medium like *buon fresco* in an impulsive way, as it requires careful planning for each day's work, which can only be executed on fresh plaster, or the *intonaco*. The immediacy of a Japanese pot is achieved through a lifetime of practice that enables the potter, like all expert performers, to free up conscious effort, so that creative flow can take place. We can think of Vasari's account of Michelangelo destroying his drawings at the end of his life. In keeping with the Neo-Platonic theory of art that prevailed in his time, Michelangelo wanted to leave the impression that artistic facility was a sign of divine inspiration, and evidence in his drawings that he had done preparatory drawings, in sixteenth century thought, might indicate that he was not divinely inspired. Repeating Vasari's account might be a very effective way of communicating the importance of preparation in building the necessary quality in an artist's work.

Art is also made against constraints imposed by geography, which the modernist international style in architecture undermined and undervalued. Historically, works of art have been made in a wide variety of styles influenced by local materials and weather conditions. Fresco painting is more common in southern Europe because the prevailing damp conditions in the north would make it less stable. Weather and climate result in roofs in the Middle East being flat while in Scandinavia they are pitched at an acute angle. The light and colour in Constable's landscapes is different from that found in Claude's. Aboriginal Australian art's aesthetic qualities come from the red and yellow ochre and other local materials that give it aesthetic power. Or think of the way Richard Long uses mud from the River Severn in some of his work.

One way of modelling the otherness of art in context is by enabling students to understand the variable ways in which artists have made a living, what can be described as the economic dimension for art in context. In the Renaissance, the commission always took priority over the artist's autonomy. Baxandall sums up the contents of Ghirlandio's contract with the Prior of *Spedali degli Innocenti* in Florence, like this:

> *The contract contains three main themes of such agreements: (1) it specifies what the painter is to paint, in this case through the commitment to an agreed drawing; (2) it is*

explicit about how and when the client is to pay, and when the painter is to deliver; (3) it insists on the painter using good quality colours, specially gold and ultramarine. Details and exactness varied from contract to contract.[31]

This contrasts with fine art practice today which usually involves making the work and then selling it on the market through a gallery, a system that began to emerge in Holland in the seventeenth century when church patronage disappeared in the newly founded, Protestant country. By contrast, a contemporary graphic designer often works with constraints. The social dimension deals with issues related to the role of the patron, tribe, and community in the way meaning has been considered and generated. Building on Searle's terminology, this would involve a community or client-to-artist direction of fit, something that is rarely considered in art education.

Students in schools could be given commissions in which the client specifies the constraints and negotiates the finished work on the basis of seeing preparatory drawings, the materials to be used, and the time it must be completed by. The chosen work could then be exhibited in the required space, and students could follow up on its reception by researching the public's response, possibly using the semantic differential instrument already described. This would reinforce the importance of the audience and communication for art and art education.

Artists' working practices in different cultural settings could be considered as another dimension of meaning for art. If students crudely accept the popular idea of art practice as self-expression they will never understand the conditions in which nearly all art has been made. Prior to Romanticism, art in old Western culture, and in non-Western culture of all times, the practice of art has not been based on self-expression. The related idea, also a legacy of romanticism, that artists operate on the fringes of society makes no sense as in most cases art has had a vital role to play in representing shared, symbolic beliefs. Medieval artists would not have thought of themselves as artists in the modern sense, but as skilled craftsmen or tradesmen regulated by a local guild. They collaborated in workshop practice, conserving rather than challenging existing beliefs. Gothic cathedrals exemplify this form of practice. There is a similar expectation for the role of art in the traditions of non-European cultures where conserving and projecting shared values and beliefs have dominated practice. These practices of art could be contrasted with the more recent and idiosyncratic idea that art should challenge or subvert values.

Conclusion

This chapter has explored the theoretical reasons why the practice of critical and contextual studies continues to be marginalized in secondary art education. In doing so it has identified two models for understanding art and art practices that continue to influence art education despite alternative approaches to curriculum

being available for the last 30 years. Formalism and the related idea of the autonomy of the artist, and its opposite of collectivism and the idea of the spirit of the age, are shown to be hostile to one or other of the multi-dimensional influences that give art meaning. The autonomous approach of formalism isolates art from life, in contrast to real works of art that metaphorically suggest ways of taking action in the world by projecting a worldview. The Hegelian idea of style and cultural change being the inevitable outworking of spirit, marginalises individual human agency, and proves unnecessary for explaining the way human beings establish will-to-form through communicating their actions and ideas. In contrast to Hegelianism, art is the ordinary product of the multi-dimensional way that human beings live out their lives together, a combination of individual psychological, social and cultural processes.

The historically specific approach to art advocated in this chapter is one way of grappling with art's meaning, for any approach to critical and contextual studies will have to appreciate the tension in which art belongs to but also transcends its context. By using Searle's idea of world-to-mind or mind-to-world as a selective emphasis or direction of fit, we can begin to demarcate epistemic, transpersonal explanations for art from interpretative, personal responses, thus allowing students to encounter works of art from their own cultural position of mind-to-world, as well as extending their understanding through providing the world-to-mind knowledge seeking method of the logic of the situation. Both approaches make it necessary for students to grapple with understanding that Podro argues is the basic feature of the twofold approach of critical art historians:

> *A brief remark about that two-sidedness may therefore be in place here. Either the context-bound quality or the irreducibility of art may be elevated at the expense of the other. If a writer diminishes the sense of context in his concern for the irreducibility or autonomy of art, he moves towards formalism. If he diminishes the sense of irreducibility in order to keep a firm hand on extra-artistic facts, he runs the risk of treating art as if it were the trace of a symptom of those other facts. The critical historians were constantly treading a tightrope between the two.*[32]

By achieving conceptual clarity about the causal relationship of direction of fit of mind-to-world or world-to-mind, students wrestle with the same issues that have preoccupied critical art historians. Both approaches provide the necessary means for taking students in and out of worlds through understanding the constraints and possibilities associated with each direction of fit when exploring art.

Originally published in the Journal of Art and Design Education, *Volume 15: 3, 1996; up-dated and expanded by author 2003*

Figure 1: Using comics to 'bridge' from pupils' experience to works of art

Write down the exaggerations that you can find in the comic picture of the face on these lines

Do your copy from Picasso's painting that uses similar distortions here

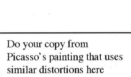

Write down the exaggerations that you can find in the comic picture of the football player in this space

Do your copy from Picasso's painting that uses similar distortions here

Look at and write down the exaggerations in the drawings of the face and footballer from a comic. Then copy a section from Picasso's painting, *Guernica*, that have similar exaggerations to the ones from the comic

Figure 2: Bridging exercise for understanding attributes in art

Figure 3: Bridging to stimulate discussion on comparative forms of representation

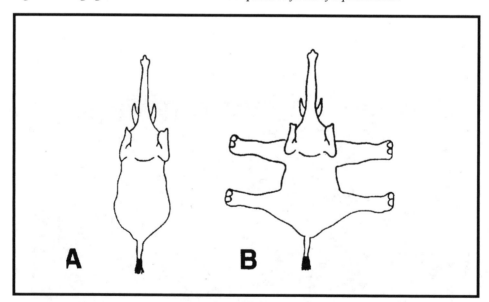

Figure 4: Bridging exercise using physiognomic perception to improve the perception of abstract art

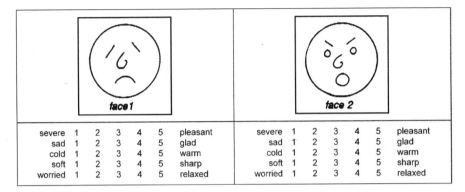

severe	1	2	3	4	5	pleasant	severe	1	2	3	4	5	pleasant
sad	1	2	3	4	5	glad							
cold	1	2	3	4	5	warm							
soft	1	2	3	4	5	sharp							
worried	1	2	3	4	5	relaxed							

Look at the two faces above and give a response to them on a scale of 1–5, based on whether you think they are sad/glad, etc. After you have done this, look at the scores and decide which face is more sad and worried.

Now try to do the same for the abstract painting below. Try to imagine it as a face and record your response as you did above. This time try to think of the shapes and colours as being sad/happy, like you did with the faces above

reproduction of abstract painting here

Is the 'face' of this work of art:	busy	1	2	3	4	5	static
	excited	1	2	3	4	5	bored
	severe	1	2	3	4	5	gentle
	happy	1	2	3	4	5	sad
	noisy	1	2	3	4	5	quiet

Notes and References

1. Cited in: McEvilley, T. (1991), *Art and Discontent - Theory at the Millennium,* New York:

Notes and References

1. Cited in: McEvilley, T. (1991), *Art and Discontent - Theory at the Millennium,* New York: Kingston, Documentext, p. 23.

2. Field, D. (1970), *Change in Art Education*, London: Routledge; Eisner, E. W. (1972), *Educating Artistic Vision*, New York: Macmillan; Perkins, D. N., & Leondar, B. (1977) (eds.), *The Arts and Cognition*, Baltimore: Johns Hopkins; Taylor, R. (1986), *Educating for Art*, Harlow: Longman; Clark, G. *et al.* (1987), 'Discipline-Based Art Education: Becoming Students of Art', *Journal of Aesthetic Education*, 21: 2; Efland, A., *et al.* (1996), *Art Education: An Approach to Curriculum*, Reston: NAEA.

3. Gombrich, E. H. (1979), *Ideals and Idols, Essays in Values and the History of Art*, London: Phaidon, pp. 24-59.

4. McEvilley, T., *op. cit.,* p. 25.

5. Neisser, U. (1976), *Cognition and Reality*, New York: W. H. Freeman.

6. Cunliffe, L. (1994), 'Synaesthesia - Arts Education as Cross-Modal Relationships Rooted in Cognitive Repertoires', *Journal of Art and Design Education*, 13: 2, pp.163-172.

7. Wolterstorff, N. (1980), *Art in Action*, Grand Rapids: Errdman, pp. 4-5.

8. Briskman, L. (1981), 'Creative Process and Creative Product' in Dutton, D., & Krausz, M. (eds.), *The Concept of Creativity in Science and Art*, pp. 129-155.

9. Quoted in Best, D. (1992), *The Rationality of Feeling*, London: Falmer, p. viii.

10. Baxandall, M. (1972), *Painting and Experience in Fifteenth Century Italy*, Oxford: Oxford University Press; Gombrich, E. H. (1972), *Art and Illusion*, London: Phaidon; Gombrich, E. H. (1982), *The Image and the Eye*, London: Phaidon, pp. 11-39.

11. *Ibid.,* p. 40.

12. Popper, K. R. (1957), *The Poverty of Historicism*, London: Routledge.

13. Gombrich, E. H., & Ebiron, D. (1993), *A Lifelong Interest*, London: Thames & Hudson, p.159; Gombrich, E. H. (1984), *Tributes: Interpreters of our Cultural Tradition*, pp. 93-115.

14. Gombrich, E. H. (1972), *op. cit.,* p.18.

15. Kerr, F. (1986), *Theology after Wittgensten*, Oxford: Blackwell, p. 56.

16. Abbs, P. (1989), *A is for Aesthetic*, London: Falmer.

17. McEvilley, T., *op. cit.,* p. 174.

18. Harré, R. (1983), *Personal Being*, Oxford: Blackwell.

19. Foucault, M. (1972), *The Archaeology of Knowledge*, New York: Harper.

20. Wittgenstein, L. (1967), (Anscombe, G.E.M., & Von Wright, G. H., (eds.), trans. Anscombe, G.E.M.) *Zettel'* Oxford: Blackwell, pp 567-569.

21. Searle, J. R. (1983), *Intentionality*, Cambridge: Cambridge University Press.

22. *Ibid.,* p. 8.

23. Taylor, R. (1992), *Visual Arts in Art Education*, London: Falmer.

24. Osgood, C. E. *et al.* (1957), *The Measurement of Meaning*, Chicago: University of Illinois Press.

25. Osgood, C. E. (1969), 'The Cross-Cultural Generation of Visual-Verbal Synaesthetic Tendencies' in Osgood, C. E. & Snider, J. G. (eds.), *Semantic Differential Technique*, Chicago: Aldine, pp. 561-84.

26. Cunliffe, L. (1999), 'Enhancing Novices' Abilities to Achieve Percipience of Works of Art', *Journal of the Empirical Studies of the Arts*, 17: 2, pp. 155-169.

27. Best, D., *op. cit.,* pp. 34-36.

28. Deregowski, J. B. (1973), 'Illusion and Culture' in Gregory, R., & Gombrich, E. H. (eds.), *Illusion in Nature and Art*, London: Duckworth, pp. 161-191.

29. See: Fuller, P. (1980), *Art and Psychoanalysis*, London: Writers & Readers, pp. 177-238; Gombrich, E. H. (1971), *Meditations on a Hobby Horse*, London: Phaidon, pp. 45-55; Winner, E. (1982), *Invented Worlds: the Psychology of the Arts*, London: Harvard University Press, pp. 104-111.

30. Abbs, P. (1994), *The Educational Imperative*, London: Falmer, p. 46.

31. Baxandall, M., *op. cit.,* pp. 6-7.

32. Podro, M. (1982), *The Critical Historians of Art*, London: Yale University Press, p. xx.

Chapter 10: School Students' Responses to Architecture: A Practical Studio Project

Richard Hickman

Overview

This paper focuses on a built environment project with a mixed ability group of Year 7 students (aged 11-12 years) who, at the time of the project, attended Deacon's School in Peterborough. It is intended to show simply how one teacher has made use of a particular approach to the critical and contextual studies element of the art and design curriculum. Deacon's School caters for students aged between eleven and eighteen, from a wide range of ethnic and cultural backgrounds (including a substantial minority from the Indian sub-continent); it is an active participant within the University of Cambridge PGCE partnership and has established itself as a 'beacon school'.

In practical studio terms, the project was concerned with school students making 'pop-up cards' based on first hand observation of local architecture under the guidance of the head of art.[1] The project length was twelve weeks, consisting of one fifty-minute lesson per week. The focus for students' learning was on their critical responses to their built environment, in and around the City of Peterborough. In particular, students were encouraged to make full use of their sketchbooks and to engage in active oral work. The approach taken builds upon that advocated by Wolff and Geahigan[2] by emphasising the relationship between students' personal engagement with art and design and their personal response to it through their own art; students were encouraged to learn about art and design objects through the process of reacting, researching, responding and reflecting.[3]

Context

Three principles underpinned the approach to this project: first, that students should have first hand experience of their built environment; second, that learning should be heuristic, building upon what they already know feel and understand in a structured way, and third, that students should have the opportunity to respond creatively to their aesthetic experiences. Together, these three principles ensured that students were learning in a way which was meaningful to them; they would not simply be given second hand information, but would have genuine experiences of art and design which involved personal response and self directed learning in a guided and structured learning environment; this was facilitated through an approach I developed through working with school students which I have termed *React, Research, Respond and Reflect*.[4] The process begins with students' initial affective responses to art works and guides them through a structured programme

of personal research. The research is both intrinsic to the art work, i.e. concerned with the formal aspects of it, and extrinsic, i.e. concerned with the contexts within which the art object was made. Students are encouraged to reflect upon the meanings which they construct about the art objects they examine, and to consider the impact which the art object has had upon them in a personal way. Reflection (having researched into the art work) is facilitated by questions such as:

- How do you feel about it now?

- Has it changed or in any way affected your view of art?

- Has it given you any insights into the way you see things?

Through this project, the emphasis was on bringing together the skills of art criticism and practical skills of construction. This was done by giving the Year 7 students opportunities to see and respond in an 'aesthetic' way to actual buildings, viewing the buildings as one would art objects, and to record their responses visually and verbally in sketchbooks. In practice, this involved students in observing local buildings closely and making annotated sketches. The school students are fortunate in having a range of architectural styles in the locality, including a mediaeval cathedral, mosques and examples of architectural styles from several centuries. However, this is not a pre-requisite and students can learn and appreciate just as much from viewing modern and postmodern architecture, both ecclesiastical and secular, given appropriate instruction. It was felt to be particularly important for students to experience the architecture first hand, in order to get the sense of size and scale; in the same way it is important for us to view works such as Picasso's *Guernica* or Rothko's large expressionistic works in order to gain some sense of the power of those works.

Architecture is one of the three major topics that are covered in the Year 7 syllabus at Deacon's School. It is approached in an individual way by all art teachers in the department according to the teacher's own subject specialism within art, craft and design. In the past the project has been tackled through using a variety of media such as paint, collage, print and clay. At the beginning of each year, an artist or designer, art movement or specific culture is chosen as the focus of the study. When using collage and mixed media for example, students normally look at the work of the designers and architects such as Gaudi. The project is resourced with slides, photographs, books and postcards, and is supported by research undertaken by the students themselves, using the school library; the students also make use of whatever information they can glean from the internet - this is encouraged as it facilitates individual heuristic learning.

For the purposes of this project, it was decided to base the work on studies

observed first hand around Peterborough. The information was collected in the students' sketchbooks, and for the first four weeks was gathered during lesson times, and also during the 30 minute fortnightly set homework. At the same time as producing on-the-spot sketches, the students were also expected to gather information about other famous examples of architecture in Britain and around the world, giving their own written comments.

The students were expected to:

- Understand the design of buildings, their style and function

- Describe and comment on the designs from a personal standpoint, using aesthetic criteria

- Be able to translate the first hand evidence in front of them, and be able to translate it quickly in sketch form, some of them being able to interpret it using their own personal drawing style

Having gathered the information, the students were then to use it to create a completely separate piece of artwork in the form of a pop-up card and plan. They were expected to consider the composition of their final piece, using factual information and their own imagination to 'create' their own abstract city. In order to do this, they were to become familiar with the various mechanisms needed to make an effective 'pop-up' card.

Planning and resourcing the unit
It is important to discuss with the students the buildings which are to be the focus for the project. For this particular project, we decided that the focus for attention would be one of the following:

- The student's own house

- The school itself

- A building in the immediate environment, e.g. the corner shop

- Peterborough Cathedral

- A famous old building in Peterborough's city centre

- A well-known modern building in Peterborough's city centre

Outside their class work, students were encouraged to research various famous buildings in Britain and from around the world, and also to find out about some famous architects and their work. This was in addition to collecting and making visual material (including sketches) of one or more of the above.

Resources included books, pamphlets, slides and reproductions about the architectural styles which the students were focusing on, as well as CD-ROM and internet access. On the walls of the art room, displays were set up showing photographs of famous buildings with information about the architects who designed them. Such a display could also include reproductions of, for example, Monet's studies of Rouen Cathedral, or the Houses of Parliament, Hundertwasser's decorative buildings, or David Hockney's simple, uncluttered interpretation of California.

The project was introduced with a slide-show, showing the students a wide variety of different examples of architecture and artwork based on them. The students give verbal responses to the slides in the form of a class discussion, making notes in their sketchbooks. In the subsequent weeks, they used lesson time to go out into the local environment, accompanied by the art teacher. This work was backed up with homework involving similar activities. They slowly built up a bank of sketches and notes, from which they took the final composition for their pop-up cards.

The sketchbooks were also used as a repository for collected photocopied examples of architecture, examples found in magazines, postcards and photographs from places the students have visited. These are always a useful source of reference for adding imaginative details to the cardboard buildings on their main pieces. Background research involved extensive use of outdoor work with students looking into the history of particular buildings. Working out of school is fraught with potential difficulties, but it is worth it to expose students to actual art objects, and have them engage with art in a personal and direct way. The potential practical difficulties can be largely overcome by detailed forward planning and giving a clear structured brief to the students.

It was necessary to find appropriate visual material, such as reproductions of work by Hundertwasser and Monet; this necessitated some further background reading around the life and work of these artists. In practical terms, it was essential to do several 'trial runs' of the pop-up mechanism and to have previously prepared examples to show the students.

The unit as a whole took place over twelve fifty minute sessions and was divided up into several different activities. The main period of the actual making of the pop-up card extended over seven class sessions. The first two sessions were devoted to getting students to respond to various buildings in the locality, both in their

sketchbooks and by encouraging talk. Students made sketches and notes and brought these back into the school to review during the third session. The visual and other information was then drawn upon to work out a basic design for their card.

The fourth lesson focused upon developing the basic design, with reference to paper folding mechanisms. The instruction on making the pop-up card began with a demonstration. To save time, when this project has been taught in the past, the different sections have been pre-cut to the correct size (usually A4), ensuring that the actual cardboard outer cards are all exactly the same size. A visual aid was prepared beforehand, providing an example of how a composition might be put together, and also demonstrating how the various pop-up mechanisms work. Over the next seven sessions, students were involved in making new sections for their card - drawing out their ideas and making their own decisions about composition and design. Students were encouraged to work individually, with assistance given where appropriate.

Towards the end of each lesson, it was found useful to gather the students around and review the work produced, encouraging individuals to talk about their work and discuss their progress with the group as a whole. Concept learning and the development of a specialist vocabulary, was facilitated through the use of a list of words which students were expected to acquire. Such words might include those referring to visual elements, such as texture, composition and foreground, but might also include more general concepts such as geometry and structure. Lists of words are regularly written out to accompany lessons and form part of the art classroom's display. Students are normally expected to make use of the appropriate terms in their discussions; they gain understanding about the concepts underpinning projects more rapidly when they are encouraged to use the relevant words themselves. It is well known that for learners to learn effectively, there should be a combination of oral, written and visual supporting material.[5] It is therefore considered important to give written and pictorial back up to oral instruction and discussion work.

The final two sessions were concerned with finishing off the practical aspects of the project, such as completing the front cover of the pop-up card. At this stage, there is a greater focus on verbal feedback, looking in particular at students' level of critical engagement with the buildings that provided the original stimulus material. Questions such as those following were used to encourage thinking and more considered verbal responses about architecture:

- Does the card have a 'feeling' of the City of Peterborough? In what ways have you captured it?

- Is the final outcome of the card how you envisaged it? How is it different?

- If you were to repeat the project, how would you improve it?

- How has your view of your local built environment changed as a result of this project?

Experienced teachers will know that simply exposing students to art and design objects is not enough; many teachers will have found to their cost that an unguided and unstructured visit to a gallery will result in the majority of students ending up in the gallery coffee bar, claiming to have seen all there is to see after twenty minutes! In the case of the students involved in this project, they were shown what to look out for and were given the vocabulary to describe what they had seen. Guidelines would normally include things such as styles of different types of windows to look out for, types of building materials and their relation to the environment. To give a flavour of how students interacted with the architecture in their environment, an example is given below of one student's engagement with Peterborough Cathedral:

[React] - what is your initial impression?

At first, I wasn't all that interested; I have seen the Cathedral lots of times. Then when I really looked at it, I noticed things that I hadn't seen before - even things I'd seen before looked different when I looked more carefully. The other thing is, when you sit quietly, it's so huge.

[Research] - look (more) carefully; refer to notes given in class; read up on it, Cathedral guide book; stained glass windows (books) internet:

I did drawings of the things which interested me, like the windows, especially the colour of the stained glass. I read about the windows in the guidebook...

[Respond] - sketches in sketchbook; written notes through to pop-up card; discuss in class

I found out that the style of windows is called Gothic, now I know when I see windows like that, with the point at the top, that's what they're called.

[Reflect] - *I think the Cathedral is really great - it's got such a lot in it. Even though I'd seen it before I never really knew how much there was in it, like the carvings.*

Procedure for making the pop-up cards
Before beginning this aspect of the project, it is important to consider carefully the

specific materials that will be available for students to use on their pop-up cards. If white card is being used, details can look just as impressive using fine-liner pens or pencils, the result being a clean, monotone effect, with windows and doorways cut out of the sections using craft knives. If the emphasis is to be on decoration, and the students had been looking at artists and designers such as Hundertwasser, then paint, collage or mixed media would be very effective. For this particular project, it was decided to restrict the media to fine-liner pens and the end result in stark monotone, emphasising line and details such as roof tiles, brickwork and the surface textures on the ground.

The students were expected to work with their sketchbooks in front of them. Just as they would in a painting, they work from the background to the foreground. They insert the largest 'back section' first, which forms the backdrop to their pop-up city. This section needs to be large and solid. It must have the strength to be able to pull up the levels attached to the smaller sections in front of it. Once the back section is in, they can then add the smaller sections as they go, building up their cities working from the compositional sketches in the sketchbooks.

Assessment

As a way of consolidating the students' learning, it was found useful at the end of every lesson to have a 'mini-crit' on the work in progress. All the cards were displayed on a central table, with a class discussion on the progress of selected examples. This also gives the students a valuable opportunity to look at and discuss each other's work - something that doesn't always happen in a busy 50-minute lesson. This formative assessment also helped develop the students' art-specific vocabulary in addition to more general language skills such as listening.

Differentiation occurs 'naturally', by outcome, in the work. The less able students, who in the present case usually work at a slower rate, might only achieve a few sections, but the results will be equally as successful as those of the faster, more able students, who can add a far

Figure 1: Peterborough cathedral

Figure 2: A 'pop-up' picture, Year 7

greater number of sections. The more able students are also inclined to experiment with different and more elaborate sections, perhaps with pull out tabs, or a greater inclusion of imaginative details.

At the end of the twelve-week project, the students filled in an art department assessment and self-evaluation form. They briefly outlined the research they had done, the process they had learnt, and what they felt had been problematic and successful during the project. There were boxes on the sheet for the teacher to add an attainment level and also an effort grade from A-E.

Here are some comments from two of the Year 7 students involved in the project.

Zoe: I drew some buildings in my sketchbook, including my house, the school, the cathedral, a few corner shops and other well-known landmarks in Peterborough. I then drew the buildings onto card and cut them out. I stuck them onto a thicker bit of card (the base) and it worked!
The hardest bit was sticking the cards onto the base, and the easiest was drawing the buildings.
I very much enjoyed going outside to draw the buildings. It was better than copying from books because you got a chance to go and see the build ings for yourself and put in all the detail that was necessary.

Amanda: First of all I drew some buildings which are in Peterborough, including my house. I did it in my art book first and then drew them out neatly on card. I cut the buildings out and folded the card at the bottom to make a flap. You do the biggest building

first, so that was the Cathedral. I thought sticking it was quite hard, but the rest was easy.

If I were to do it again, I probably wouldn't do it differently because I got a good grade for it.

I enjoyed going out and drawing the buildings. I think its better than copying because you can draw them from your own point of view.

School students appear to gain a lot of inspiration and stimulus from being taken out of the art room and physically sitting down in front of their subject matter; they respond to being given the opportunity to react in an individual way to live subject matter, and also benefit from being taken out of the art room into the context in which the work is studied. This way of working requires much more planning and organisation on the part of the art teacher, and is definitely more time consuming. However, the freshness of the students' work and their overwhelmingly positive response in approaching their work like 'real artists' do outweigh the risks and challenges.

Concluding remarks

It is clear that the school students gained a great deal from this project; many who might have been uninterested or disaffected were 'turned on' to architecture and to a greater appreciation of the built environment. This was due to several factors which can be identified as follows:

- Emphasis put upon students' own personal responses and value given to them, in an environment which was personal and meant something to them

- Direct experience with *actual* objects as a source for criticism and aesthetic appreciation (in this case buildings)

- The facilitation of personal research and heuristic learning through a range of different sources[6]

- The follow-up practical work as a means of expressing personal responses to architecture

The most successful outcomes, both in terms of student learning and in terms of the quality of art work produced, were those based on the local medieval cathedral.[7]

There are few works of human creativity skill and imagination more monumental than cathedrals, and so it is not surprising that students were, when given the opportunity, and personal space, clearly impressed and positively affected by the grandeur of the historic building which many of them used as a basis for their

work. Cathedrals were (and continue to be) built to be impressive and awe inspiring, but many of us rarely go beyond being awed. As with all works of art, cathedrals are complex structures and embody several layers of meaning, not least with regard to the various contexts in which they were constructed: the social, spiritual, political, cultural and technological contexts which give form to the idea. However, it is not necessary to use a Cathedral as a starting point; any piece of architecture that the student feels able to respond to would be a suitable focus for engagement and response.

School students involved in this project learnt about the work of architects, artists and designers in a way which was meaningful to them. Through guided research, the students were able to make connections and gain knowledge and understanding of aspects of art history and art criticism which were not only relevant to the school work but to their own understanding of the world. A very worthwhile educational aim related to this project is the students' development as critical consumers of visual form; such forms could of course include the everyday environment. The most important learning outcome was concerned with the students' acquisition of critical 'tools', together with the notion that their opinion was of value. There was put in place a foundation from which more sophisticated learning could emerge, learning which focused more explicitly upon the contexts of the objects of criticism.

Originally published in the International Journal of Art and Design Education, *Volume 20: 2, 2001, updated 2004*

Notes and References

1. I am in debt to Maria Fletcher who, at the time of the project was head of art and designated an 'Advanced Skills' teacher; she had a significant input into this paper.

2. Wolff, T. F., & Geahigan, G. (1997), *Art Criticism and Education,* Chicago: University of Illinois Press.

3. See Hickman, R. D. (1994), 'A Student-Centred approach to Understanding Art', *Art Education,* 47: 5, pp. 47-51.

4. This approach was first described in reference 3 above, and is expanded upon in the context of school students' use of language in the art room in 'React Research Respond and Reflect: Language and Learning in Art', in E. Bearne (1999) (ed.), *Use of Language Across the Secondary Curriculum,* London: Routledge. See Appendix IV.

5. See for example Koroskik, J. S., Short, G., Stravopoulos, C. and Fortin, S. (1992), 'Frameworks for Understanding Art: The function of comparative art contexts and verbal cues', *Studies in Art Education,* 33: 3, pp. 154-164.

6. Sources used were:

 www.wfuna-art.com/docsheets/hundertwasser_mar.html; Zerbot, R. (1999), *Gaudi Architecture and Design,* Benedict Taschen Verleg; Mathey, J. F. (1986), *Hundertwasser,* Bonfisi Press; Kalitina, N. (1994), *Claude Monet,* Parkstone Press.

7. From a general citizenship perspective, the focus on a cathedral had, in retrospect, a positive effect for those members of the group who were Muslim in that they were able to visit an important Christian building in their city without feeling alien or intimidated. Many however chose to focus on their local mosque. Muslim students often avoid doing three-dimensional

work, especially if it is representational; this project was one with which they felt comfortable. For an account of teaching art to Muslim students, see Hickman R. (2004) Teaching Art to Muslim Students, *Visual Arts Research*.

Chapter 11: Visual Culture Art Education: Why, What and How

Paul Duncum

Introduction

Visual culture has become a hot, new, trans-disciplinary term, and, as Eisner notes, many art educators are, in turn, using it to describe their primary focus.[1] Instead of studying art, they claim to be studying visual culture. What they mean by visual culture, however, appears to vary and is not always entirely clear. Dobbs uses it to refer to 'paintings, drawings, sculptures, architecture, films and so on'[2] while for most of those who use the term it is the 'and so on' that is of special interest: the sites of contemporary cultural experience, television, the Internet, malls, video games, theme park rides, and so on. Freedman would study 'human-made visual influences on our lives',[3] Tavin would study 'popular' and 'other images',[4] while Smith-Shank[5] and Irwin[6] make visual culture refer to embodied visual memories. In this paper I will examine why visual culture has become a focus for such broad interests, the ways visual culture might be usefully conceived within art education, and how we might go about teaching it. In short, I will examine its rationale, its nature, and its pedagogy; the why, what and how of Visual Culture Art Education (VCAE).

Why visual culture?

Visual culture is a focal point for many, diverse concerns, but all have in common the recognition that today, more than at any time in history, we are living our everyday lives through visual imagery, what Jameson calls 'a whole new culture of the image'.[7] As a description of our times, the culture of the image refers to two phenomena: a whole way of life, or ways of life, that is lived through imagery, and a particular kind of image culture. Evans and Hall see visual culture as one in which the use of images is a major defining characteristic.[8] They approvingly cite Alphers, who is usually credited with first using the term visual culture. Alphers writes, 'a visual culture is a culture in which images, as distinguished from texts... [are] central to the representation (in the sense of the formulation of knowledge) of the world'.[9] According to Mirzeoff ours is a visual culture because of our 'tendency to picture or visualise experience'; for him, the visual appears both as global in scope and as part of ordinary, everyday life.[10]

Ours is not only a visual culture, however, it is a visual culture with a particular character. Today's particular image culture is characterised by depthless and self-referential images, more concerned with surface than substance, and more with play than significance.[11] These so-called postmodern images involve immediate, short and intense sensations. They are said to refer to each other rather than

anything beyond other images; for example, magazine advertisements refer to television programmes that refer to the cinema that refer to product brands that appear in magazine advertisements. A loop of reference is created that always turns back upon itself.

Both developments – a visual way of life and a culture of self-referential, depthless images – causes much angst among scholars, many of whom – including Jameson – deplore the ascendancy of images over words. They see in what they regard as the epistemological inadequacy of images a serious debasement of logical thought that threatens civil society.[12] Echoing Plato's distrust of the image, they claim that nothing less than the future of democracy is at stake. For them, any image culture would be deeply concerning, but the postmodern culture of depthless images is deplorable. Not only is there now more imagery than ever before, not only is imagery tied more then ever to the economy and inserted into everyday life, but also imagery itself refers increasingly to itself rather than anything real. Postmodern images privilege form over content, signifiers over signification, surface play over narrative, spectacle over characterisation and plot. To those suspicious of visual culture, how can these characteristics be anything but dangerous?

Alternatively, others see today's visual culture as offering people a new freedom of expression involving a knowing willingness to play at their own games of signification. People are thought often to resist preferred meanings and to create their own.[13] People are also seen to revel in the pleasures offered by the formal characteristics of postmodern imagery, which have long historical precedence.[14] Thus, these critics argue that previous manifestations of what today are seen as contemporary, postmodern characteristics did not destroy civilisation as we know it, and, furthermore, gave pleasure and meaning to people's lives. The implication is that today's indulgence in postmodern characteristics is likely to be no more harmful.

Whichever perspective is held, no one appears to doubt the ascendancy of the image. If pictures have not come to replace words, then at least they have an unprecedented influence in what we know about the world, and how we think and feel it, beyond personal experience. According to Kress, this revolution in communications is forcing us to rethink 'the semiotic landscape of Western "developed" societies'.[15] This rethinking involves an attempt to theorise the visual as a form of communication that applies broadly across disciplines and social circumstances rather than just a specialised form of expression and aesthetic good taste. Visual culture represents an attempt to theorise the visual as part of a general theory of communications, not just a specialised activity. Conceptualising the visual in this way, away from art, is necessary given the proliferation of imagery as part of everyday life. It has also been made possible because the older, modernist

distinction between high and popular art has eroded at both the levels of production and reception. During the modernist period, art educators focused on art imagery and thereby helped to maintain a clear separation between high art and popular art,[16] but art educators are now acknowledging that the separation has broken down. Many artists draw upon popular references, and the small audiences who once showed an almost exclusive interest in high art are now more than likely as not to range freely between high art and popular art.[17] Whereas once high art provided for its minority public a frame of reference, a major point of which was to distinguish it from the popular rabble, now, increasingly, a reflexive indulgence in popular pleasures is knowingly sought.[18] For most people a vast array of images provides both pleasures and reference points for everyday living. Thus, at both the levels of production and reception, the once powerful distinction between high art and popular art has broken down to be replaced by constant traffic between the two. Increasingly it makes more sense to think of high and popular culture, not as binary opposites, but, 'a much more pluralist – or indeed "multicultural" – model of culture'.[19]

Developed economies are increasingly information driven or knowledge based, and the technologies of information are increasingly visual because for many purposes the visual turns out to be more efficient than older forms of written communication.[20] Indeed, it always was.[21] Kress and van Leeuwen[22] argue further that in homogeneous societies, literate communications are able to dominate because language does not lend itself to quite the plurality of meanings that images enjoy. Images come into their own, they argue, in heterogeneous societies. For a message to reach the whole population it has to be adaptable to a variety of cultural and ideological constructions, and images meet this demand. Because capitalist society is complex, diverse, even divided, images provide a sense of common culture which is altogether more diverse than a literacy-based one.

In a capitalist society the underlying purpose of communications is, of course, the continued expansion of consumer markets. Writing of the logic of capitalism, Jameson says, 'Aesthetic production today has become integrated into commodity production'[23], and adds:

> *The frantic economic urgency of producing fresh waves of ever more novel-seeming goods (from clothing to airplanes), at ever greater rates of turnover, now assigns an increasingly essential structural function and purpose to aesthetic innovation and experimentation.*[24]

Herein lies the primary motive for a visual culture approach to art education. From recognition that consumer society and civil society are fundamentally at odds, with the former emphasising individualism and the latter emphasising civic responsibility, comes the need to address how consumer markets employ images.

As Chapman asks, 'Who benefits most when artistic skills are widely deployed by a few, in ways not critically fathomed by the many?'.[25] Chapman argues that it is unwise to have students ill-equipped to know how and why they are seduced by images and a connection must be made between their study of imagery and everyday life. Similarly, Tavin argues that all forms of imagery should be studied as political texts for the purpose of developing critical citizenship in the cause of social reconstruction.[26] Duncum and Freedman agree that education in visual culture is underpinned by the impulse to maintain democratic processes and institutions.[27, 28] Students, they claim, need a space in which to become articulate about their involvement in visual culture. Since much of visual culture is politically reactionary and anti-social, its study is seen as a way to counter its negative effects and to offer the tools for transformative thinking and action.

What is visual culture?

So far I have described visual culture as a description of our times, but what is visual culture when considered as a field of study with implication for art education? In one sense, the term visual culture is a reworking in contemporary terms of an earlier art education project described as visual literacy.[29] This project also sought to broaden the canon to involve a wide range of imagery, but whereas visual literacy focused primarily on the image as a text, visual culture is concerned with the contexts of texts, the real, material conditions of image production, distribution and use. In this sense visual culture has more in common with another more recent project in critical pedagogy and art education called cultural literacy.[30] What is new is that visual culture has attracted interest well beyond art education, and even critical pedagogy, to incorporate many disciplines, to the point where it now constitutes an emerging, trans-disciplinary field in its own right. There appear to be three main threads to this emerging field: a broadened canon offering a very inclusive list of images and artefacts, a focus on how we look at images and artefacts and the conditions under which we look, the study of images within their context as part of social practice. I will deal with each thread in turn.

The most contentious is the first thread, the broadened canon. The key issue is: Just how broad is the canon to be? Mitchell was among the first to deal with this question where he succinctly summed up the tensions inherent in developing a working definition of visual culture by saying that we have both to reckon 'with those parts of culture that lie outside the visual, and those parts of the visual that lie outside of culture'.[31]

On the one hand visual culture is never wholly visual. The term is being used even while some recognise that it is inadequate to describe actual cultural experience. Today, more than ever, visual images are accompanied by other forms of representations that appeal to sensory modes other than sight.[32] As Chapman says in addressing theme park rides that rely on sound and kinaesthetic effects, 'The

culture of consumerism is not just visual'.[33] Television and the Internet, paradigmatically, combine imagery with human gesture and behaviour, music, sound, and written and spoken texts. For the New London Group of literacy educators this recognition has given rise to the term multiliteracies and an emphasis on mulitmodalities.[34] They are attempting to grasp what is new about the interactions of communicative forms that have traditionally been studied separately.

On the other hand, the field of visual culture is much broader than either the traditional focus of art education on art or even to a new art education focused on a much-expanded range of cultural sites. As the *Journal of Visual Culture* makes clear, the area of visual culture includes many areas that are of a primarily scientific nature and, at best, of marginal interest to art educators; for example, dreaming, blindness, the microscopic, cartographies, and topographies.[35] How are we to discriminate? Clearly, not everything visual could conceivably entertain art educators. A very wide range of imagery does not mean all imagery. For this reason the following two definitions from introductory texts on visual culture appear too broad.

> ...*those material artefacts, buildings and images, plus time-based media and performances, produced by human labour and imagination, which serve aesthetic, symbolic, ritualistic, or ideological-political ends, and/or practical functions, and which address the senses of sight to a significant extent...*[36]

> ...*anything visual produced, interpreted or created by humans which has, or is given, functional, communicative and/or aesthetic intent.*[37]

My hesitation to accept these definitions lies in their inclusion of images whose sole purpose is functional. Brook helps clarify what is of interest to us, and what is not in his description of culture generally.[38] He dismisses the idea that we are interested in just any visual communications, in, for example, road markings because while they are meant to communicate they are not, at least as they are intended and are normally used, representative of anything. We are interested in what is 'symbolic and communicative, and not just mechanically effective'.[39] He writes:

> *Perhaps culture is second order communicative artefacture, in which communication floats on representation: the production of artefacts whose prime significance is to be about something else. So a drawing of a landscape might not be a cultural product if its purpose is, let's say, wholly and solely to guide us to the spot; but it becomes a cultural product as soon as it guides our thoughts about how, and in whose interest, the wilderness has become a garden.*[40]

Thus, if the word functional is dropped from the above definitions, I believe they can stand as definitions of visual culture that are of interest to art educators. When images act only in a functional way they are of interest to design educators but not art educators. As soon as they are viewed as representational, however, they become part of our purview. As already noted, observers of postmodern visual sites often complain that images today refer to nothing other than other visual images,[41] but, crucial for the definition of what interests us, such images do represent even if it is only other images.

The second strand of visual culture as a field is what some call 'visuality', the process of attributing meaning to what we see.[42] For Mitchell[43] attributing meaning involves the various ways we look, gaze, observe, survey and take visual pleasure. To this, Walker and Chapin add glancing and voyeurism.[44] Much of the debate among cultural observers involves the different kinds of looking that are characteristic of modern and postmodern cultural sites/sights: prolonged gazing at depthful images versus quickly glancing at depthless images. Visuality also involves the conditions under which we are allowed to look and under which conditions looking is forbidden or variously regulated. We attempt to prevent children from looking at images of violence and sex for example, and many religions have strict rules about whom, when, and where sacred artefacts can be viewed.

The third major strand of visual culture as a field of study is a concentration on images as social practice rather than just textual analysis. This, in turn, involves three dimensions: people's lived experience and their subjectivities, socio-economic issues, and the history of image production and reception. Williams' term for this enterprise, cultural materialism, captures the attempt to study images as part of the actual lived conditions in which they are produced and used.[45] The aim here is to understand images in terms of people's actual social relationships, as they attempt to make sense of the materials at hand, often squaring impossible circles. This is culture as 'sensible practice'.[46] The emphasis is on the wide range of meanings people make of images, as they not only accept preferred meanings but also resist and negotiate meaning. It involves understanding images in terms of how they are slipped into people's daily rituals, rather than as self-contained texts. Meaning is not simply read off the images themselves.

Understanding images as social practice equally involves seeing images as part of power struggles between opposing social groups. Barnard, for example, sees visual culture as a tactic or strategy in the multiple ways in which power is exercised, which today is principally through the institutions of government and corporate capitalism.[47] A concentration on contemporary images, however, does not mean discounting the history of imagery. Indeed, an essential context for contemporary images is the history of images because contemporary images often have more to do with longstanding conventions of representation than they do to today's

realities. The history of visuality is not the same as the history of art however. Alphers distinguishes between visual culture history and art history.[48] She studied the way seventeenth century Dutch looked at the world – their scopic regime – through, among other means, their painting. Traditional art historians work in the opposite direction. They begin with the physical fact of the artworks and connect them to their cultural context. To illustrate further, Mirzeoff develops a very different history to that of art to understand contemporary science fiction films; it is a history that involves psychoanalytical interpretations of the gaze and fetishism he claims is inherent in nineteenth century photographs of African natives.[49]

In analysing the aliens in such films he does not draw upon the history of the fantastic in art, but the tendency to make people of different races 'other'. In summary, visual culture involves three strands that are of interest to us as art educators: a greatly expanded but not all inclusive range of imagery; visuality; and the social contexts of imagery including histories of imagery.

How should visual culture be studied?

What would VCAE be like? Space prevents more than an outline of principles, and it is important to signpost the provisional nature of these principles. As Kress says of the shift towards visual culture, 'the implications... have not in any sense begun to be drawn out or assessed in any coherent, overt, full and consistent fashion'.[50] However, between two undergraduate texts on visual culture[51] and two anthologies of readings[52] there is some general consensus that the study of visual culture should follow the characteristics and content of the field as a whole. These include not only a much-broadened canon of artefacts but also the study of the institutions of production and distribution as well as the subjectivities of the viewing audience. It should be focused on the contexts of texts as much as the texts themselves, which means moving beyond semiotic readings to include both the phenomenology of people's lived experiences – the meaning of imagery as part of people's daily rituals – and institutionalised frameworks – the socio-economic and political functions of imagery. As Bolin writes, with reference to the associated field of material culture studies, questions need to be raised not only about the artefacts but 'also about those who make, use, respond to, and preserve the artefact'.[53] This includes, as Bracey argues in relation to art, the institutional practices that help form the discourse of artefacts.[54] The institutional practices of visual culture are much more diverse than the art world, however. A consideration of television, for example, should include the phenomenological experience of watching television but also a consideration of who owns television networks, what else they own, how television operates financially, how programmers operate within government regulations, how programmers survey their audiences and how they deal with public criticism. Context also includes the social nature of reception. Buckingham and Sefton-Green demonstrate that adolescents make sense of imagery not as isolated individuals but as part of the social interaction of everyday chit chat.[55]

Furthermore, a focus on contemporary cultural sites would be contextualised by the critical perspective offered by comparing past and present visual culture. Thus, VCAE would go beyond visual texts to their various contexts – phenomenological, institutional, and historical.

Second, VCAE should be based on both the making and appraisal of images. While the impetus for studying visual culture is to develop critical consciousness and transformative action, VCAE would not abandon the traditional emphasis of art education on making imagery. Through making images students learn about visual culture as a practitioner; they acquire insight into the thinking process of the salaried and outsourced professionals who construct the images of corporate capitalism. I put the issue this way to make the point that, while making images in a visual culture curriculum remains important, it would not be the same as it exits in most art classes now. Professional institutionalised art today often involves an experimental investigation into the intricacies of the self and deeply private experience, and art in schools sometimes follows this model. Making images in VCAE, by contrast, would allow students to discover their own personal positions in relation to questions and issues specifically of cultural experience rather than anything in which students might be interested. It would involve issues such as the demography of audiences, media ownership, and the reproduction of society through stereotypical representation. It would assist students to understand the construction of their own subjectivities by visual culture and how they can reconstruct themselves through imagery. Thus image making and critique would continue to go hand in hand, the one supporting the other, where critique is used to focus making and making informs critique.

Third, a curriculum should be organised around central questions rather than reproducing the study of separate media.[56] We need to avoid the art school model of curriculum which consists of painting, sculpture, textiles and so on, and of media studies where the curriculum is similarly organised around television, video and so forth. Instead, VCAE should arise from the questions it asks and the issues it seeks to address. VCAE should be based on the broad questions we ask ourselves as a society; how, for example, do we represent race, class, gender, and unequal power, as well as what we leave unrepresented and why. Questions should address both the imagery itself and their contexts, including ways of viewing. Examples of questions include those posed by Darley about new media:

What, specifically, do concepts such as simulation, hyperrealism, pastiche, interaction, and immersion designate? How do they manifest themselves in cultural practices? What are the implications with respect to questions of aesthetics and spectatorship? What is the significance of the changes that are involved and how are we to make sense of them?[57]

For example, how are we to understand the nuances of aesthetic experience between, say, shoot-em-up computer games, simulation rides, and blockbuster, eye-candy Hollywood films? How do we compare the slow languid investigation of a painting with the intensity of these postmodern experiences? If, as many claim, this is a typically postmodern phenomenon, what does this say about what is happening in society more broadly?

Fourth, we need to acknowledge that increasingly there are generational differences in the way cultural sites are experienced.

To many people of a certain age the characteristics of contemporary culture sites mentioned above are an anathema. They see these sites as representing a dumbing down of cultural experience and a shift from natural and authentic experience to the artificial and inauthentic. These sites are said to deny or even to destroy our basic humanity. However, the history of new technologies is one of gradual naturalisation, so that we have to accept that what is unnatural for one generation, is not necessarily unnatural for another. What begins as an intrusion into daily life comes to be accepted as the natural backdrop to daily activity. The Internet, still a confounding new technology for many, is for many youngsters quite ordinary because they have never lived without it. What for teachers remains perplexing, for youngsters forms the basis of their references for living.[58]

For this reason – and this is the fifth point – visual culture should be taught through a dialogical pedagogy. Students have a lot to teach their teachers about new and emerging cultural sites. About the details of particular sites they often know more and learn faster than their teachers. Buckingham and Sefton-Green argue that in this context teaching needs to be conducted through dialogue between student knowledge and teacher knowledge.[59] They describe how for decades media studies in Britain was taught through a transmission model whereby students learned how to pass tests by regurgitating the language of media studies but failed to transfer their lessons to their everyday lives. Thus we would want to avoid visual culture becoming just another academic subject, another form of cultural capital that served the distinction between the haves and the have-nots. It should not be seen as 'learning to "talk posh" – as our students would say – about things that everybody else just talks of normally'.[60] Rather, while validating students' lived experience, education needs to reframe that experience in light of historical precedents and theory.

Conclusion
I believe the reconceptualisation and reconstruction of art education is urgent. The image genie long ago escaped from the bottle of the art world, and it has spread across the entire planet and permeated everywhere. While change to our practices will not be as rapid as the issue demand, we can do two things immediately. We can

take up visual culture as an urgent matter to consider and we can begin the process of changing our practices, one contemporary cultural site at a time. By reading just one book on one contemporary cultural site and working out ways to deal with it in the classroom, the process begins.

Notes and References

1. Eisner, E. (2001), *Competing conceptions of art education: Just where do we stand?*, paper presented at the National Art Education Association Conference, New York.

2. Dobbs, S. (1998), *A guide to discipline-based art education: Learning in and through art*, Los Angeles: The Getty Education Institute of the Arts, p. 9.

3. Freedman, K. (2001), 'Context as part of visual culture', *Journal of Multicultural and Cross-Cultural Research in Art Education*, 18, p. 41.

4. Tavin, K. (2001), 'Swimming up-stream in the jean pool: Developing a pedagogy towards critical citizenship in visual culture', *Journal of Social Theory in Art Education*, 21, p. 153.

5. Smith Shank, D. L. (1999/2000), 'Mirror, mirror on the wall: Searching for the semiotic self', *Art and Learning Research Journal*, 16, pp. 93–96.

6. Irwin, R. (1999/2000), 'Facing oneself: An embodied pedagogy', *Art and Learning Research Journal*, 16, pp. 82–86.

7. Jameson, F. (1984), '–ism, or the cultural logic of capitalism', *New Left Review*, 146, p. 584.

8. Evans, J., & Hall, S. (1999), 'What is visual culture?' in Evans, J., & Hall, S (eds.), *Visual culture: A reader*, London: Sage, pp. 1–8.

9. *Ibid.*, p. 3.

10. Mirzeoff, N. (1999), *An introduction to visual culture*, London: Routledge, p. 3.

11. Darley, A. (2000), *Visual digital culture: Surface play and spectacle in new media genre*, London: Routledge.

12. For example, Baudrillard, J. (1987), *The evil demon of images*, Sydney: Power Institute of Fine Arts.

13. Fiske, J. (1994), *Television culture*, London: Routledge.

14. Darley, *op. cit*. He argues that in their formal characteristics of non-narrative spectacle, of immediate, short, and intense sensation, they share much with the dioramas and phantasmagoria of the late 1700s and 1800s.

15. Kress, G. (2000), 'Mulitmodality' in Cope, B., & Kalantiz, K. (eds.), *Mulitliteracies: Literacy learning and the design of social future*, pp.182–202. Melbourne: Macmillan, p. 182.

16. For example Kaufman, I. (1966), *Art education in contemporary culture*, New York: Macmillan.

17. Featherstone, M. (1991), *Consumer Culture and –ism*, London: Sage.

18. Darley, *op. cit*.

19. Buckingham, D., & Sefton-Green, J. (1994), *Cultural studies goes to school: Reading and teaching popular media*, London: Taylor & Francis, p. 214.

20. Kress, *op. cit*.

21. Ivins, W. M. (1953), *Prints and visual communication*, Cambridge: MIT Press.

22. Kress, G., & van Leeuwen, T. (1996), *Reading images: The grammar of visual design*, London: Routledge.

23. Jameson, *op. cit.*, p. 56.

24. *Ibid.*, p. 57.

25. Chapman, L. H. (2000), *Arts of aesthetic persuasion in contemporary life*, paper presented at the National Art Education Association Conference, Lost Angeles, p. 1.

26. Tavin, *op. cit.*

27. Duncum, P. (2001), 'How are we to understand art at the beginning of the twenty-first century' in Duncum, P., & Bracey, T. (eds.), *On knowing: Art and visual culture*, Christchurch: Canterbury University Press, pp. 15–32.

28. Freedman, K. (2001), 'How are we to understand art?: Aesthetics and the problem of meaning in curriculum' in Duncum, P., & Bracey, T. (eds.), *On knowing: Art and visual culture*, Christchurch: Canterbury University Press, pp. 34–46.

29. For a review see Boughton, D. (1986), 'Visual literacy: Implications for cultural understanding through art education', *Journal of Art and Design Education*, 5: 1–2, pp. 125–142.

30. For a review see Duncum, P. (1991), 'Varieties of cultural literacy art education', *Canadian Review of Art Education Research*, 18: 2, pp. 45–59.

31. Mitchell, W. J. T. (1995), 'What is visual culture?' in Levin, I. (ed.), *Meaning in the visual arts: Views from the outside,* pp. 207–217. Princeton: Institute for Advanced Study, p. 208.

32. Mirzeoff, *op. cit.*

33. Chapman, *op. cit.*, p. 6.

34. Cope & Kalantiz, *op. cit.*

35. This comment derives from advance publicity. *The Journal of Visual Culture* is published by Sage, and the first issue was due out in April 2002.

36. Walker, J. A., & Chaplin, S. (1997), *Visual culture: An introduction,* Manchester: Manchester University Press, pp. 1–2.

37. Barnard, M. (1998), *Art, design and visual culture: An introduction,* London: Macmillan, p. 18.

38. Brook, D. (1983/1984), 'Reflections on the state of art: The art of the state', *Artlink*, 39: 6, pp. 2–3.

39. *Ibid.*, p. 2.

40. *Ibid.*, p.2

41. Darley, *op. cit.*

42. Jenks, C. (1995) (ed.), *Visual culture,* London: Routledge.

43. Mitchell, *op. cit.*

44. Walker & Chaplin, *op. cit.*

45. Williams, R. (1981), *Culture*, London: Fontana.

46. Slater, D. (1997), *Consumer culture and modernity*, London: Polity Press, p. 164.

47. Barnard, *op. cit.*

48. Evans & Hall, *op. cit.*

49. Mirzeoff, *op. cit.*

50. Kress, *op. cit.*, p. 182.

51. Barnard, *op. cit.*; and Walker & Chaplin, *op. cit.*

52. Evens & Hall, *op. cit.*, and Jenks, *op. cit.*

53. Bolin, P. (1992/1993), 'Artefacts, spaces, and history: Art education and material culture studies', *Arts and Learning Research*, 19: 1, p. 154.

54. Bracey, T. (2001), 'What does it mean to know art? An institutional account' in Duncum, P., & Bracey, T. (eds.), *On knowing: Art and visual culture,* Christchurch: Canterbury University Press, pp. 47–65.

55. Buckingham & Sefton-Green, *op. cit.*

56. Mitchell, *op. cit.*

57. Darley, *op. cit.*, pp. 76–77.

58. Thomas, A. (2001), 'Cyber children: Discursive and subjective practices in the palace', *disClosure: A Journal of Social Theory*, 10, pp. 143–175.

59. Buckingham & Sefton-Green, *op. cit.*

60. *Ibid.*, p. 212

Chapter 12: Out of this World: Theme Parks' Contribution to a Redefined Aesthetics and Educational Practice

Nick Stanley

Introduction: the ubiquity of theme park mentality

The audacity that the Disney Corporation has shown in co-opting the Millennium celebrations as an adjunct to the programme for Walt Disney World takes one's breath away. To harness the occasion Disney has created a new show. A Disney manager explained, 'Our challenge was to create something people can touch and share, but at the same time create an important celebration that's a visual feast, something outrageously wonderful'.[1] But this is only one example of the expanding universe of theme park development across the world. At the same time as this extravaganza was announced in the USA the corporation was unveiling the first Disney park in China, with an equally novel justification: 'If there is only one Disney theme park in a country with 1.3 billion people, that doesn't compare very well to five theme parks in the US with only a population of 280 million'.[2] This self-confidence reinforces theme parks' claim to be the undisputed favourite forms of entertainment, and the vehicle for the expression of popular fantasy. This combination is the more powerful because theme parks tap simultaneously a range of sources, from the narrative of the folk and fairy tale, to the architecture of pleasure gardens, the technology of funfairs, and the animation effects of movies and cartoons, all achieved through meticulous marketing. Like black holes in space, these parks seem to have an immense ability to consume new forms of entertainment and to recycle them in theme park vernacular.

But educators have very seldom asked their students why they go to theme parks. Nor do they relate their personal experience, following their own young in these parks, to the educational process that they offer students. This is perhaps understandable as there appear to be so few links between the worlds of popular entertainment and education. A polar typology could explain this division. Theme parks engage in sentimental whimsy, schools and colleges are grimly devoted to realism and objectivity. Theme parks enjoin hedonism, schools offer at best deferred gratification. Yet educators in general, and art educators in particular would do well to study how the choreography of the theme park relies upon strategies which should be inspected seriously.

One of the first things that educators will find is that designers have seized the opportunity to colonise these sites and have seen off all comers, including

historians, architects, surveyors, builders and merchandisers. It could almost be said that theme parks are a manifestation of the untrammelled imagination of designers who treat the architecture of the park as a 'film set' offering a set of visual experiences analogous to those given by the movie camera - from long shot to close-up.[3] In these parks the visiting art educator will be implicated in the action, being offered the seduction (and embarrassment?) of becoming an 'extra' in the performance.[4] It is more than a little ironic that their next-door neighbours in design should have engineered such a major coup in terms of entertainment, consumption and cultural development. Why, the reflective art educators might muse, have these designers been able to get away with it?

Designers have not 'got away with it' - they have reconceptualised the relationship between the everyday and the aesthetic and in so doing have rejected emphatically the European culturalist approach to education. There are three paired features that characterise the designer approach: Spectacle/performance versus reception/consumption; Mimesis versus the spelling out of the imaginary; Experience versus instruction. The principal feature that sets off the theme park from other forms of entertainment is the theatricality built into the very fabric of the enterprise. Theme parks provide a series of dioramas or tableaux reminiscent of late eighteenth and early nineteenth century pleasure gardens, but with one major difference. Theme parks features are more like theatre sets than architectural features. As with film sets there is a viewing perspective but no backstage. It is on such sets that performances take place. But theme park performances are not the same as those on the stage because visitors are not the same as members of a theatre audience. In theme park tableaux visitors are not restricted to sitting out the show, they can move on or accept the invitation to engage with actors in performative enactments, or submit to the mechanical narrative of the ride. Theme park visitors are constantly involved in calculation in terms of scopic and psychic choice. Such choices are as complex as those in econometrics, but in the calculation pleasure substitutes for financial advantage. Designers of theme park attractions build in choice as a fundamental dynamic principle. Axiomatically, no individual should be able to take in everything in a single visit: the designer sets out to both entertain but also to frustrate the visitor.

Designers in theme parks have the tricky job of balancing in their tableaux the realistic representation of a tale or topos with the spelling out of the imagination. So, in Disney, as in very many other parks around the world,[5] the Fairytale Castle, or Sleeping Beauty's Castle, is loosely constructed on Ludwig of Bavaria's 'fairytale gothic' at Neuschwanstein. This is, however, dangerous territory, as the imaginary should outstrip realism. One of the major issues confronting designers is how to prevent the closing down of the imaginary world of the visitor.[6] Children's fairy tales provide a major stock in trade for shows in Disneyland. In the section called 'Fantasyland' Alice in Wonderland, Snow White, Mr Toad and Pinocchio compete

with King Arthur's Carrousel in a reprise of English bourgeois children's literature (and incidentally the associated illustrators). The scope of imagination is a major challenge that theme park designers have to face in order to confront their cultural critics.

One of the techniques adopted by designers to frustrate their critics is to sidestep them altogether. Rather than defend their creations in terms of educational value (though they do this as an aside as well) they point to the experience that the theme park provides to their visitors. This not just everyday experience, but one that is out-of-this-world. Using the technology of the fairground, theme park designers take their riders to the edge of danger. So Ferris Wheels take riders to dizzying heights and panoramas and then drop them back to earth. Roller-coasters transport the participants across the landscape of the park or, as in Disneyland's Pirates of the Caribbean, propel them through 'realist scenery, spirited music, non-stop action and a couple of short but stomach-lurching drops'.[7] There are also 'virtual rides' that offer 'simulated kinesis'[8] usually via IMAX movies. So in World Showcase at EPCOT, Walt Disney World, the least alluring 'nations', Canada and China, draw in customers with total immersion three-hundred-and-sixty degree Circle-Vision shows. These provide physical sensation and a bounded experience. Even in the virtual reality of the IMAX show the content is entirely subservient to the form of delivery. It is the 'ride-like' experience that remains with the viewers as they emerge dizzy from the performance. Kinesis seems to leave both young and adult viewers in a similar state of mild shock. The question that this paper seeks to address is whether kinaesthesia forms a satisfactory basis on which to construct an aesthetic that can reach across to art educational instruction.

The phenomenology of theme parks

At the heart of theme park experience is what Duncum, following Featherstone, has called 'calculated hedonism'.[9] This oxymoron attempts to put both elements into a stable equation. Visitors to parks are presented with both scopic and psychic choice. It is worth reflecting what such choice might involve, especially for the young visitor. Hedonism may be described in less colourful terms. Herbert Read in *Education Though Art* cites with approval the distinction that Lowenfeld makes between the visual and the haptic. The visual subject starts from the environment and develops concepts from perceptual experiences. The haptic, on the other hand 'is primarily concerned with his own body sensations and with the actual space around him. The haptic artist is primarily concerned, not with an object in the outer world, but with his own inner sensation and feeling'.[10] Hedonism may, in these terms be a misnomer. Rather, young and older visitors alike may be engaged in something that looks much more like an exercise in utilitarianism than in seeking unbridled pleasure. It is quickly apparent to all that haptic experiences come at considerable cost. The iron law of theme parks states unequivocally that the better the ride the longer the hours waiting in line for those minutes of pure

pleasure. It becomes inevitable that the hours of tedium have to be entered into the equation - hence the qualifying adjective 'calculated' attached to 'hedonism'. Most theme park guidebooks have as a central objective helping their readers beat the system through tactics of military precision.[11] They are, of course, self-defeating as their readers, all following the same directions, strategize simultaneously to take the same short-cuts.

Theme parks are treated by most theorists, and even by the most sympathetic commentators,[12] as sites of cultural coercion and policing. The programming of events and the controlling of the flow of human traffic are portrayed as malevolent and sinister examples of mass manipulation in which the visitors are unwitting victims being fleeced at every turn by cynical merchandisers of heavily promoted products in a monopolist market. Alternatively, the visitors are treated as wilfully gullible fools who connive in their own manipulation. The fact that Universal Studios, Knotts Berry Farm, Six Flags Parks and a host of others in the United States follow the format set by Disney at Anaheim and Kissemmee, and that Disneyland Paris is almost a replica of Disneyland despite the most persistent attempts to Gallicise it, reinforces the claim that it is a well-laid conspiracy. Critics regard the phenomenon of theme parks as a crucial development in economic and cultural imperialism as well as in the enslavement of young people's imagination.

This is not the way that young people tend to see things. There is, of course, a conspiracy - between young people and those that pay for their days in the park. The conspiracy is that, since the cost of the day is so high, the experience must be memorable and enjoyable. But grim hedonism cannot be guaranteed. Park operators attempt to mitigate disaster (the other side of coin) by segmenting the audience for the shows and rides in a number of different ways. The first is age. Disneyland was the first to offer contrastive areas based on age. So Fantasyland provides quieter shows like Dumbo the Flying Elephant which are aimed at the very young, whereas Tomorrowland has a roller coaster Space Mountain that provides visual and physical disorientation as does the neighbouring Star Tours. Both are popular with adolescents and adults. Some parks, like the Legoland parks in Denmark, Norway, California, and Windsor (England) are themed with younger children as their main audience. The contrast can also be related to levels of noise, colour schemes, and degree of energy dissipation. Not all of these can necessarily be predicted in straightforward ways.

There is no simple equation that younger people are more willing to suspend disbelief than their elders, although older children may display a keen sense of irony. Much has been made of the ubiquity of the family in these parks. But it is precisely the range of different interests that various members bring to the day that threatens to make the day a potential disaster for one or more members. Irony provides a potential escape for the bored and disaffected older child. The theatrical

devices and pretensions behind the shows become of intense interest to such disbelievers. There are also other players who may become collaborators in such dissidence. The most likely are the performers, or in Disney's terms, 'cast members'. As Jane Kuenz documents, the Disney Corporation is ever wary of its employees breaking out of part and extemporising. The Corporation has a high proportion of its staff not committed to family structure, the lesbian and gay workers who represent such a significant proportion of the total staff.[13] And then there are the packs of teenagers who do not come to parks with a family but as self-organised groups, often girls aged thirteen or fourteen, as well as boys some two years or so older. All of these have different takes on the park. Willingness to suspend disbelief may not be as important to visitors as the particular agendas and identities that they play out in this enormous theatrical set.

A major criticism of theme parks is that they pre-digest and package experience in aseptic ways. Marin makes the point more emphatically: 'the possible tours in Disneyland are absolutely constrained by the codes which the visitors are given'.[14] By this Marin means that the design is no more than a stereotyped fantasy. Whilst individuals may think that their form of experiencing is uniquely personal, it is, in effect, merely a stock response. This is a point that I wish to take up later. This point is phenomenologically more significant than most commentators realise. There is something else going on in these themed experiences that is not often considered. What the organisation of architecture, sets and texts in these parks presages is something that may be termed psychic compression. By this I mean that not only is there a morphology of theme park rides, shows and events, but there is another dimension which should be considered alongside - the manner in which the visitor is processed emotionally. It is possible to see such operations along a continuum restriction or prohibition and allows visitors to 'tailor fit' their visit to their personal requirements'.[15] Such choices are planned to take the pressure off the 'real event' attention, it diverts it from the real experience and simulates it not only visually but kinaesthetically. Visitors are pressed together and concentrated into one spot at a dramatic moment. At the culmination of the event the subjects are then released into an outer decompression area where they recover. What is interesting, and a cause for reflection, is that this form of processing blurs the distinction between 'real' and virtual experience.

A particular trope of theme parks (discussed in detail beneath) is the treatment of terror. One of the main applications of theme park technology is in creating thrills or fabricating fear. Here physical sensations of compression on the uphill climb to the summit of the ride are released in the plunge to earth not once but a number of times.[16] The compression-decompression syndrome becomes itself a major trope of the ride. But terror is also subject to fashion. Whilst the Ferris Wheel provided the rider with a panoramic view that unfolded simultaneously as the ground fell away, contemporary rides combine the familiar physical sensations of

defying gravity with the virtual reality effects adopted from the genre of disaster movies.[17] Each ride promises thrills within the context of safety but the riders all take a calculated risk that much publicised 'real disaster' will not strike this time.

One of the major developments in the design of public spectacles and experiences has been the blurring of boundaries. This is the work of designers who have incorporated audience emotional response into their displays. Designers work across the visual spectrum from theme parks to museums and in a wide variety of media. It is perhaps not surprising, then, that there is a seepage across previously clearly demarcated zones of education and entertainment. This development is by no means wholly new as the next section will reveal, but theme parks bring together a number of features of popular culture, technology and display in a way not achieved elsewhere.

Social signification in themed experience

It comes as something as a surprise to recognise that the amusement of theme parks has a history over a century old. It is not much of an exaggeration to say that young people of today would recognise the most significant themes of current parks on the site of the great Chicago fair of 1893 (World's Columbian Exposition). It was there that the Ferris Wheel first appeared as a mechanical successor to the Eiffel Tower. This was the first fair that had all the recognisable features that we expect of an Expo or theme park. As one commentator notes:

> *The Columbian Exposition was a fully realized environment that surrounded visitors with canals, bridges, fountains, promenades, reflecting pools, statues and other examples of neo-classical set dressing. The enveloping fantasy city, with its meticulous concern for the spectator's experience, makes the Columbian Exposition the first world's fair that can be examined from a scenographic rather than an architectural point of view.*[18]

So water, structural engineering, stage-set scenery and statuary, aerial perspective all had their first outing together here. But it was not only the landscape of theme parks that Chicago initiated, but also the forms of entertainment. The Ferris Wheel was sited in the middle of a mile long strip (the central core of the University of Chicago subsequently) which bisected the exhibition. This was the 'Midway Plaisance' or 'joy zone'[19] with rides, and an Electric Theatre that simulated alpine scenery with glistening snow, a storm accompanied by sound of thunder, lightning, and all in a refrigerated one hundred-seat theatre. In a contrastive show elsewhere on the Midway there was a stuffy subterranean theatre where one could experience the simulated sensation of descending over one thousand feet into the earth.[20]

The Chicago Exposition with the Ferris Wheel and the subterranean theatre introduced physical motion into the experience for the audience. It also cemented

the new form of enjoyment with the thrill of mechanical technology. This is perhaps the most enduring feature that present-day 'attractions' (the term was employed at Chicago) have inherited. Dewey recognized: 'two forces... constitute the "modern" in the present epoch. These two forces are natural science and its application in industry and commerce through machinery and the use of non-human modes of energy.'[21] What Dewey correctly perceived was the intimate connection between industrial design and mechanical engineering on the one hand with commercial entertainment on the other. All theme park attractions are powered by electro-mechanical and electronic means. The substitution of electronic for hydraulic power is the only major technical difference between Disney World and the Columbian Exposition. The shows are more remarkable for their similarity than their difference. It should also be noted that technology expands the realms of experience. The Ferris Wheel of 1893 is the first example in the development an ever more daring entertainment technology that has produced Disneyland Paris's Space Mountain, impertinently dedicated to Jules Verne and billed as 'the first adventure of the third millennium'. The form of experience, despite advances in technology, is remarkably close to that of the Ferris Wheel:

Every 36 seconds the Cannon Columbiad fires, launching a 24 passenger rocket train through its five metre wide barrel. Intrepid space travellers aboard shoot to the top in a heart-stopping 1.8 seconds. At the summit they experience a moment of zero gravity, before descending into the mountain and the dark, black depths of outer space for a thrilling, high-speed adventure from the earth to the moon.[22]

This ride uses the extensive links that the Disney Corporation has with the United States space programme to create a combination of mechanical with virtual motion. Hence Eco's aphorism 'Disneyland tells us that technology can give us more reality than nature can'.[23]

Whilst the name of Space Mountain's carrier refers rather to the United States' space shuttle than to 1893 it nevertheless follows a common theme - the American adventure which is seen evidenced in the prototypic voyage of Christopher Columbus to America. Technological advance and Americanism are displayed conjointly not only in Disney but in other theme parks around the world.[24] The conjunction of advanced technology with meticulously planned display tempt theme park designers to become utopian in their vision. But this utopianism should not be confused with universal humanism. Unlike their predecessors at the beginning of the twentieth century theme parks today are constructed away from urban environments in their own totally managed systems. This means that the designers can create without constraint and produce a social artefact only paralleled in ambition by the planners in the Garden City movement who were at their height from 1930s to the 1950s. But there are some significant differences between the two. First, Garden Cities integrate public transport into their plans.

The early amusement parks like Coney Island did the same, but currently parks are built on green sites well away from cities on major highway systems readily accessible only to those with private transport. Even those 'parks' which are created in large shopping malls in major cities are still virtually inaccessible by public transport.[25] Unlike the Garden Cities these parks do not have any commitment to democratic social integration but are concerned only with profitability. As Davis remarks, 'with their focus on the largely white, English-speaking, upper-middle-class, film-going audience with children, theme parks are part of a search for reliable ways to reach the people who have money to spend'.[26] Not only is the high cost of admission to park and rides an effective social form of discrimination, but once inside, the bookish, middle-class literary references serve to provide none too subtle markers of whose culture is being celebrated. The surveillance and policing of the parks ensures that nothing occurs to upset this dream. There are no poor, few members of minority communities, and despite the visible facilities for the handicapped, few young or old who are not fit enough for the gruelling pace of the day's endurance test.

Disney designers can claim to have had as much if not more influence on contemporary architecture than the Garden City designers. Their utopianism comes in a more comfortable form, scarcely noticed by young visitors but, nevertheless, it offers an important means of providing reassuring familiarity from the first moment in the visit. What theme park designers do (and Disney Corporation and Time-Warner's Six Flags parks lead the way) is to create a symbolic architecture. As Davis comments:

> The Disney artists' feel for detail, diversified style, for artifice and trompe l'oeuil, and for drama (all skills based on cartooning and animation), are not only more interesting than that of conventional city planners but [have] produced an amazingly different set of assumptions about what architecture could do'.[27]

The appearance of figures from movies in logo form on sets, clothing, and merchandise throughout the park is matched by 'cute' characters acting on screen or 'live' in costume. Whether this 'symbolic architecture' works is a matter not of architectural taste but more according to emotional response. Because the architectural features and tropes are contained within the cinematic reference system they are treated as part of it. Architecture is not mere stage set but an integral element in the creation of mood. So theme park architecture is like a reverse case of the emperor's clothes. If one is emotionally swayed by the ensemble of the park one is as unlikely to notice the architecture as the psychic processing that is occurring. But if, for any reason, the spell is broken, the dissident immediately notices the slipshod, the tawdry and the visual impoverishment of the sets. To enter a theme park as a dissident is like entering a theatre the morning after last night's performance.

Successful theme parks, with their weave of cartoon movie imagery, psychic processing and choreographed performance, come to acquire a symbolic over-determination. They become synechdoches for all pleasurable symbolic events. So it is not in the least ironic that people who have enjoyed these parks when young and celebrated their birthdays there should elect to return to them when they get married. Walt Disney World is now the most popular honeymoon destination in the world.[28] An element of similar nostalgia combined with symbolic investment may well attach to those who now flock to Disney Corporation's housing estate at Celebration Place. Day to day living out of symbolic imagery may have its own attendant problems, however.

Reconciling the imagination with product and process: the challenge for art education

Up until this point my discussion of art education has been a tale of missed chances. Designers have been described as stars of the show. There are other disciplines that find a place for theme parks in their curriculum. Tourism and tourism research is a recent addition to the high school syllabus and places itself strategically between business and social studies. It is also a well placed subject to offer work experience and careers management, especially given the importance of the sector in providing employment. So, for example, Alton Towers, one of Britain's largest amusement parks, a technologically advanced type of Coney Island, offers a national vocational qualification in Leisure and Tourism. Similar vocational schemes operate in many parks across the world. At Alton Towers students undertake modules in planning a special event, health and safety, human resources, customer services and marketing.[29] But there are some considerable obstacles in the way for art education before it can take its place in the 'themed curriculum'. The most significant is the concentration within the discipline on process and product. Art education could be said to be engrossed with its own epistemology and attendant methodology. The prominence of such movements as Discipline Based Art Education ensures that art education remains locked into itself as a discipline. Why designers have been so successful in theme park construction and philosophy is that they have been able to look at issues external to their discipline and then reconceptualise their approach to the presenting issues.

I do not think that one needs to abandon the underlying project of art education - the development of visual awareness and capacity to create visually significant artefacts - to entertain my suggestions for a redefined aesthetics and art practice. I am not proposing that we substitute the study of theme park architecture and experience for the current art curriculum. It would be a mistake to propose a naïve celebration of populist taste. What I feel we need is the opportunity to reflect on popular visual and cultural worlds not currently within the purview of art education. Of necessity I owe the reader and the deviser of the art education curriculum some practical examples of what I have in mind. But before outlining a

curriculum proposal it is worth noting that there are already well-established principles from within the mainstream of art education that can be invoked and employed. The most immediate is Dewey's notion of building on experience, and using the closure of a satisfying experience as the basis for an aesthetic. Certainly, Dewey warns us sternly against 'dissipation, incoherence and aimless indulgence'[30] but this is not an injunction against using everyday experience. Instead, what Dewey is arguing is that everyday experience can be used, or one might say, phenomenologically, 'bracketed' and made the subject of rigorous study. To this one might add Read's endorsement of the haptic. One might say that contemporary art education falls almost entirely into what Read following Lowenfeld calls 'the visual type' committed to representation of the environment, whilst the haptic is concerned with the student's 'own inner world of sensation and feeling'.[31] If one takes seriously the body of students' everyday experience and then interrogates their world of sensation and feeling some interesting fresh concerns may become apparent. I further emphasize that I am not claiming that the subjective inner world of everyday experience is a sufficient basis on which to construct a robust curriculum. I am asserting that it is worth inspection and incorporation into a revised one.

My proposal is for students aged fifteen to seventeen involved in any mainstream art education programme. The International Baccalaureate perhaps offers the most widely available model. I would ask students to take any local or national theme park with which they are familiar and then to devise a series of projects that consider the construction of particular themes. At the same time students would be asked to run a parallel exercise taking an event, story, or theatrical presentation, and devise a storyboarding project either in simple graphic form, animation or real time. Both aspects of the work require group discussion and planning as well as individual personal response. I offer beneath two suggested examples, but the principles should work with local alteration, in general terms. The examples are 'Sleeping Beauty's Castle' in Disneyland, Anaheim (reproduced in Florida, Paris, Tokyo, as well as in other parks in Barcelona, Jakarta, Manila and Shenzhen) and *'Space Mountain - De la Terre à la Lune'* in Disneyland Paris. I have chosen them for the range of contrasts that they present but also to explore some common qualities that they share.

For each theme, students are asked firstly for their personal response to the experience, visiting the castle or lining up for and then going on Space Mountain. Students may find giving an opinion initially quite difficult as there are no pre-existent rules of engagement. Stock responses may cover for nervousness. So, 'I liked it' or 'I didn't like it' may be the most that young people may venture as a response. This will probably be a result of their inexperience in construing meaning in circumstances that they know are normally considered beneath the realm of serious critical discourse. But some simple criteria can be explored to

loosen up student response. The examples chosen here appear to provide a dichotomy that can be spelled out in a number of ways. The promotional literature for each offers a neutral way in. 'Sleeping Beauty's Castle' is described thus:

> *This majestic structure is the frame of reference for all of Disneyland. Towering above Main Street, and encircled by a rock-rimmed moat, the castle is a masterful facsimile of Mad King Ludwig's famous Neuschwanstein castle in Germany. Its royal-blue turrets and gold spires glisten in the sun, providing the ultimate visual fantasy. You cross the medieval palace's drawbridge into a world of magic and wonder. The Sleeping Beauty tale is told in colorful, three-dimensional miniature sets, complete with the Prince's tender kiss that brings the fair maiden back to wakefulness. This attraction won't thrill any but the very young, although adults may appreciate the detail in the Lilliputian dioramas.[32]*

There are a number of ways that this text can be compared with the experience of the students. The most obvious relates to the design and architecture. In what way can the castle be said to offer 'the ultimate visual fantasy'? What in their view is 'visual fantasy'? What are the visual tropes that are used to supply it? How is the content of the fairy tale integrated into the display? How is narrative flow produced? Students may also like to reflect on the extent to which they are 'symbolically and psychically processed' by the attraction. The guidebook is quite clear that they will not be and that the show will only engage one segment of visitors, the very young. The degree of psychic compression is very low. But, is this judgement true? The whole show can be treated ironically and the sexual and gender imagery can be either sent up or subjected to further discussion. This could be treated as an example of 'visual ideology',[33] that is to say, the language and the underlying philosophical premises expressed in plastic form can be subjected to sustained and systematic criticism by the viewer or reader. The tale of Sleeping Beauty can be explored from a number of different perspectives. Perrault's nursery tale of 1697 has been subject to a range of interpretations from literary criticism, psychoanalysis and feminist theory. Again, students could be asked how they would treat the tale and its visualisation themselves. How would they generate 'a world of magic and wonder'? This, I suggest, is not a rhetorical question. It is in the making that students will further work out the implications of the intellectual question that they are studying. Furthermore, this particular work serves to give them pause to reflect upon the process of change in visual and critical experience they have gone through from their earliest days in preschool and first cycle education. It is more than likely that at the end of the exercise in both examination and construction that no single answer suffices. An aspect of postmodern art education is that elements of ambiguity and contradiction surface and cannot easily be reconciled.

'Space Mountain' differs dramatically from 'Sleeping Beauty's Castle'. The language of the promotional literature contrasts markedly in tone and emphasis:

Hang on - it's quite a ride!

The most sophisticated state-of-the-art adventure of its kind anywhere in the world, 'Space Mountain - From the Earth to the Moon' features five Disney firsts. Technological enhancements to a computerised ride system result in an experience you've got to fly to believe. Close up, Space Mountain is a breath-taking sight. At night the huge brass dome glows green and gold. As the cannon pounds and recoils, shafts of light spray through the jets of steam. It's pure fantasy in the oldest and greatest Disney tradition (yet built with the latest space-technology specifications). It looks back to a time when extravagant mysteries about space still existed, in a homage to the stories of French visionary, Jules Verne.[34]

Students will quickly become aware of the contrast in mood and emotional engagement at 'Space Mountain'. Not only are the young or rather, the small, excluded on the grounds of safety (and students may want to consider the design implications of 'safety') but the psychic compression that starts on joining the line builds inexorably during the hour or more wait right up until getting on board and being catapulted into motion. The technological vocabulary could be described as masculinist - it certainly suggests a sexual metaphor. Students might want to discuss their impressions of the experience and the extent to which they felt it had been mediated through age, gender, race and sexuality. Is the presentation of technology inevitably gendered? Students may also look for cognitive dissonance in the literature. How can 'fantasy in the oldest and greatest tradition' be squared with 'latest space-technology specifications'? And what is the reference to Jules Verne doing here? Students may find material here for discussion into the politics of display.[35] One of the hardest tasks that students might set themselves is how they would go about displaying technologically complex amusements in a non-gendered way.

But students could also explore some of the common features that both of these examples display. First, they both offer visual pleasure through experience. It is suggested in both these cases that students start from their own responses. They are then invited to inspect and unpack these experiences so that they no longer remain 'out of this world'. Instead they provide a basis for these young people to develop specific personally meaningful aesthetic systems that they are able to articulate. The apparent paradox of experiences being simultaneously 'out of this world' and everyday can be resolved when their aesthetic features become open to inspection.

The exercises that I have suggested can be tried with much younger children and with adults. One thing that teachers whether they be in art education, literature, history, design or business studies and marketing need to keep is an openness to student experiences and a willingness to work with the categories that students

devise. I believe that art education is in a potentially privileged position here to expand the range of haptic approaches based on experience. The particular appeal of work based on theme parks is that art educators will, perforce, have to rub shoulders with colleagues in other disciplines and listen intently to their students. In the process the ambition of art education may itself become extended, more self-reflective and, hopefully, more enjoyable for all.

Originally published in the International Journal of Art and design Education, Volume 21: 1, 2002

Notes and References

1. (1999), 'Walt Disney World Vacations', *The Chicago Tribune*, 23 October 1999.

2. Judson Green, chairman of Disney theme parks, *South China Morning Post*, 2 November 1999.

3. Bukatman, Scott (1991), 'There's always tomorrowland: Disney and the hypercinematic experience', *October*, 57, p. 61.

4. Eco, Umberto (1986), *Travels in Hyper-Reality*, p. 42.

5. Stanley, Nick (1998), *Being Ourselves for You: The Global Display of Cultures*, Middlesex University Press, p. 58.

6. The responsibility is onerous: 'Disney's technical wizardry and capacity to present *the* view has to be acknowledged. It has long been recognized that Walt's versions of fairy-tale classics became in most people's minds the way in which they conceptualised these classics in the future'. Alan Bryman (1995), *Disney and His Worlds*, Routledge, p. 190.

7. Wade, J., Gillenwater, S. and Ritz, S. (1992), *Disneyland and Beyond: The Ultimate Family Guidebook*, Ulysses Press, p. 41.

8. Bukatman, (1991), *op. cit.*, p. 75: 'The wraparound movie screens inevitably feature helicopter drops into the Grand Canyon'.

9. Duncum, P. (1999), 'Towards an art education of everyday aesthetics' manuscript, citing M. Featherstone, *Consumer Culture and -ism*, Sage, 1991.

10. Read, H. (1958) (Revised Edition), *Education Through Art*, London: Faber and Faber, p. 133.

11. Wade et al *op. cit.*:

 About five minutes before attendants drop the rope on Main Street to let visitors into the park, head for the China Closet or Carefree Corner, the last two shops on the right of Main Street as you face Sleeping Beauty Castle. They both have back doors that are opened when the Main Street rope is dropped, which let you zip through and get a 100-yard head start on the crowd that inevitably surges towards Space Mountain and Star Tours Angle to your right to Tomorrowland and you will be one of the first on either ride. As soon as you're off one, speed on to the other (which will be 30 seconds away.) Having polished off these two, you can now dash across the park to the Haunted Mansion and Pirates of the Caribbean, two other attractions that develop lines quickly. If you do it right, you will have ridden four major attractions within an hour of opening time. [p. 34]

12. Among the more sympathetic, and the less conspiracist studies is that conducted by Jane Kuenz and her colleagues and published as The Project on Disney *Inside The Mouse: Work and Play at Disney World,* Duke University Press, 1995. Louis Marin offers one of the most theoretically interesting hostile reviews in his 'Disneyland: a degenerate utopia', *Glyph*, 1, 1978.

13. '...casual estimates made to me of the park's gay and lesbian population ranged from 25 to 75 per cent depending on the department'. Kuenz (1995), *op. cit.*, p. 153.

14. Marin, *loc. cit.*, p. 59.

15. Eugene Keene 'Brú na Bóinne: achieving sustainable balance in heritage landscape management', *The European Tourism and Environment Workshop*, Kinsale, 2-3 April 1998.

16. The new ride at Walt Disney World is called 'The Twilight Zone Tower of Terror'. The publicity states: 'Walt Disney Imagineering has made the Tower more terrifying than ever, dropping guests 13 stories into "the Twilight Zone" again and again - and again. There's a brief moment of panic when cables "snap" and electrical sparks join a shower of screams.'

17. I am grateful to Pat Cooke here for his observations on the dystopia of terror.

18. Steve Nelson (1986), 'Walt Disney's EPCOT and the world's fair performance tradition', *Drama Review*, Winter, 1, pp. 7-8.

19. Ley, D. and Olds, K. (1988), 'Landscape as spectacle: world's fairs and the culture of heroic consumption', *Environment and Planning D: Society and Space*, 6, p. 199.

20. Burg, D. (1976), *Chicago's White City of 1893*, University of Kentucky Press, p. 230.

21. Dewey, J. (1958), *Art as Experience,* Capricorn Books, p. 337.

22. Disneyland Paris website July 1999.

23. Eco, *op. cit.*, p. 44.

24. Perhaps the most unexpected of these are the 'American Dream Park' in Shanghai and 'Beijing World Park'. See Peter Beaumont and Martin Parr 'Taking the Mickey' (London) *Observer* Life section 28 February 1999.

25. The largest example that I know of is the shopping mall in Minneapolis that draws an international clientele. This mall is built around a roller coaster and contains a large range of other attractions and rides.

26. Davis, S. G. (1996), 'The theme park: global industry and cultural form' *Media, Culture and Society*, 18, p. 418.

27. Davis, M. J. (1981), 'Disneyland and Walt Disney World: traditional values in futuristic form', *Journal of Popular Culture*, 15, p. 126.

28. Kuenz (1995), *op. cit.*, p. 80.

29. Alton Towers website, July 1999.

30. Dewy, J. (1958), *op. cit.*, p. 40.

31. Read, H. (1958), *op. cit.*, p. 133.

32. Wade et al., *op. cit.*, p. 48.

33. The term is Nicos Hadjinicolaou's. He defines it as 'a specific combination of the formal and thematic elements of a picture through which people express the way they relate their lives to the condition of their existence, a combination of which constitutes a particular form of the overall ideology of a social class', (1978), *Art History and Class Struggle,* Pluto Press, p. 95.

34. Disneyland Paris website, July 1999.

35. The politics of display is always an interesting and provocative topic, whether it be in relation to linguistic and cultural divisions in Canada, religious in Ireland, or indigenous/settler in South Africa, USA, Australia or New Zealand. In the case of Disneyland Paris there were major negotiations between Disney and the French Ministry of Culture including the Minister, Jack Long, over Gallicising of American folk and fairy tales. The results, as here with Jules Verne, ended up as mere cosmetic tokens.

Chapter 13: Who's Afraid of Signs and Significations? Defending Semiotics in the Secondary Art and Design Curriculum

Nicholas Addison

Critical studies and classroom practice

Although there is still much potential for its neglect, the National Curriculum has ensured that the critical reception of art cannot be disregarded. Despite Thistlewood's heresies[1] and an increasing literature, critical and contextual studies are at best a secondary observance servicing the primary concern of making: its significance in the classroom is far from secure. What is actually happening at the point of delivery? Past research highlights the modernist canon which lies at the centre of primary and secondary education up to and including GCSE.[2] Pupils learn to copy, transcribe and pastiche exemplary sources and occasionally integrate some technical or stylistic feature, pointillism, fragmentation, and apply it to their own observations. One might argue that the Eurocentric historical period chosen (approximately 30 years either side of 1900) is appropriate to the focus of GCSE which emphasises personal response accommodated within the orthodoxy of working from observation. With young children transcription is a revealing process because they select from the image to be 'copied' those things or features which hold most interest for them. But at secondary level, with its analytical imperatives and tools, the process of transcription focuses on the more superficial task of the imitation of surface. This is not without its benefits, but it is time consuming and cannot be said to include critical or contextual investigation. Thus at GCSE, A level and GNVQ, the critical and contextual sketchbook is all too often a collection of transcriptions (some annotated), drawings and pamphlets from exhibitions, written personal responses to favoured images, extracts copied from art historical texts and serendipitous reproductions. It often possesses great energy and enthusiasm, seems to indicate visual investigation, but in truth has only its 'look': closer inspection reveals appropriation, imitation, material exploration and variation.

Several authorities, including Dyson,[3] Taylor,[4] Parsons,[5] Csikszentmihalyi,[6] Schofield[7] and Cunliffe[8] have suggested useful methods by which art and design can be critically approached in the classroom. Most will no doubt be criticised for belonging to modernist paradigms, whether those of developmental psychology, structuralism, humanist universalism or disinterested aestheticism. Some teachers possessing an art historical background may in addition use formalist and/or iconographic methods, for example, respectively, those of Wolfflin[9] and

Panofsky[10] who are both part of a modernist critical tradition. As such their methods depend on analytical processes that are sequential and developmental and may therefore seem inappropriate, especially at key stage 3, because there is little time to incorporate their use in any sustained and rigorous way. It is unlikely therefore that pupils would be able to assimilate and apply these methods independently or in other analytical contexts. What interpretative methods do pupils tend to use in their everyday lives? I would argue that they use semiotic ones; they seek clues as to a person's personality, status, accessibility, through categories of signs. They interpret such external signs as clothes, body forms, posture, responsive actions before moving to the interactive ones of gesture, speech and so on (perhaps this is a more synchronous process). These are the methods of interpretation which should be built upon in the classroom. On one level the way that such processes can be applied to representational art is obvious, represented indicators like gesture being decoded in the same way. But this transference from life to art would suggest that the vehicle of representation, its material base and style, is neutral, as if it were independent of meaning: the old form/content dichotomy which, I would contend, a structured and contextual (or framing) semiotics is able to resolve.

The contemporary field of images is extraordinarily diverse and inclusive - historical and multicultural ones no more or less than others - and the National Curriculum requires that this diversity be addressed. How, therefore, can teachers enable pupils to understand art objects that have signifying systems which are obscure or unknown? After all these objects, familiarised through reproductions, are often known in appropriated, decontextualised or recontextualised forms. Should they revive the critical methods and criteria from the maker's culture or period, or should they have recourse to familiar and current methods? If teachers encourage the clue seeking most usually employed by pupils, they would need to complement it by providing, or asking pupils to research, contextual information. Without it pupils would be unable to decode what are likely to be relatively opaque sign systems. However, teachers should be careful not to impose preconceived structures which will predetermine interpretation. Puttfarken demonstrates how, in bypassing traditional methods in favour of semiotic 'detective' work, one can strip away years of formalist misinterpretation. In his analysis of Caravaggio's paintings on the *Story of St. Matthew,* he attends to the sort of details which can be marginalised in formalist accounts. This allows him to question received notions about the determining role of such privileged signifiers as compositional rhetoric and leads him to a radical reinterpretation:

> *We know that in good detective stories the person caught with a smoking gun or a blood stained knife is not the murderer. To traditional admirers of Caravaggio's art, in fact of most European art, this may seem an entirely inappropriate attitude to adopt in*

front of his masterpieces. Yet I believe it is an attitude which we are invited to adopt by the picture itself (The Martyrdom of St Matthew)... we find that the close scrutiny of details belies the obvious display of pictorial composition. Expecting to witness the murder of the saint, we have virtually no option but to see the nude man with the sword as attacking Matthew; this is the logic of pictorial normality, and the immediate visual evidence seems fully to confirm our expectations. Yet in carefully observing and considering the details of dress, movement and expression, we come to a different conclusion.[11]

However, semiotics remains something of a dirty word for art and design education in schools. It is often perceived as a hopelessly indulgent method employed by academics who, divided into factions, pursue nothing but the niceties of introverted speculation. Alternatively semiotics' association with both linguistic semiology and that great 'other', Media Studies, condemns it as an alien and corrupting influence: art is fearful of methodological contamination. In relation to a curriculum embracing post-feminism and post-colonialism, semiotics is stuck in the past, tainted by its collusion with modernist metanarrative and imperial in its ambition. Furthermore, the hybridity and virtuality of -ism's anointed vehicle, multi-media, is seen as alien to semiotics which appears bound to structuralist principles and therefore constipated in an age of fluidity. In schools, for whatever the reason and from whichever perspective, the potential accessibility of semiotic methods for both the reception and production of art (visual and aesthetic literacy) is avoided:

...the meaning of technological images cannot be simply understood in terms of what has been called 'visual literacy', which has generally meant the semiotic reading of signs and symbols... the concept of visual literacy is an attempt to force images to fit illegitimately into a structuralist analysis of literary texts that tends to narrow visual meaning. Rather a broad view of creative production and interpretation in relation to multiple meanings and visual qualities is called for if we are to understand and teach about the use of images in contemporary life.[12]

Such sentiments are the product of misapprehensions. Semiotics is not synonymous with semiology: it belongs to a tradition which sought to define systems of communication other than language.[13] Semiotics as an analytical method has no need to differentiate between or within types of object, unlike art criticism and history which are bound to hierarchical distinctions: fine/applied, genius/artisan, primitive/decadent. Semiotics has not remained inert or stuck in a rigid structuralist paradigm; poststructuralist semiotics admits of no closure:

Derrida, in particular, insisted that the meaning of any particular sign could not be located in a signified fixed by the internal operations of a synchronic system; rather, meaning arose exactly from the movement from one sign or signifier to the next, in a

perpetuam mobile where there could be found neither a starting point for semiosis, nor a concluding moment in which semiosis terminated and the meanings of signs fully 'arrived'.[14]

In considering the possibility of a postmodern curriculum it is essential to examine the institutional host (schools) by which it will be framed. Universal secondary education is a modernist phenomenon. The inclusion of art and design in the curriculum is equally a product of modernist utopian philosophies, whether utilitarian, conceiving design education as answering to the needs of industry and thus the common good, or aesthetic, responding to innate critical and creative faculties to enable personal actualisation. Neither of these seems to hold much cogency or viability for schools any longer so art and design is in a crisis of identity. Squeezed by rationalisation, threatened by technology and media studies it takes up defensive positions. A radical and wholesale shift to the concerns of the postmodern appears to be a proactive answer, but art and design cannot take on the position of postmodern vanguard alone. However, within the modernist structures of education the case for postmodern intervention is a sound one paralleling Modernism's built-in critique of itself (as an artistic not an educational phenomenon). Foster elucidates this potential for continuous critical self-renewal:

Thus was formal modernism plotted along a temporal, diachronic, or vertical axis: in this respect it opposed an avant-gardist modernism that did intend 'a break with the past' - that, concerned to extend the area of artistic competence, favoured a spatial, synchronic, or horizontal axis. A chief merit of the neo-avant-garde... is that it sought to keep these two axes in critical coordination... it worked through its ambitious antecedents, and so sustained the vertical axis or historical dimension of art. At the same time it turned to past paradigms to open up present possibilities, and so developed the horizontal axis or social dimension of art as well.[15]

In ignoring semiotics art educators are avoiding their 'ambitious antecedents' and neglecting to take on methods which will allow them to position art more cogently in its multiple contexts. Furthermore semiotics is close to pupils' own modes of meaning-making in ways that logic, mathematics, formalist aesthetics and other systems that share a privileged status in the school curriculum are not:

Compared with logic it (semiotics) is highly pragmatic, because the inferences with which it is concerned are ones which pervade our everyday lives. They are the inferences by which we make sense, or fail to make sense, of our environment. Semiotics is profoundly social, because of the fundamental role which signs play in every moment of human life and of our interaction in society.[16]

The 'what' and the 'how'
Where semiotics as an academic discipline adds to the everyday process is in its

concern not only with the 'what' of signs, but in the 'how'. When considering how signs work in art it is necessary to examine them as signifying through a series of relationships. Thus the artwork is not a repository of meaning but a site for meaning-making. Seen from this perspective its multiple signifiers; materials, composition, modality, in combination with its signifieds; representations, ideology, allusions, become an interrelated system through which meaning is actively produced. These meanings are not fixed in any intentionalist or affective way but are constructed through an interactive relationship between a work (no doubt once replete with intentions) and a perceiver and are thus open to difference and multiple significations. How the signifier relates to its signified (form with concept) and how in turn the perceiver relates the resulting sign to a referent (an experience or thing in the world) is the interesting question. How does the sender relate to the receiver? How is meaning altered by investigating the contexts of the artwork's making? Which contexts are significant? Who produces the meaning? How are intentions and interpretations negotiated? Where is meaning situated? In the artwork, in one or more of the active participants or somewhere outside and between them? In understanding how a system of signs works pupils are enabled to consider not just the content or technique of their own work and its relationship to exemplars, but their own practice, looking and making, as a method for the production of meaning and as a vehicle for communication.

Some commentators have argued that art historical methods are semiotic,[17] if so, why introduce a new terminology for something that already exists? Formalism, iconography and even connoisseurship, in their separate ways, isolate the work of art from its subjective and social dimensions. They posit objective systems that can produce 'right' or 'appropriate' attributions and interpretations through the retrieval of intentions.[18] The new semiotics is more concerned with the uses of art, understanding the social application and transformation of artefactual codes, than in reinforcing its status as autonomous and ineffable. Nonetheless formalist methods might be seen as a proto-semiotic in that they answer:

> ...the perfectly legitimate concern to assert the specificity of artistic, and principally plastic phenomena, and to preserve their study from any contamination by verbal models, whether linguistic or psychoanalytic, since the characteristic articulation and import of the work of art are assumed to be irreducible to the order and dimension of discourse.[19]

At the beginning of the twentieth century the desire to map out the semic territory of a particular expressive and communicative mode, here the plastic arts, must have seemed urgent, a task giving credence to the hard-won position of (illusory?) autonomy which unburdened artists, however briefly, of their previous function as recorders and propagandists to power, servants to texts and design. Wolfflin's system of formalist, binary oppositions has particular similarities to the self-

consciously semiotic system formulated later by the anthropologist Levi-Strauss,[20] itself Saussurean in derivation. Although Wolfflin's method, like any other, can be applied as a blunt or subtle instrument, its basic tenet, the interrogation of an artwork through the imposition of associated oppositions, has very real possibilities for use with school pupils: in his case; linear/painterly, plane/recession, closed/open form, multiplicity/unity, absolute/relative clarity,[21] in Levi-Strauss' profane/sacred, cooked/raw, celibacy/marriage, female/male, central/peripheral. Wolfflin's formal and Levi-Strauss' social oppositions might be usefully extended through issue-based oppositions, e.g. conservation/redevelopment, purity/hybridity, popular/elite, genetic/social.

Iconographic analysis, or even its Panofskian extension into iconology, contains the danger of assuming that the vehicle, or in semiotic terms the signifier, is neutral (an issue already identified above). Here the artwork's content (the signified) is delivered by its formal means (signifiers) in a seamless process of transmission where only the symbolic nature of its represented objects stands in the way of literal interpretation. The iconographer's job is then to decode the represented symbols: to do this they need recourse to originating texts (in the beginning was the word):

> *It means introducing into the analysis of the picture the authority of the text from which the picture is supposed to derive its arrangement through a kind of figurative and/or symbolic application, in which each pictorial element corresponds to a linguistic term... iconography as a method, is theoretically founded on the postulate that the artistic image (indeed any relevant image) achieves a signifying articulation only within and because of the textual reference which passes through and eventually imprints itself in it.*[22]

The insertion of art historical methods to support and provide academic credibility to a 'recreational' or 'vocational' subject is a tempting strategy. But is the insularity of formalist analysis a suitable method for assisting pupils to learn through and about the visual? Particularly in a period when art is having to defend its position in the curriculum not only on intrinsic but extrinsic grounds. Does the primacy afforded texts by iconography provide a suitable method to prepare pupils for the semiotic landscape of today's multi-media arts and communications which no longer attribute to the word a beginning? The implications here for the relationship between verbal/visual modes of communication and power are touched on by Kress and Leeuwen:

> *...the opposition to the emergence of a new visual literacy is not based on an opposition to the visual media as such, but on an opposition to the visual media in situations where they form an alternative to writing and can therefore be seen as a potential threat to the present dominance of verbal literacy among elite groups.*[23]

The authors' 'grammar of visual design' is a systematic and exacting semiotic method for the analysis of 'images', largely two dimensional, from 'Western culture'. It would take too long here to examine its benefits and pitfalls in relation to its application to the classroom, but teachers of art and design would do well to examine its assertions. Like any grammar it aims to establish patterns of use, if not rules, and teachers may be wary of any such exercise that aims to define and thus limit and control. However, the authors contend that it is disempowering to deny pupils critical access to the dominant modes of communication. Building on the inclusive visual field embraced by Barthes,[24] the authors construct a method for analysing the production of meaning in images concentrating on their formal as opposed to lexical components. However, in place of formalist insularity they 'provide inventories of the major compositional structures which have become established as conventions,' and, following the principles established by the psychologist Arnheim, '...analyse how they are used to produce meaning...'.[25] For Kress and Leeuwen, unlike Saussure, signs are never arbitrary but always motivated. Although the motivated sign bears some resemblance to the notion of intention already criticised, for the authors signs are only interesting as a means of 'social (inter)action' not 'self-expression'. It is the use of images, not their intrinsic properties, that is the target of their method, an emphasis that provides a critique of much art and design practice in schools and one that is surely a key factor in any programme that seeks to educate the individual in a social context.

In addition to providing art educators with a method to engage pupils in the social, interactive potential of art, semiotics provides ways of examining the relationship between word, image, sound and the other sensory modes used simultaneously in multi-media and installation. Rather than force the visual into the straitjacket of linguistic terminology recent semiotics provides a cross-modal vocabulary: '...it liberates the analyst from the problem that transferring concepts from one discipline into another entails'.[26] Art education does not possess a discrete formal language and teachers are fooling themselves if they think they have not already had recourse to the metaphoric application of others' terms; tone, rhythm, harmony, and metaphor itself, all have their origin in other arts. Semiotics can thus provide a common critical language which addresses not only the relationship between objects and their contexts, but also the problematic relationship between objects and their viewing subjects:

> The idea of 'context' as that which will, in a legislative sense, determine the contours of the work in question is therefore different from the 'context' that semiotics proposes: what the latter points to is, on the one hand, the unarrestable mobility of the signifier, and on the other, the construction of the work of art within always specific contexts of viewing.[27]

If modernists, artists and educators, have tried to limit the arts by separating them

into discrete 'areas of competence... unique to the nature of its medium,'[28] they have not done so without forming equivalent definitions of excellence across the arts. The postmodern art educator might consider a different alliance, one in which the key criteria is not quality, and its concomitant genius, but interest achieved in and through diversity: semiotics seeks out qualities of significance not significant quality. In this way the curriculum does not have to be based on hierarchical constructs of worth with their territorial claims and value oppositions but on motivated inquiry, a plural and critical approach to visual culture and its contexts including the pupils' own.

Originally published in the Journal of Art and Design Education, *Volume 18: 1, 1999, updated by author 2003*

Notes and References

1. Thistlewood, D. (1993), 'Curricular Development in Critical Studies', *Journal of Art & Design Education*, 12: 3, reprinted in this publication.

2. QCA (1998), 'A Survey of Artists, Craftspeople and Designers Used in Teaching Art Research' in *Analysis of Educational Resources in 1997/98*, research coordinated by Clements, R. (1996-97), CENSAPE: University of Plymouth.

3. Dyson, A. (1989), 'Art History in Schools' in Thistlewood, D. (ed.), *Critical Studies in Art and Design Education,* Harlow: Longman/NSEAD, pp. 130-131.

4. Taylor, R. (1989), 'Critical Studies in Art and Design Education: Passing Fashion or Missing Element' in Thistlewood, D. (ed.), *Critical Studies in Art and Design Education*, Harlow: Longman/NSEAD, pp. 38-39.

5. Parsons, M. J. (1989), *How We Understand Art*, Cambridge: Cambridge University Press.

6. Csikszentmihalyi, M. and Robinson, R. (1990), *The Art of Seeing: An Interpretation of the Aesthetic Experience*, Malibu: J Paul Getty Museum, Getty Center for Education in the Arts.

7. Schofield, K. (1995), 'Objects of Desire: By Design' in Prentice, R. (ed.), *Teaching Art and Design*, London: Cassell, pp. 68-79.

8. Cunliffe, L. (1996), 'Art and World View: Escaping the Formalist Labyrinth', *Journal of Art and design Education,* 15: 3, an up-dated version is in this publication.

9. Wolfflin, H. (1915), *Principles of Art History,* 6th edition (trans. M. Hottinger) (1960), New York.

10. Panofsky, E. (1955), *Meaning in the Visual Arts*, 1983 edition, Middlesex: Penguin.

11. Puttfarken, T. (1998), 'Caravaggio's *Story of St. Matthew*: A challenge to the conventions of painting', *Art History*, 21: 2, p. 177. Oxford: Blackwell.

12. Freedman, K. (1997), 'Teaching Technology for Meaning', *Art Education*, 50: 4, p. 7; Freedman refers to N. Brown, (1989), 'The Myth of Visual Literacy', *Australian Art Education*, 13: 2, pp. 28-32.

13. Sturrock, J. (1993), *Structuralism*, London: Fontana.

14. Bal, M. and Bryson, N. (1991), 'Semiotics and Art History: A Discussion of Context and Senders' in D. Preziosi (ed.) (1998), *The Art of Art History: A Critical Anthology*, Oxford: Oxford University Press, p. 247.

15. Foster, H. (1996), *The Return of the Real*, Cambridge, Massachusetts & London: MIT Press, p. ix.

16. Sturrock, J. (1993), *op. cit.*, p. 73.

17. Holly, M. A. (1984), *Panofsky and the Foundations of Art History,* New York: Ithaca.

18. On the intentional fallacy see pp. 81-87 in Preziosi, D. (1989), *Rethinking Art History*, New Haven & London: Yale University Press.

19. Damisch, H. (1975) in D. Preziosi (ed.) (1998), *The Art of Art History: A Critical Anthology*, Oxford: Oxford University Press, p. 237.

20. Levi-Strauss, C. (1963), 'Do Dual Organisations Exist?' in *Structural Anthropology*, Middlesex: Penguin.

21. Fernie, E. (1995), *Art History and its Methods,* London: Phaidon.

22. Damisch, H. (1975), *op. cit.*, p. 237.

23. Kress, G. and Leeuwen, T. (1996), *Reading Images: The Grammar of Visual Design*, London: Routledge.

24. Barthes, R. (1957), *Mythologie,* (1990 edition) (trans. Lavers, A. and Smith, C.), London: Jonathan Cape.

25. Kress, G. and Leeuwen, T. (1996), *op. cit.*

26. Bal, M. and Bryson, N. (1991), *op. cit.*, p. 246.

27. *Ibid.*, p. 252.

28. Greenberg, C. (1965), 'Modernist Painting' in Frascina, F. and Harrison, C. (1982), *Modern Art and Modernism,* London: Paul Chapman Publishing and the Open University.

Appendix I: Breakdown of Images from Seven Packs

(Alison Bancroft, see chapter 5)

The Packs included in this analysis are:

Baker, E. (1993), *Primary Art: Modern Artists; KSI*, Folens.

Brigg, C. & Penn, A. *Art Pack: Animals*, Philip Green Educational Ltd.

Brigg, C. & Penn, A. *Art Pack: Faces*, Philip Green Educational Ltd.

Brigg, C. & Penn, A. *Art Pack: Families*, Philip Green Educational Ltd.

Clement, R. & Page, S. (1992), *Primary Art*, Oliver and Boyd.

Somerville, J. & Ulph, C. (1990), *Art and Design Resource Packs: Portraits*, Oliver and Boyd.

Texture, The Goodwill Art Service, 1992.

These were chosen from the range because they could be reasonably expected to show a good spread across the categories for consideration. *Modern Artists* is the exception as this would obviously not have any artists in the pre-modern category, however, it was included to examine the balance in the other categories.

It is acknowledged that the categories themselves could be challenged, but it is hoped that the broad picture they present is still useful in the general patterns it identifies. It is possible that one or two of the works in the *Texture* pack have been misplaced when dates were not given and works could not be traced. In all cases the artists are twentieth century, but the work could have been produced pre or post 1950. A move between these categories would make small difference to the overall picture. I have not however placed Ann Kearns (listed as nineteenth century) because if her work was pre-modern this would be significant, as it would mean that she was the only woman artist represented before 1850.

I was not prepared to categorise the art work that did not fall into the white European/American section. These images have therefore been listed using details from the packs.

Table 1: Breakdown of images from seven packs

Breakdown of images from seven packs										
	White European/American									
	Pre-modern			1850 – 1950			Contemp.			
	M	F	U	M	F	U	M	F	U	
Modern Artists (12 cards in pack)				10			1	1		
Animals (12 cards in pack)	3		1	3			2			Buffalo Hunt, Volino Shijie Herrera, American Indian, 1930 Two Sleeping Cats, Tsuguhara Foujita, Japanese, 1930 A Composite Elephant, patna Artist, India, 19th C.
Faces (12 cards in pack)	3			4			2			The Wedding: Lover's Quilt, Faith Ringgold, American, 1986 Beaded Cloth Hat, Yoruba Tribe, Nigerian, 19th C. Tutankhamun's Funerary Mask, Anon., Egyptian, c. 1354–45 BC
Families (12 cards in pack)	2		1	3	2	1	1	1		King Tutankhamun & Queen Ankesenamun, Anon., 1350 BC
Primary Art (24 cards in pack)	3		2	10	3		2	1		Twelve Squirrels in a Chennar Tree, Abu'l Hasan, Mughal Empire, C. 1630 Carved Wooden Gates, Yoruba (Nigeria) The Spinning Top, Torii Kiyohiro, Japanese, c. 1751–7
Portraits (11 main images)	2			7			2			
Texture (37 possible artist)	3			23			7	3		Tawny Owl and Young, Ann Kearns, English, 19th C.

Key: M = male, F = Female, U = Unknown

Appendix II: The Domains of Subject Knowledge in Art & Design

(Nicholas Addison)

matic and/or issue-based the seasons, inside/outside: demonisation of Islam, homelessness	**technical and/or materials-based** e.g. carving, weaving: plastics, virtual space	**formal and/or aesthetic** e.g. colour theory, spatial systems: beautiful and sublime, grotesque and abject
semiotic g. materials as signs, the ning of represented gesture	**own practice: production** e.g. conceptual, critical, making **own practice: teaching** e.g. collecting, resourcing, planning, enabling, assessing, displaying	**historical** e.g. chronology, social history, the artefact as document/text
functional e.g. why? contemplation, utility, propaganda, or whom? private/public us, ideology e.g. 18th/19th tury needlework, a means of communication	**SUBJECT KNOWLEDGE IN ART CRAFT & DESIGN** **APPROACHES AND METHODS OF INVESTIGATION**	**art historical** e.g. material evidence of culture: Ancient Egypt, Iconography: Italian Renaissance stylistic change and development
interdisciplinary . anthropology, sociology, psychoanalysis, cultural studies	**sites (real and virtual)** e.g. Studios, Galleries, Museums, Libraries **object based analysis** e.g. description, form, content, function, context	**critical** e.g. art criticism, engagement with contemporary practice, judgement and taste
contextual stimulus for wider cultural vestigation: gender, race, class, religion	**visual investigation** e.g. drawing, photography and making	**comparative** e.g. cross cultural, high/low, applied/fine
cross-curricular e.g. ecology, politics, the performing arts	**textual/historiographical investigation** e.g. the writing of artists, critics, historians	**multi and intercultural** e.g. world cultures: visibility, diversity, interrelationships: trade, mutual exchange, colonialism, essentialism, hybridity

mode
e.g. discussion,
critical evaluation, written,
visual/haptic,
multi-media, mixed

UNDERSTANDING EVALUATION INTERPRETATION

Appendix IIa: Ways into the Object:Object-based Analysis

(Nicholas Addison)

<table>
<tr><td colspan="2">

0 – Initial responses (optional)
What is your initial response

</td></tr>
<tr><td colspan="2">

1 – Empirical analysis
Record your observations and cite evidence

a) *Description* (recognition and identification)

</td></tr>
<tr>
<td>

What can you see?
What do you think is happening?

Where are you positioned?
What does this position suggest?

</td>
<td>

- things, participants, forms
- the relationships between the participant
 or the object's constituent parts/forms
- height, angle, distance, etc.
- e.g. subservience, dominance, privilege

</td>
</tr>
<tr><td colspan="2">

Do you have to be static or can you move round the object or interact with it?
Do you need to view the object over a period of time (temporarily) or can you view it, or its various parts, at any one moment (simultaneity)?

</td></tr>
<tr><td colspan="2">

b) *Form*

</td></tr>
<tr>
<td>

Which formal elements are used?
How are they used?

</td>
<td>

- e.g. line, colour, texture, space
- e.g. is the colour local, descriptive, evocative, symbolic, arbitrary?

</td>
</tr>
<tr><td colspan="2">

Is a particular perspectival system used?
Is the space defined by solid or empty forms
(presence or absence), mass or plane?
What are the relationships between the formal elements and how do they interact?
composition

</td></tr>
<tr>
<td>

Try using binary questions

</td>
<td>

- e.g. simplicity/complexity; sameness/difference; unity/fragmentation

</td>
</tr>
<tr><td colspan="2">

c) *Materials and Techniques*

</td></tr>
<tr>
<td>

What is it made from?
What <u>processes</u> are used to make it?

</td>
<td>

- e.g. bronze, fabric, light
- e.g. casting, embroidery, performance

</td>
</tr>
<tr><td colspan="2">

Identify the <u>material evidence</u> for this
Is it permanent (or intended to be so) or is it transient and ephemeral?

</td></tr>
</table>

2 – Functional analysis	
a) *Patronage* For whom was it produced? What did the patron determine?	• e.g. its content, form, materials
b) *Purpose* Why was it made and what purpose did it serve? Has its function changed: is it used in ways other than intended?	• e.g. propaganda, decoration, ritual, habitat, self-expression • i.e. recontextualised and/or decontextualised
c) *Provenance* Where was it originally? Has it moved? Where is it now?	• If so, trace its journey

3 – Contextual analysis

a) *Art Historical Classifications*

Iconography

What is the art object about, what do its images/references mean? Is it:	• e.g. the man standing with an axe through his skull represents a martyr
a <u>literal</u> representation?	• concerned with appearances, e.g. a portrait bust, a visual record
a <u>metonym</u>?	• a causal or associative connection, e.g. a palette and chisel suggest a traditional artist
a <u>symbol</u>?	• an analogy or <u>metaphor</u>, something other than itself defining its character, e.g. the lotus blossom symbolises union
an <u>allegory</u>?	• a symbolic story, often with moral overtones, e.g. a biblical parable

Is it historical, literary, utilitarian, genre, etc?

Style

Does it belong to an identifiable <u>tradition</u> identified with a culture, nation, period, etc? Is it composite?	• e.g. Islamic, Ming, Baroque, Finnish, Popular, Folk, International, – • intercultural, <u>hybrid</u>

Mode

Does it conform to a specific way of representing/making?	• e.g. mimetic, abstract, diagrammatic, functional, documentary, narrative
Does it conform to a specific aesthetic category?	• e.g. beautiful, sublime, grotesque, abject

Influences

What might its influences be?	• e.g. intercultural, generational

b) *Contexts*

How does it relate to its historical and
contemporary contexts?
What is its relationship to broader
cultural structures, including race,
gender, class?

- e.g. religious, political, economic,
 social

- It would be useful here to consider the
 methods of other disciplines, e.g.
 anthropology, sociology,
 psychoanalysis (interdisciplinarity)

c) *Interpretation: Significances*

How do the various elements, (forms, techniques, materials, images) work
together as signs to suggest particular meanings? (semiotics)

Are there any differences between the
explicit representations (denotation)
and the unconscious content
(connotation), in other words are there
any hidden messages? If so what are
they?

- e.g. intentional or subliminal,
 celebratory, subversive?

How might its changing site/function alter its meaning? (framing)
How has it been understood by others in its own and other times?
What is its significance(s) today?
What do you think it might mean?
What do you bring from your own experience that might condition the way you
make sense of it?

Appendix III

Table 1 (see Cunliffe, chapter 9)

The inter-dependence and inter-relationship of 'external' aspects of works of art and their 'internal' features

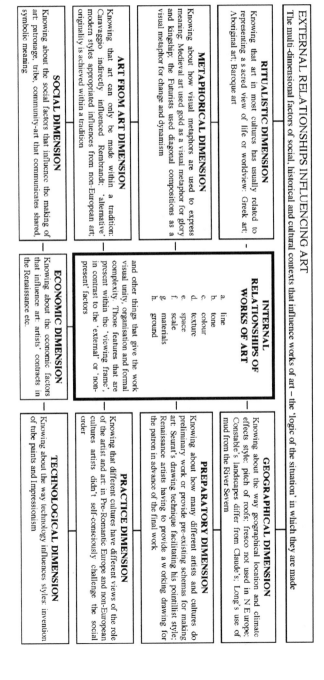

EXTERNAL RELATIONSHIPS INFLUENCING ART
The multi-dimensional factors of social, historical and cultural contexts that influence works of art – the 'logic of the situation' in which they are made

RITUALISTIC DIMENSION
Knowing that art in most cultures has usually related to representing a sacred view of life or worldview: Greek art; Aboriginal art; Baroque art

METAPHORICAL DIMENSION
Knowing about how visual metaphors are used to express meaning. Medieval art used gold as a visual metaphor for glory and kingship; the Futurists used diagonal compositions as a visual metaphor for change and dynamism

ART FROM ART DIMENSION
Knowing that art can only be made within a tradition: Caravaggio indirectly influenced Rembrandt; 'alternative' modern styles appropriated influences from non-European art; originality is achieved within a tradition

SOCIAL DIMENSION
Knowing about the social factors that influence the making of art: patronage, tribe, community-art that communicates shared, symbolic meaning

INTERNAL RELATIONSHIPS OF WORKS OF ART
a. line
b. tone
c. colour
d. texture
e. space
f. scale
g. materials
h. ground

and other things that give the work visual unity, organisation and formal complexity. Those features that are present within the 'viewing frame', in contrast to the 'external' or 'non-present' factors

GEOGRAPHICAL DIMENSION
Knowing about the way geographical location and climatic effects style: pitch of roofs; fresco not used in N.Europe; Constable's landscapes differ from Claude's; Long's use of mud from the River Severn

PREPARATORY DIMENSION
Knowing about how many different artists and cultures do preliminary work or provide pre-existing schemas for making art: Seurat's drawing technique facilitating his pointillist style; Renaissance artists having to provide a working drawing for the patron in advance of the final work

PRACTICE DIMENSION
Knowing that different cultures have different views of the role of the artist and art: in Pre-Romantic Europe and non-European cultures artists didn't self-consciously challenge the social order

ECONOMIC DIMENSION
Knowing about the economic factors that influence art: artists' contracts in the Renaissance etc.

TECHNOLOGICAL DIMENSION
Knowing about the way technology influences styles: invention of tube paints and Impressionism

Appendix IIIa

Table 2: (see Cunliffe, chapter 9) Semantic differential technique for an OPEN-ENDED RESPONSE

Artist's name _____ Title_____

Type of work: painting, drawing, sculpture, print, other _____

Is this work of art:

rough 1 2 3 4 5 6 7 smooth
give some reasons for your choice_____

fresh 1 2 3 4 5 6 7 stale
give some reasons for your choice_____

fast 1 2 3 4 5 6 7 slow
give some reasons for your choice_____

healthy 1 2 3 4 5 6 7 sick
give some reasons for your choice_____

rough 1 2 3 4 5 6 7 delicate
give some reasons for your choice_____

pungent 1 2 3 4 5 6 7 bland
give some reasons for your choice_____

sad 1 2 3 4 5 6 7 happy
give some reasons for your choice_____

light 1 2 3 4 5 6 7 dark
give some reasons for your choice_____

Use some of your words to describe the qualities you think this work of art has

Table 3 Semantic differential technique for a response to PROCESS OR TECHNIQUE

Artist's name _____ Title_____

Type of work: painting, drawing, sculpture, print, other _____

Is the PROCESS or TECHNIQUE of this work of art:

rough 1 2 3 4 5 6 7 smooth
give some reasons for your choice_____

thick 1 2 3 4 5 6 7 thin
give some reasons for your choice_____

precise 1 2 3 4 5 6 7 imprecise
give some reasons for your choice_____

detailed 1 2 3 4 5 6 7 sketchy
give some reasons for your choice_____

sharp 1 2 3 4 5 6 7 blurred
give some reasons for your choice_____

busy 1 2 3 4 5 6 7 static
give some reasons for your choice_____

Use some of your words to describe the mood that you think this work of art creates

Table 4: Semantic differential technique for analysing MOOD

Artist's name _____ Title_____

Type of work: painting, drawing, sculpture, print, other _____

Is the MOOD of this work of art:

happy 1 2 3 4 5 6 7 sad
give some reasons for your choice_____

sober 1 2 3 4 5 6 7 serious
give some reasons for your choice_____

nice 1 2 3 4 5 6 7 awful
give some reasons for your choice_____

healthy 1 2 3 4 5 6 7 sick
give some reasons for your choice_____

mysterious 1 2 3 4 5 6 7 ordinary
give some reasons for your choice_____

aggressive 1 2 3 4 5 6 7 gentle

give some reasons for your choice_____

Use some of your words to describe the mood that you think this work of art creates

Appendix IV: React, Research, Respond, Reflect – Engaging Students with Visual Form

(Richard Hickman, see chapter 10)

The following are guidelines which can be used with school students. They begin with students' initial affective responses to the chosen item - which can of course be each student's own choice.

REACT - *this is your first reaction to the item (which can be any kind of visual form - a comic, piece of graffiti, automobile advert, a piece of pottery in a museum, or famous painting in a big gallery. How do you feel about it? What does it remind you of? How do you 'relate' to it? You might well see a piece of art in a modern gallery and say 'my dog could do better than that!' which is a perfectly reasonable initial response, but you need to go further and ask yourself why the art object is in a gallery in the first place. Note down your first feelings and ideas about it and its surroundings.*

RESEARCH - *this is an important second step, involving a systematic examination of the chosen item in two stages - firstly of the work itself and then the circumstances surrounding its production. The first stage of the research involves looking carefully at the work, either as a reproduction or (preferably) in real life. Examine the visual and tactile elements, (colour, pattern, texture, composition, shape, form, line, space, tone) and their relationship to each other. You should look at the item's content if a painting, what if anything, does it depict? What does it seem to be about it about? Look carefully at what it is made of - what kind of paint seems to be used? Is it a collage or montage? How is it put together? Make a list of all the things which you can see, dividing the list into different categories, such as 'subject matter' 'colour' and 'composition'.*

The second stage of the Research part of this approach involves inquiry without the chosen item. This is where really involved research comes in, and can get quite complex, but you can discover a great deal of interesting stuff. You could investigate the maker's intention, perhaps looking up things that they have written. You should look at the relationships between the content and process, and the various contexts in which it was produced - you might want to consider such things as the technological, cultural, religious, social and historical issues which might have influenced it.

RESPOND - *this third step is concerned with making a considered response, based on what you have discovered through systematic inquiry (having found out about*

the artist and her/his circumstances, how do you now feel about the item - would you call it art? If so, what makes it so). This is an opportunity for you to talk or write in an informed way about the chosen item, and to use an appropriate specialist vocabulary.

REFLECT - *this is an opportunity to think over and contemplate the meaning and nature of the item in the light of the above (what does it mean to you? How does it relate to issues which concern you?). It is important to let things sink in, to give yourself time to build upon what you have learned and to think about the object you have looked into. Some visual forms, especially those labeled art objects, after all, are often made to have a significant, deep and moving effect upon those who look at them. Art has been, and still is, considered to be very important for all cultures, since the beginning of time - have you ever thought why?*

Index